SPLINTERS

Also by Leslie Jamison

Nonfiction

Make It Scream, Make It Burn: Essays
The Recovering: Intoxication and Its Aftermath
The Empathy Exams: Essays

Fiction

The Gin Closet

SPLINTERS

Another Kind of Love Story

LESLIE JAMISON

Little, Brown and Company

New York Boston London

Little, Brown and Company
Hachette Book Group
1290 Avenue of the Americas, New York, NY 10104
littlebrown.com

First Edition: February 2024

Little, Brown and Company is a division of Hachette Book Group, Inc. The Little, Brown name and logo are trademarks of Hachette Book Group, Inc.

The publisher is not responsible for websites (or their content) that are not owned by the publisher.

The Hachette Speakers Bureau provides a wide range of authors for speaking events. To find out more, go to hachettespeakersbureau.com or email hachettespeakers@hbgusa.com.

Little, Brown and Company books may be purchased in bulk for business, educational, or promotional use. For information, please contact your local bookseller or the Hachette Book Group Special Markets Department at special.markets@hbgusa.com.

ISBN 9780316374880
LCCN 2023938832

Printing 1, 2023

LSC-C

Printed in the United States of America

For Ione Bird

MILK

What is the robot owl that makes babies fall asleep? What is the doll with a heartbeat that makes babies fall asleep? What is the name of the thousand dollar crib that does everything a mother does? Does the skin shelf above a C-section scar ever go away? Marina Abramovic had how many abortions? Why is the Cold Moon also called the Mourning Moon? Is a flying ant always the queen trying to start a new colony? What makes the queen ant want to start a new colony? What is the average hourly rate for divorce lawyers in New York City? How will the Wolf Moon change my life?

The baby and I arrived at our sublet with garbage bags full of shampoo and teething crackers, sleeves of instant oatmeal, zippered pajamas with little dangling feet. At a certain point, I'd run out of suitcases.

We had diapers patterned with drawings of scrambled eggs and bacon. *Why put breakfast on diapers?* I might have asked, if there had been another adult in the room. There was not.

Outside, it was nineteen degrees in the sun. For the next month, we were renting this railroad one-bedroom beside a firehouse. I'd brought raspberries and a travel crib, white Christmas lights to make the dim space glow. Next door, a fireman strutted toward his engine with a chainsaw in one hand and a box of Cheerios in the other. My baby tracked his every move. What was he doing with her cereal?

It was only when I told my divorce lawyer, "She is thirteen months old," that my voice finally broke. As it turns out, divorce lawyers keep tissues in their offices just like therapists, only not as ready to hand. "I know we've got them somewhere," she told me warily, rising from her swivel chair to search. As if to say, *We aren't surprised by your tears, but it's not our job to manage them.* If I cried for five minutes, it would cost me fifty dollars.

"Just *over* thirteen months," I said, wanting to make it seem like we'd stayed married longer than we actually had. Again and

again, he told me, "Our baby is just one year old." My best friend said, "Better to get out now."

It did not help to argue with him in my head. It only helped to hold the baby so close that the globe of her belly became the whole world. And even that—well, it cut both ways.

Our sublet was long and dark. A friend called it our birth canal. It seemed to be owned by artists; it was not made for a child. The coffee table was just a stylish slab of wood resting on cinder blocks. The biggest piece of art was a large white canvas that looked like a wall hanging on the wall. Sometimes the firemen next door ran their chainsaws for no good reason. But what did I know? Maybe there was a reason for everything.

Our nights were full of instant ramen and clementines. My fingers smelled like oranges all winter. Our rooms were lit by the liquid pulsing of red siren lights through the slatted blinds. The kitchen counters were streaked with trails of red velvet batter and little beige buttons of hardened pancake mix. The residue of throwing sugar at a problem.

By day, my baby crouched among the heavy art books with her wooden maraca and smacked the translucent pages of a story about a pile of leaves: the willow, the birch, the stray mitten, the lost key, and, at the very bottom, a tiny worm. My baby was gentle with her stuffed moose, nuzzling his patchy brown fur against her cheek. But with her wooden xylophone she was an Old Testament God. It barely survived her music.

We moved out in the middle of flu season. One night I woke up at four in the morning with my mouth full of sweet saliva. I

stumbled to the bathroom, past the dreaming baby, and knelt in front of the toilet until dawn. When the baby woke, I crawled after her from room to room, then lay on my side on the wooden floor and watched her, sideways. I didn't have the strength to stand but I didn't want her out of my sight. The things she put in her mouth just blew my mind. All I could do was lie beside her toys, wrapped in a gray blanket, flushed and shivering. She handed me her favorite wooden stick, the one she used to play her rainbow xylophone. She picked up a Cheerio from the floor and lifted it tenderly toward my mouth.

I was myself a "child of divorce," as they say, as if divorce were a parent. When I was very young, I thought divorce involved a ceremony: the couple moved backward through the choreography of their wedding, starting at the altar; unclasping their hands, and then walking separately down the aisle. I once asked a friend of my parents, "Did you have a nice divorce?"

Falling in love with C was not gradual. Falling in love with C was encompassing, consuming, life-expanding. It was like ripping hunks from a loaf of fresh bread and stuffing them in my mouth. In those early days, he was a man frying little disks of sausage on a hot plate in a Paris garret, asking me to marry him. Making me laugh so hard I slipped off our red couch. Loving the smoked tacos we got from a tiny shack just north of Morro Bay. Pointing out backyard chickens from the garage we rented behind a surfer's bachelor pad. Putting his hand on my thigh while I drank contrast fluid that tasted like bitter Gatorade, before a CT scan to find my burst ovarian cyst. Playing the Nitty Gritty Dirt Band on

a road trip, putting a cinnamon bear on our rental car dashboard because it was our mascot, our trusty guide. Our thing. We had a thousand things, like everyone. But ours were only ours. Who will find them beautiful now?

In those early days, he was a man ordering room-service steak at the Golden Nugget after we said our vows in a Vegas wedding chapel at midnight. He was a man curled beside me watching our favorite obstacle-course program on TV, a man getting my face tattooed on his biceps, a man whispering in my ear at a crowded party.

He is still that man. I am still that woman. We have betrayed those tender people, but we still carry them around inside of us wherever we go.

The first class I taught that semester of our separation—when my life consisted of sublet-hunting, angry texts, and taking care of the baby, or else getting her to childcare—I arrived at class with my pulse loud against my temple, skittery from too much caffeine. My heart was a hive of bees in my chest. My students tucked their hair behind their ears and picked at their cuticles and took turns telling me what they wanted to write about: Labiaplasty. Chronic pain. Getting caught in an avalanche. They didn't know it, but they were all my children. My beehive heart had enough love for all of them.

Once you're finally out of a broken marriage, it feels like you're just dripping with love. Or at least, it felt that way to me—like it was a heap of bubble-bath suds growing larger and larger all around me. I wanted to slather it across the whole world. That was me in my bathtub next to the fire station. Me with my baby

taking care of business in every room of our birth canal. She needed to take the spoons out of the spoon rack. She needed to take all the baby jeggings out of the baby-jegging drawer. She needed to play her rainbow xylophone like it was a creature that had wronged her. Like she was telling me, You better get on your knees. You better get on the floor and start listening.

Watching her slam the meat of her tiny palms against the wooden slats, I almost turned to the phantom of her father beside me, so we could watch her together—then caught myself. Would every moment of happiness carry this weight tucked inside of it?

A year earlier, my water had broken during a blizzard. My labor went fine until it didn't. Suddenly it was two in the morning and a nurse was bending over me, saying, "I need another pair of hands," over and over again, until there were many pairs of hands, too many pairs of hands, and they were looking for a heartbeat. Then they were running my gurney to the operating room, their voices calling out, "It's in the sixties! It's in the fifties!" and I knew they were talking about her heart.

They draped a blue tarp over the lower half of my body and tipped me backward to let the anesthesia flow faster up my torso. I remember wondering why we needed to depend on gravity like that. Hadn't science given us a better way? But mainly I just wanted them to make her okay.

After they cut her out of my abdomen, they carried her to the corner of the room. One impossibly small leg stuck out of the blanket. The anesthesiologist kept trying to take my blood pressure while my arms bucked against the gurney cuffs like tethered

dogs. I didn't care about my blood pressure. My baby was small and she was purple and she was not in my arms. The whole time, I was shaking. The whole time, C was holding my hand.

Drugs and adrenaline ran wild through my veins. It was only once they let me hold her that I finally went still.

On the postpartum ward, during latch class, other women wore striped French-sailor nursing blouses and cradled their quietly sucking babies, while my hospital gown hung open to show my bare breasts, no baby attached. My blue mesh underwear was pulled high over my incision bandages. I said, "My name is Leslie, and my baby isn't nursing," as she cried in my arms, unlatched. It felt like bringing an open container to an AA meeting.

Latch class summoned the delusions of junior high school all over again, the belief that other girls were moving effortlessly through the rituals of femininity while I fumbled. And it was just as false, this conviction that the women in their striped sailor shirts didn't have troubles of their own.

At night, the Empire State Building loomed beyond my hospital window, its tiny yellow squares glowing beyond the roof maze of snow-dusted vents and pipes. On the muted television, kids made macarons on some program that seemed to be called *Worst Bakers in America*. Whenever I walked to the bathroom, my IV cord got tangled around its pole. A blood clot fell out of my body and landed on the tiles. It was the size of a small avocado, jiggling like jelly.

The window ledge filled up with snacks from friends: graham crackers, cashews, cheddar cheese, coconut water, oranges with tiny green leaves. Someone handed me a form to fill out, Did I

want bone broth? There were suddenly flowers—big blooming lilies, purple orchids, lavender tulips. The blue mesh hospital underwear was the only kind of underwear I could imagine wearing. The swaddled baby in her glass-walled bassinet was like a deity at the foot of my bed. Sometimes her eyes opened and the world stopped.

When my mother arrived from California, I sat there on the starched sheets holding my baby, and my mother held me, and I cried uncontrollably, because I finally understood how much she loved me, and I could hardly stand the grace of it.

At three in the morning, a nurse came to our hospital room to say they were taking my baby to the bilirubin lights for her jaundice. The Billy lights, they were called. It was only when the nurse said, "Don't worry, it's quite common," that I realized I was crying. How could I explain? I knew it was common. My body just didn't want to be away from her body. I wasn't crying from anyplace inside my mind. I was crying from a wordless cave of muscle and milk. It was the part of me that wanted to eat her just to get her back inside me.

After a little while, I pushed my IV pole down the hallway to find her in the nursery, reclining under the blue lights in her tiny diaper—one leg propped on the blanket like a little honeymooner, her skin drinking the liquid cobalt world.

Back home from the hospital, my baby opened a seam in the night and pulled me into its darkness—those silent hours between two and seven, when she slept on my chest as I watched reality television about aspiring Australian models and paced the living

room looking at the single lit window on our block, wondering, *Who?* And, *Why?* It was like I'd landed on another planet that had been invisibly tucked inside our ordinary world all this time.

People told me motherhood would feel like deprivation—losing time, losing sleep, losing freedom—but it felt more like sudden and exhausting plenitude. There were more hours in the day when you never slept.

Of course I'd heard babies were always waking up. But this now seemed like a joke. How did anyone get them to sleep in the first place? Every time I put the baby in her bassinet, she cried and cried. I tried sixteen different swaddles and none of them worked. Even the cheating swaddles were impossible to figure out, at least at three in the morning. Their flaps were covered with labyrinths of Velcro. What was supposed to stick to what?

The baby only slept when she was being held. So C and I stayed up in shifts. Our red couch was covered in bright orange Dorito crumbs and sugar crystals from the Sour Patch Kids that split my tongue into jagged furrows as I ate them mechanically, unstoppably, in little fistfuls. When our steam heaters rattled, it sounded like tiny elves protesting their imprisonment with giant hammers. I clenched my teeth against their clanging, afraid they'd wake the baby up.

Each day I tried to pump enough milk to fill a single bottle, wedging this pumping between nursing sessions so frequent it was hard to imagine any milk accumulating between them. This bottle was used to enable a few hours of sleep each night. Usually I stayed up holding her till eleven or midnight, C was with her for a few hours until two or three, and then I woke up to hold her again until morning. Sometimes I'd wake to hear him fetching

the bottle from the kitchen earlier than I'd hoped, barely past midnight, and I'd think, *No, no, no,* because it meant the clock was ticking. We were getting closer to the moment when my body would become irreplaceable again.

Before her birth, I'd felt that frantic nesting impulse. You could survive parenting if you just had all the *things.* You could gather them around you like a room of plundered treasure. But then none of them worked! The white noise machine didn't do much besides articulate a kind of stubborn hope.

Whenever I googled *baby won't sleep in bassinet,* I saw only the purple results I'd already clicked. At 3 a.m. one night I typed *thousand dollar crib that does all the things a mother does,* and wondered what percentage of sales for these thousand-dollar cribs occurred between the hours of midnight and five in the morning.

During the first few weeks of my daughter's life, I lived in the gray glider by the back window. Our fridge was full of rotting aspirations: the salad-bound cucumber, now leaking brown fluid; the forgotten, softening strawberries; the marinara sauce furred with mold. As I nursed my daughter, my mother brought me endless glasses of water. Our three bodies composed a single hydraulic system. My eyes were always on the top of my daughter's head, my fingers stroking her cheek to keep her awake as she nursed. She'd been born three weeks early. She was little.

Every few hours my mother put a plate on my lap, jigsawed with crackers bearing little squares of cheese, clusters of green grapes, apples fanned into slices. She said, "You need to eat." She

held my baby girl against her chest and whispered in her ear, "You know how your mama loves you? That's how I love her."

My mother. After my parents split up, when I was eleven, it was just the two of us. On Sunday nights we watched *Murder, She Wrote,* eating bowls of ice cream side by side on the couch. She always solved the mystery by the second commercial break; she knew from the lost umbrella in the corner of the shot, or else from the fishy alibi that didn't check out because the murderer used "he" to describe a female dentist. "Just got lucky," she'd say. It wasn't luck. It was her close attention to the details of the world, the same keen eye that kept track of every doctor's appointment, every passing comment I'd made about a school project, a tiff with a friend; she always followed up, wondered how it went.

Her skin carried the sweet, clean scent of her soap—that blue tub of chilly white pudding that she rubbed across her high cheekbones. She baked loaves of fresh brown bread and gave me heels straight from the oven, still warm.

She helped me write down recipes in a little spiral-bound notebook of index cards so I could make us dinner once a week: sloppy joes with soy crumbles, or a casserole of pop-up biscuits and cream of mushroom soup. My economist father was on the other side of the country, or in his apartment across town, or in the sky. It was hard to keep track. He and I had dinner once a month. Sometimes more, sometimes less. He'd never had my biscuit casserole.

In many photos from my childhood, my mother is embracing me—one arm wrapped around my stomach, the other pointing at something, saying, *Look at that.* To talk about her love for me

would feel tautological; she has always defined my notion of what love is. Just like it's meaningless to say our ordinary days meant everything to me, because they created me. I don't know any self that exists apart from them.

Twilight was the witching hour. The baby cried and cried. Nursing helped until it didn't, and then I had nothing.

The Internet said babies needed reassurance at dusk because of their primal fear of being abandoned in the dark. "Don't worry, baby," I told the crying pajamas in my arms. "I won't abandon you in the dark." But saying it out loud, it didn't sound like the worst idea.

Her crying had the urgency of an itch you might scratch all the way to the bone. Every wailing came as an accusation, *You are not making this better.* One evening I finally snapped. "Why are you crying?" She looked at me for a moment, betrayed, then cried some more. She was just eleven days old! I offered her my breast as a peace offering. She wanted none of it. I tucked my face close to hers, held my cheek against her hot red cheek, rubbed my skin against her warm little tears. She needed to understand me as the one who would never leave.

As I held her, I rocked back and forth, swaying left foot to right. My mother told me that her mother, raised on a farm north of Saskatoon, had called this the Saskatchewan shuffle. But every mother knows it, that swaying. Every mother calls it something. Sometimes you will see a woman doing it instinctively, her arms empty, when she hears the crying of a stranger's baby.

After hours of crying, hours of nothing helping, I began to understand why babies get shaken. I understood why the Victorians

gave their babies tinctures of opium. Eventually, still holding her cradled against my chest, I started banging my head against the bedroom wall. Our bodies still felt like part of the same body. But this way only mine would hurt. The harder I banged my head against the wall, the steadier I tried to keep her—cradled by a pair of loving arms attached to a woman losing her mind. Maybe the baby would never stop crying, but that was okay because eventually I would...die?

The old druggists had the perfect name for their baby opium potions. They called them the quietness.

What happened? She stopped crying. She slept. She woke. She cried again. She slept again. She nursed again. I kept feeding my baby. My mother kept feeding me.

Months later, in couples therapy, C said: "The three of you were a closed world in that back room. I had no place in it."

It seemed like I was never doing anything besides nursing or wandering around with the baby against my chest. Life was little more than a thin stream of milk connecting my body to hers, occasionally interrupted by a peanut butter sandwich.

My mother had a two-month sublet nearby. I yearned for her arrival every morning. Her presence meant I could collapse into someone else, that I could ask—without apology, or hesitation—for the things I needed. A hundred times a day I looked at my mom—in her wool turtlenecks, her bright pink scarf, her winter supplies amassed from Los Angeles stores—and thought, If I can just be half the mother you've been, it will be enough.

Most days, we stayed in the back of the apartment, near the kitchen and the gray glider, perched by the window. Nursing, I watched bare branches rattling in the winter wind, against brick walls covered with dark spidery lines of ivy.

C stayed mainly at the other end of a long hallway, in the living room, on its red couch flooded with bright winter sunlight. He was working. When we retreated into separate corners of our apartment, it felt like our bodies—his at his laptop, mine on the glider—were simply acknowledging the distance that already existed.

It was easier to crawl back into the bond that had always come most naturally to me, anyway—mother and daughter. My mom was the only person to whom I'd ever been able to say, boldly, plainly, without equivocation, *Please help me.*

When I was a kid, I liked to write fairy tales with unhappy endings. The dragon roasted everyone. Or else the princess left her prince standing at the altar and flew away in a hot-air balloon over the sea. Maybe this was a happy ending, just a different kind. Not a wedding, but an untethering. Sandbags hurled over the edge of the basket. Flames blooming under the silk.

As an adult, I said this about myself so many times—*When I was a child, I liked to write fairy tales with unhappy endings*—that I started to forget another girl prowling the halls of memory. This girl had wandered the supermarket aisles hunting for glossy bridal magazines, their pages full of mermaid silhouettes and sweetheart necklines and long trains sweeping across grassy lawns like crystal spiderwebs. I begged my mother to buy one of these magazines for me, and she resisted until she didn't. Then it was mine, glossy

and reeking of perfume samples, thick as a phone book in my five-year-old palms.

The funny thing is, I can't actually remember having the magazine, only wanting it. My desire turned into something more diffuse and vexing, harder to recall, once its object was heavy in my hands.

When I met C, I was thirty years old. I wasn't a child. But there was so much I didn't know. I'd never made a choice I couldn't take back. I was drowning in the revocability of my own life. I wanted the solidity of what you couldn't undo.

The first time we met, the two of us were standing in the communal kitchen of the writers' space where we both worked, a warren of cubicles across the street from a Party City in downtown Manhattan. Just below us was a defunct bartending school, where I sometimes made my reporting calls—interviewing naval audio engineers, or the families of kids with past-life memories—while pacing the empty carpeted rooms, past peeling linoleum bars.

The first time C spoke to me, he asked about my tattoo. He wasn't the first man to do this. But I was even more interested in his tattoos than he was in mine. He had so many: the blurry stick-and-poke Hebrew character at the nape of his neck; the skeleton riding a skateboard along his shoulder; the blooming lily on his forearm. It felt like standing at the edge of a long hallway, each tattoo an open doorway.

When he eventually got my face tattooed on his biceps, a year into our relationship, we were already married. This proof of his devotion—the fact that he would make me part of his body—was

intoxicating and frightening at once. It reminded me there was no undoing what we'd done. We couldn't take anything back.

That first afternoon, I recognized him immediately. His debut novel had gotten a glowing review on the cover of the *New York Times Book Review*. In his author photo, he'd looked intimidating: dark hair, piercing gaze, tattoos, dressed in black. He wasn't going to smile at you *just because*. In person, this gruffness felt present, but it lived—uneasily, thrillingly—alongside goofiness and eagerness and curiosity. When he laughed, he shook with it. You knew it was the real thing. His face hid nothing. Every flicker of disdain, desire, anger, annoyance flashed across it like lightning illuminating the sky.

Our third date was a four-day road trip to the Catskills, where we stayed at the only motel where I could find a last-minute room. It was called Beds on Clouds, because every room had a different sky painted on the ceiling. That wasn't all our room had. As we walked in, C exclaimed, "That's a *lot* of Siegfried and Roy." There must have been thirty photos of them all over the walls, posing proudly with their tigers. We loved it.

Every morning we ate breakfast at a little diner down the road. The coffee was mulchy and bitter and hot, but I drank cup after cup, burned my tongue on it—eager to be awake, eager to talk, eager to bite the salty bacon that made my chapped lips sting; eager to rush back to the table from the little diner bathroom because there was so much to say.

C had lived so much more than I had. It wasn't just that I was fresh from my twenties, and he was well into his forties—it was

also that he had lived through a great tragedy: the protracted, terrible illness and eventual death of his first wife. He had stayed with her in the hospital after both bone-marrow transplants. He'd shaved his head when she shaved hers. He'd tried to get her to eat when she couldn't eat. He'd punched a hole in the wall when the insurance company denied their claims, not for the first time but the twentieth. He spoke of her with deep admiration that was textured and true. He said I would have loved her; she would have loved me. We would have been friends.

When the baby was five weeks old, her pediatrician called about her thyroid. This was her third abnormal reading. All the primary screenings had been fine; but there had been a few stray readings. No cause for concern, the doctor said.

The first time, he'd said, "It's almost certainly nothing." The second time, he'd said, "It's probably nothing." This time, he said he had some bad news and some good news. The bad news was that the pediatric endocrinologist at NYU was very worried about my daughter's numbers. The good news was that she could see us right away. Like, in an hour.

A cab ride to Manhattan was more than enough time for a few more rounds of frantic googling. *Congenital hypothyroidism can cause lasting cognitive defects unless treated within the first few days of life.* On one side of me, the baby in her car seat. On the other side, my mother.

At the hospital, they took eight vials of blood from the crooks of her tiny arms. It was hard to believe they had a tourniquet that small, or—at a certain point—that there was any blood left. After

her first vein blew—I couldn't believe it when they said it, as if she were the tiniest junkie you ever saw—they shone a special light on her arm to show the shadow lace of other veins beneath her skin. The doctor explained that there were a few possible explanations for my daughter's numbers—something about binding proteins, something about cortisone—but she was nearly certain it was a congenital thyroid deficiency.

"But she's going to be fine?" I asked the doctor, staring at her with the stricken eyes of a Google-weary mother. "It hasn't damaged her brain, right?"

There was a long pause. A thousand seconds, or five.

Finally, the doctor said, "I can't promise anything. But I think..." She paused again, choosing her words carefully. "There's a good chance she's going to be fine."

All I heard was the pause. I cried into my crying daughter's open mouth. My tears and snot got all over her little face.

The doctor repeated that she was nearly certain it was a congenital deficiency. It was very rare that these were not caught immediately after birth. We could not know exactly what the impact on her brain development had already been. "If I'm wrong about this," she said, "I'll be the happiest person in the world."

When the doctor called the next day, it was only to say they needed more blood. Then they needed more blood after that. On one visit, the nurses said, "We've never taken this much blood from someone this small." The baby looked up at me from her nest in my arms, with her impossibly bright eyes. Why was I doing this to her?

It was days of blood draws and indeterminate results, more blood draws and waiting by the phone, taking endless scribbled notes. Back in tenth grade, taking perfect notes had helped. These ones were full of ugly thyroid code: Total T4. Free T4. T3 uptake index. TBG. TSH.

One night I tried to talk to C. I was trying to tell him how worried I was. But instead it sounded like an accusation, as if I were quizzing him. Did he know the difference between total T4 and free T4? Did he know why the TSH might have been normal at the newborn screening even if the thyroid wasn't producing any hormone? Did he see all those purple links written on the inside of his eyelids as I did, when I fell asleep at night, with the baby sleeping beside me, breathing her milky breath, dreaming her inscrutable dreams?

I didn't know how to share my worry with him. I only knew how to wall myself in worry like a tower. I didn't ask him if all these numbers brought back memories of other numbers, other hospital days. Not *if.* They must have.

After days of this, the endocrinologist finally called to say it wasn't a congenital deficiency after all. It was the binding protein—the benign thing we'd wanted to be wrong, instead of the worse thing being wrong. There was no brain damage to worry about.

I was standing in my living room, with the baby against my chest. My mom was standing at the doorway; C was sitting on the couch. I scribbled everything on the back of a receipt: Free T4 0.72. TSH 5.2. Total T4 3.43. T3 uptake 68. As soon as we hung up, I turned to tell my mother what the doctor had said.

For months, C brought us back to that moment: "Why did

you turn to your mother first, to tell her our daughter would be fine? Why not me?"

Sometimes I felt the baby belonged to me absolutely. Sometimes when she lay sleeping beside me in her bassinet, I ran my fingers along my scar in the darkness: the thick stitches, the shelf of skin above like an overhang of rock. It was just a slit that led to my own insides, but it felt like the gateway to another world. The place she'd come from.

From the very beginning, there was a goodness in her. I knew it was nothing I had made.

Once she was big enough to get tucked into a carrier, I started taking her everywhere, pressed snug against my chest inside her origami nest of stretchy fabric. When I got back from hours of wandering through the cold, my numb fingers were reminders of how badly I needed to be away from my own home. Checking the baby's fingers, too. But she stayed warm against my chest, tucked under the folds of my down jacket.

On our walks, I learned the names of trees I'd been walking past for years without noticing at all. London plane tree, silver maple, Siberian elm. I watched the branches beyond the nursery window turn from bare to bud to bloom, and remembered my first sponsor saying her Higher Power was just the fact that trees could grow from seeds. Her notion of divinity lived not in the spectral body of an old man with a beard, but in the fact of this absurd, stupendous transformation—at once radical and commonplace, happening in plain sight.

Being with my baby every hour of every day demanded close

attention, not just to her—how close she'd rolled to the edge of our bed, whether her fluttering eyelids meant she was waking up or just dreaming—but also to everything else. The alternative to paying attention to all these little things was growing bored out of my mind. My gaze was sensitized, the way your eyes can see more after you've spent a few minutes in the dark.

Those first months made the everyday visible again. It was all suddenly *there,* the humdrum moments stretched across our days: my daughter's giggling as she nursed, milk dribbling from her mouth; or the pinprick drizzle against our skin on rainy afternoons, when I'd walk for miles with her sleeping against my chest. Her breathing swelled against my ribs. Her hands in their fleece-lined mittens startled like birds when she woke.

Those early days with my daughter felt like excess and hallucination. It was all too much, but when I tried to find language for it, it was nothing at all: milk and diapers, milk and diapers, milk and diapers. The astonishing revelations of caring for a baby felt shameful to claim as astonishing, or—honestly—as revelations at all. Attachment bathes every common thing in the glow of false remarkability. My love-drunk gaze made it impossible to see if anything was worth seeing.

Twelve-step recovery had already taught me that everything I'd lived had been lived before. This lesson had prepared me for parenthood, which was nothing if not unoriginal. Not everyone had a baby, but everyone had been one. It was, by definition, nothing special at all.

When I recorded bits and pieces from our days in a journal, my inner critic and mother argued. The critic wanted to choose

lyrical details—my daughter getting her little hands covered with wet cherry blossoms—while the mother in me wanted to choose...everything. Wanted not to choose.

Meanwhile, a third self—the woman who hadn't had more than a few hours of sleep in many weeks—wanted to leap twenty years into the future. Not stuck inside these days, but remembering them all.

In the middle of the night, as I watched the Winter Olympics happening on the other side of the world, my daughter's milk breath came in puffs against my cheek. I stared with glazed eyes at whatever off-prime-time events were broadcasting at 3 a.m.: the two-man bobsled, the skeleton championship, the ice dancers and the downhill training runs.

Our warm den of lush milk nights and rumpled clothes, chapped lips and soaked bras, the tropical panting of our steam heaters—it all felt like the opposite of these faraway slopes of snow, crisp and white, all the scraping and slicing of skis and boards against ice and rails. Their breath plumed into the cold. Their pivoting was disciplined and relentless.

All my adult life I'd considered time a resource that could be converted into other things—more than anything else, into art. Time was the instrument of my endless ambition, which was itself a frantic thing, an attempt to grasp the materials of the world and fashion from them a justification for my own existence. Being alive involved constantly justifying why I deserved to be alive, as if I were building a bridge one rung at a time across a vast chasm.

But with my baby, time became something else—an element

to be *gotten* through, swum in like water, rather than a currency to be traded for the talisman of some accomplishment. The point was simply moving through the hours. This was our only job. It was liberating and exhausting.

I'd always been a creature of to-do lists and efficiency. Now I was doing little with my days besides keeping this tiny creature alive. The rhythm of my days was simple: left breast, right breast; left breast, right breast.

I'd heard that giving birth acted as a temporary appetite suppressant for sharks, so they would not eat their own young. But I was still hungry. I longed to write. In its best moments, writing made me feel like I was touching something larger than myself. During those early days with the baby, however, it was hard to feel that I was contacting anything larger than my home or my child—anything larger than I could see the edges of.

Now that I could not hurl myself constantly into work and trips and teaching and deadlines, I had to look more closely at the life I'd built: this husband, this marriage. It was impossible to ignore my daily desire to leave: to wander the cold streets of our neighborhood with our baby, making ceaseless, ever-widening loops away from home.

Soon after meeting C, I read a profile of him that had run in the *New York Times Magazine* years earlier, when his first novel was published. C had shown his profiler around Las Vegas, the city of his birth and youth, including his parents' pawnshops, and the writer kept losing track of C because he kept stopping to give money to homeless men, calling each one Sir. That was the image that stuck with me most—this man wandering away from

his interviewer in these crowded streets, sidewalks full of spenders and dreamers, digging through his pockets, addressing every man who had fallen into the invisible margins, looking him in the eyes and saying *Sir, Sir, Sir.*

Early in our relationship, C gave me a copy of his novel. It was about Las Vegas, but most of its characters were hustling to survive in the shadows of the Strip. Pierced runaways leaning against casino walls, squeezing condiment packets down their throats. A skinny girl convinced she stopped getting her period because she was an adolescent witch. A pregnant runaway who imagined giving her baby milk from a carton with her own face on it.

On the copy C gave me, he scribbled notes everywhere. *Did you make it this far? It gets a lot better now, I think.* On the back flap, he wrote that he hoped that in ten years we'd look back on this note with laughter, whether we were together or apart, *which would be sad, apart, but still always with great nostalgia and affection and lovely memories too.*

C loved basketball sneakers and bodega snacks, drank soda rather than coffee. He was easily affronted and absolutely forthright. He was not afraid of hard work or a crisis; he was consolidated by difficulty. He always rooted for the underdog. He loved Lloyd Dobler, John Cusack's character from *Say Anything*: the kickboxer wooing the beautiful valedictorian, standing beneath her window in a baggy beige blazer and a Clash T-shirt, hoisting his boombox high above his head.

Early on, C told me I was a miraculous creature. "You're the future of the species," he said. Whenever we slept apart, we texted

each other first thing in the morning. *My big gulp,* he wrote. *My dolphin.*

The first time C and I talked about my eating disorder, a few weeks into our relationship, he asked me how much I'd weighed when I was sick. Partway through my response, he broke in to tell me how little his wife had weighed by the end of her life. The memory was so painful it cut through him, like a splinter breaking through the surface of his skin. He had no choice but to say it out loud. In that moment, and many others, everything I'd lived seemed trivial in relation to everything he'd survived.

Still, some part of me had wanted to finish my sentence.

Another part of me thought that making this man happy would be more meaningful than anything else I'd ever done. From early on, he said, "You are giving me another life." Every time I felt a flicker of doubt, it seemed like a betrayal of this hope.

Early in our dating, when a stranger at a cocktail party asked C if he could call him by a nickname, he just said, "Nope!"

He didn't deform himself to say whatever he thought someone wanted him to say. He was loyal to the ones he loved—not the false, impossible god of pleasing everyone.

C saw right through the performances of mine that impressed everyone else. He was a keen but tender observer of other people's coping strategies and blustering compensations. Listening to me do a radio interview, he could tell I was nervous because I was speaking too quickly. There was something electrifying, even erotic, about the experience of being seen through. The X-ray.

Eventually, of course, there was another side. Years later, he

told me that even though I'd managed to convince the world I was a good person, he knew what lay behind this façade: the self-ishness underpinning my ambition, the virtue-signaling others mistook for virtue. Some part of me believed him. Some part of me would always believe him. Where others looked at me and saw kindness, he saw the elaborate puppetry of a woman desperate for everyone to find her kind.

That first summer we were falling in love, I spent a month teaching in Paris. For a week, C came over to stay in my attic apartment on Rue Bertholet. We bought oozing almond crois-sants from the curt woman at the boulangerie. We got to be the bumbling Americans, with a wary Parisian shopkeeper correcting our change. I mumbled apologies for my terrible French while C cracked a joke—"I'm a dumb American who doesn't know any-thing!"—and she loved him for it, for not being mealy-mouthed and pandering, but jovially owning what he was.

We stood on a bridge arched across the Seine and gazed at beautiful Notre Dame and for a while didn't even realize we were looking at the back of it. "The ass end of Notre Dame," he said. Sometimes I wonder how many times he made me laugh across our years together. In the thousands? The tens of thousands?

At a party, a wine-drunk student who knew C's backstory asked if he'd ever imagined some version of the impossible sce-nario in which he had to choose between rescuing his first wife from a burning building and... He gestured toward me.

You didn't have to be drunk to wonder about this question, only to ask it. But I was never drunk anymore. I never got to ask.

Of course C didn't answer. He gave the guy some trapdoor out

of the moment. This was a skill he'd learned—how to make his grief more conversationally bearable for other people. But in an odd way I appreciated that this blundering drunk guy had made this explicit: another woman's death was nestled inside every moment between us. It was the house we lived in.

I told myself it was a sign of maturity to surrender the fantasy of being someone's only great love. But it also made me crave our reckless escalation—our midnight Vegas wedding, a few months later—as proof we had a great love, too.

During that month in Paris, I spent an evening with my friend Harriet talking about doubt. It was a muggy night, and we were walking through a park full of cobwebs and flies; during every monologue I swallowed at least one. I told Harriet that this relationship with C didn't feel plagued by doubt the way others had. She called this living under the shadow of the question mark: constantly questioning a relationship while you were inside of it. Her phrase made me imagine a giant question mark silhouetted against the sky.

Harriet imagined this as the greatest relief—stepping out from under this shadow. She wanted to know what it felt like.

"It feels..." I paused for a long time, wondering the same thing. Finally, I said, "It feels good."

I wanted it to work like a spell. You denied your doubt, and then it disappeared. My desire to feel certain was so strong it started to feel like certainty itself.

I met C soon after ending a four-year relationship so gravitational and consuming that I felt our constant friction must be

the necessary price of intensity. If you loved this hard, it couldn't be easy. For much of our relationship, Dave and I lived together in Iowa City, in a wooden clapboard farmhouse on a street lined with sororities. Our home was the physical manifestation of a life I'd conjured in daydreams. Dave wrote poems in a closet big enough to have a window, and used our dusty attic for band practice. I covered a wall with marker-scribbled timelines for my novel. At the parties we hosted, we served little shot glasses full of roasted octopus and ended up with poets asleep in our linen closet.

But when I remember that house, I mainly remember fighting at three in the morning, cleaning up after all these parties, both of us holding black trash bags full of red Solo cups, getting on our hands and knees to scrub our sticky hardwood floors, drunkenly debating the definition of words like *flirting* and *trust*. Our home festered with my simmering fear that he would eventually leave, once he grew tired of my insecurities and my needs. His side of our bedroom dresser had a stack of apology notes I'd written him, always hungover, on the mornings after our fights.

During our four years together, we broke up, got back together, broke up again. We moved, moved again, moved out, moved in, more or less, again. We fought. We made up. We fought. We made up. I drank. I stopped drinking. I started drinking again. I stopped drinking again. We moved back and forth between conflict and reconciliation. Always in transit. Somehow we felt most present to each other in that passage across the threshold.

This was life under the shadow of the question mark. I spent long, agonizing hours on the phone with my mother, explaining my uncertainty to her, hoping she could help me decide. She

asked, "What is your gut telling you?" But the question didn't help, because my gut told me conflicting things at once—that we were soulmates, and that we were doomed—and my gut wasn't a voice to be trusted, anyway. Recovery had taught me this. My gut wanted to drink and drink and drink. My gut didn't realize that no matter how much I drank, I'd still be thirsty.

By the time I met C, I was sick of listening to my gut. I was ready to bring in upper management. Upper management said I was done with waffling, done with going back and forth. Upper management told me not to listen to my doubts. They were only coaxing me back into a prior version of myself.

Lying in bed, under the sloping roof of our Paris garret, C said we should get married. I said yes, because I was in love with him, and because I wanted my whole self to want something, no questions asked. I wanted that consolation. I wanted to believe in love as a conscious decision more than an act of surrender. I'd spent years surrendering myself to feelings and I was tired of it. Surrender was just an excuse. You could bend emotion to your will instead.

This firmness would help me escape what one ex had called my "terrible, fickle heart." Maybe not escape that heart, but discipline it.

I had such an outsized sense of everything, including my own flaws. *Your terrible, fickle heart.* Everyone has an ex who says something like that.

So I told Harriet, I told everyone, I told myself: I have no doubts. I have no question marks. I made promises to C before letting myself figure out if they were promises I wanted to

make—because he'd suffered and I wanted to believe I could give him another, better life. I listened to the part of myself that was falling in love, and ignored everything else.

That false certainty is what I'll have to keep answering for—for years and years, maybe always. To my daughter, most of all.

That first fall, we went to Las Vegas for a literary festival. At this point, we'd been talking about marriage for months without telling anyone else. Late one night we drove to the Little White Wedding Chapel, which had a drive-up window and a white steeple rising from a bright green lawn of Astroturf. A sign showed the cursive names of Michael Jordan and Joan Collins with a heart between them, *married here,* as if they'd gotten married to each other. Anything was possible in this town.

Years later, after we separated, I sometimes heard myself leaning into an ironic version of our Vegas wedding, cataloguing its absurd details: the wry cherubs and the silk upholstered walls, secret speakers playing Elvis singing "Fools Rush In." But whenever I told the jaunty shorthand version, my voice always snagged on something, like a fragile stranger sitting next to you on the plane, just barely holding back tears. You watch them order another little Jack and Coke and think, *Here we go.*

In truth that wedding night held many things, including genuine hope. Back at our hotel, we got big juicy steaks from room service, and fries so hot they burned our tongues. We even had a soft spot for the pool attendant who wouldn't let us swim after midnight—*Sorry, closing time*—because his refusal became part of our crazy Vegas wedding story. I'd fallen in love with a man whose heart was like his company: effusive, unruly, surprising,

spellbinding. Now we were married after only six months. I wanted to believe you could make commitment work by speeding it up like a time-lapse video of a growing plant: Seed, stalk, bloom. Voilà.

Like a surreal fever dream, the night felt like a strange portal into new ways of being. I could become a person who eloped in Las Vegas! I could become a person who didn't change my mind. This sounds ridiculous when you say it plainly, but who hasn't yearned for it? Who hasn't wanted a binding contract with the self?

Years later, I found myself bewildered by the woman who got married in Vegas—humbled by the residue of her choices, angry at her for all the harm she'd caused. So I handcuffed her with the anecdotal version of our Vegas wedding because I was afraid to let her hands go free, to let her protest, *No! There was something beautiful that night, something you actually believed in.*

The next morning, C took me to his mother's pawnshop downtown. She picked a pair of wedding rings for us from the glass case. Desert sunlight glinted off the dice clocks, the rare coins, the jockey silks hanging behind the register. I couldn't help imagining the woman who'd once pawned our rings for cash—because she was broke, or because her marriage had imploded.

In all my relationships, I'd always been hypervigilant about what wasn't working—as if identifying every possible incompatibility would prevent me from marrying someone I'd eventually divorce. At the same time I couldn't quite believe I *wouldn't* eventually get divorced. Almost every marriage in my family had ended in divorce, and it was hard to imagine my own turning out

another way. It felt like arrogance to think I could sustain what everyone else in my family hadn't managed. Everyone except for my uncle and aunt who lived on a farm in New Mexico, growing alfalfa and training sheepdogs. Their happiness didn't seem like one I was capable of. It wasn't the life I was meant for.

When I was a kid, seven or eight, my mom took me to my father's office. He was out of town for work. He was often out of town for work. He'd forgotten something important, and needed my mother to find it. Instead, she found an angry note from a woman he was having an affair with, who had found out about another woman he was having an affair with. The note said something like: *Your wife might put up with this, but I certainly won't.*

I have no memory of this day, because my mom managed to make it a day I don't remember. She says she took me out for ice cream.

My mom and dad stayed married for twenty-two years. She kept trying to convince herself she could be with him despite his affairs. She loved his mind, his wit, his commitment to work they both believed in. She always told me, "With your father, at least I was never bored."

When I was nine, he moved across the country for work. He spent eighteen months directing a report about global health inequality. He was an economist focused on ameliorating disease burden—which, as a kid, I needed translated: he figured out how to spend money to save lives. During the time he lived away from us, my older brothers left for college. All the men had better places to be than home.

After my dad came back to Los Angeles, my parents told us

they were separating. Two years later, he was married to someone else. I'd met her once.

A few blocks away from my childhood home, there was a bakery owned by a very tall Frenchwoman. I can't remember if she was beautiful or not, only that she was tall, and always wearing a black cotton apron dusted with white flour. She made jam-filled scones that tasted like baking soda. I liked them best when they were undercooked, like little bowls of batter.

As we were leaving her bakery one day, my dad turned to me and said, "I've always been drawn to women taller than I am." As a child, I didn't know what to make of this, or why he was telling me.

Years later, when I sent him a manuscript I'd written and asked if there was anything he wanted me to change—mentions of his infidelity, or his drinking—he asked me to change only one moment. "When you describe me as powerful, I'd rather you use another word," he said. "Powerful isn't quite right."

After my parents separated, I spent the night at my dad's apartment four or five times in six years. There was no schedule. No every Tuesday. No every other weekend. He'd traveled so much during my childhood that I was already used to being apart. We weren't quite sure how to be around each other.

Sometimes he took me to dinner at the yakitori joints along Sawtelle Boulevard. Righteously vegetarian, I chose from limited options: chewy gingko nuts, skewered quail eggs. Sitting across from him at a lacquered restaurant table made me feel like I had to impress him, like it was an event, not just a regular night. In

those years, I was—quite literally—almost never at home with him. It seemed like his real life was happening elsewhere.

It wasn't until I met other children of divorce that I realized some kids moved back and forth between two homes. For me, this wasn't an easy arrangement to picture. My dad's apartment was a one-bedroom, carpeted and hushed. He traveled often, and his wife lived on the other side of the country. His furniture looked like it belonged in an office.

He got an ice-cream maker, to give us a project. Our ice cream tasted like vanilla extract and ice crystals. The hillside beyond his windows was full of eucalyptus trees. In the dry Santa Ana winds, their leaves sounded mournful and restless, as if they were shuffling away, trying to get somewhere else.

One afternoon in seventh grade, my dad came over to my mom's house to talk to me about my report card. Specifically, he wanted to talk about my B– in World Cultures. He said, "This isn't you." It was thrilling to realize—through negation, at least—that he had a clear sense of who I was. Sometimes I felt not just invisible but at risk of dissolving. That same year, a popular boy in school had stopped me in the hallway to say, "You are literally the quietest person I've ever met."

As I apologized to my dad for my report card, some resolve hardened inside me. Whatever the opposite of getting a B– was, I would spend the rest of my life doing that.

When my mom first told me about my dad's affairs, I was a teenager—and already angry at him in ways I couldn't quite name, for distances I'd grown so acclimated to I didn't even

realize how badly I didn't want them. I bristled with indignation and a blind, molten fury that I told myself was on my mother's behalf. And it was. But it was also on behalf of that little girl who'd been part of the home he left behind, and—though I didn't know this yet—on behalf of the woman I would become, who recognized some version of his restlessness in herself, and wished he'd given her a different model for how to navigate it.

On a bone-cold winter's day more than three years after my Vegas wedding, I put the baby in a puffy white snowsuit and carried her through a humid greenhouse. We walked past towering primeval ferns, rubber trees sweating thick white drops, and dangling purple sweetsop that looked like blackberries meant for a giant. It was like walking through the history of the Earth. My baby's bright eyes flicked from the palm fronds to the latticework of shadows they made on the ground. Every surface trembled, electrified by her attention. And then, there was a loud wet farting. The smell of her shit was sudden and vegetal. Sometimes I couldn't get enough of that smell. Until I could. Sometimes I saw bits of her shit crusted under my fingernail and knew I'd never get clean. It would never be done.

When we got home from the botanic gardens that day, C was in a bad mood. I could tell from his gaze, and his posture on the couch as he swiveled toward me. I wanted to tell him about the greenhouse, the ways the baby's eyes had tracked the flickering shadows, how good it was to feel my own pretensions interrupted by her shit. But I sensed he wasn't in the mood to hear it.

Instead, I asked about his day. He said it had been terrible.

"Hope you had fun frolicking in the gardens," he said, his voice taut with sarcasm.

I didn't ask why his day had been so bad. I'd asked this question so many times before, I thought I already knew the answers: his frustration with work, or else the unspoken hurt of our distance. Which is maybe how love dies—thinking you already know the answers.

I said none of this to him—just, "Our day was great," and let him read my tone however he wanted.

Our home was a place in which I'd come to feel alone, and so—in retaliation, or from depletion—I made C feel alone, too. His barbed comments left me so frayed that I stopped trying to detect or soothe the hurt beneath them.

Was this frolicking—being with the baby all day? It rearranged my soul, sure, but it didn't exactly feel like frolicking. I wondered if the only way to make the labor of my day legible to C would be to frame it as entirely exhausting. But I did not want to create a home where the main measures of love were hardship, expenditure, and burden; where these were the only dialects in which the act of parenting was spoken. I wanted language that could hold the wonder and the numbing exhaustion of the day at once. Sometimes it seemed like parenting was only visible to him as sacrifice.

His eyes got teary whenever he recalled the moment he'd seen me wince as the baby's gums clamped down on my nipple. "You love her so much," he'd said, as if my love was most visible to him then—in my willingness to hurt, this proof of my devotion.

Over the years of our marriage, I'd grown attuned to a sudden

flare in his eyes, and the shift of molecules in the room before an eruption of anger, like the pressure drop before a storm. It was almost a relief whenever the rain came. It was better than the humidity of his unspoken rage. I never knew when an explosion might come, so I was always expecting one. This vigilance was better than being surprised.

Once we separated, his outbursts grew more intense. They often left me shaking, stunned. But they were also clarifying. They made something explicit that had been running through our dynamic for a long time.

At drop-offs, as I stood with the baby in her stroller beside me, he called from the vestibule, Why don't you eat something, you anorexic bitch. Or he said, Don't you fucking talk to me. When I said, Please don't speak to me like that, he leaned closer to say, I can speak to you however I fucking want. I speak to you like you deserve.

My voice said, *Please don't speak to me like that,* but my body said something else. It hunched over. It cowered. It held the baby tighter, as she sucked her two fingers, and I tried to remember the phrases I'd practiced with my friends and my lawyer, tried to channel the part of my lawyer that wore her stiff leather jacket indoors, rocked a killer profit margin, lounged at a second home in Sag Harbor with a salt breeze ruffling her badass feathered hair.

A friend suggested that his anger was a sign of how much he'd loved me. As if love might curdle to anger with an equal but opposite intensity, like putting a negative sign in front of a very large

number. But I knew that some version of this anger had been there the whole time.

One time in couples therapy, after I'd flinched at something he said, he snapped, "Don't act like you're fucking scared of me."

I came to hold both truths at once: I'd caused him deep and lasting harm, by leaving him. And also, I did not regret choosing a life that would not share a home with his anger.

When I say I held both truths, I mean that I lay with them, sleepless, in the dark.

When I lay awake at night, in my birth-canal sublet, I remembered the vows we'd exchanged. The summer after C and I eloped in Vegas, we had a big wedding party at a farm in the Catskills, not far from the motel full of clouds. We exchanged our vows beside Esopus Creek while the children of our friends splashed in the water. We made a treasure hunt for the kids: gold boxes hidden in the grass and trees.

My boss from an old bakery job assembled our cake in her hotel room, using tools she'd packed in her suitcase, and at the reception the frosting was pocked with little streaks from where the kids had swiped at the buttercream. We assembled party-favor bags for all the guests, with tiny jars full of jelly beans and gum-drops. Everyone thought they were artisanal, but in truth we'd bought the candy late at night from a nearby gas station, bringing armfuls of plastic bags to the register.

During our ceremony, part of me doubted. But a larger part of me believed I would never escape doubt. Instead of waiting for an impossible sense of certainty to arrive, I could conjure it myself.

I also believed in that gas-station candy, and how it felt to laugh with C beside the cash register. When I imagined our future, I pictured it full of this laughter, full of moments where we leaned our heads close together to compare notes about the world's tender absurdities: the teenage pool attendant in Vegas wearing his authority like a padded football jersey, or the tiger trainers lining the walls of our weird little motor inn. I pictured our life full of gas-station treats and basketball sneakers. (It was already full of sneakers. He'd spent years struggling to fit his collection into a cramped Manhattan apartment.) I imagined him curating a collection of tiny sneakers for our child. I could picture him clapping his hands in delight when these sneakers got complimented by strangers on the subway.

If we had a child—and I'd always wanted a child—I knew he would be a loyal, playful, utterly protective father to her. I never doubted it. But now that we had a child together, I felt so alone in parenting. We both did.

Every story is only part of the story, of course, and these pages do not tell the story of C's child from his first marriage. At his request, we agreed on this. But C's life as a father—his animating love, his fierce devotion—was a river coursing through these years. All those times he told me, *You are giving me another life*—there were so many reasons I wanted to give that to them both.

In the midst of those newborn months, I had a book coming out. It would be published when the baby was three months old. I usually described it as a book about drinking, though honestly it was a book about the only thing I ever wrote about: the great emptiness inside, the space I'd tried to fill with booze and sex and

love and recovery and now, perhaps, with motherhood. The book was getting a lot of attention, which made me queasy—and also, like an addict, eager for more.

It was a book about humility, about surrendering ego. But now my ego—exhausted at 4 a.m., resting one Doritos-dusted hand on the sweet fuzz of my baby's scalp—wanted to believe that enough attention could compensate for a home that felt broken and lonely.

Everyone knows you're not supposed to visit the grocery store famished, because you'll want to eat every single thing you see. Sometimes my ambition felt like that. I wanted everything because I hadn't satisfied my hunger elsewhere.

Or rather, what other people called ambition often felt—to me—more like justifying my own existence. If I'd failed at happiness, then success seemed like a consolation prize. As if some tribunal in the afterlife would ask, *Were you happy?*

And I could say, *Well, no. But I did all this.*

One morning in early March we did a photo shoot. By *we,* I mean I did it in the living room while my mom stayed in the bedroom with the baby. The shoot involved three suitcases full of designer clothing, a stylist wearing Doc Martens covered with painted roses, and an assistant who couldn't find the bobby pins. Everyone had a green juice.

At one point, the photographer asked, "Has anyone seen my green juice?" and none of us could help—not because we couldn't see a green juice, but because we saw too many. Green juices everywhere. "Mine has turmeric," he specified, but that didn't help at all.

I was the only one who didn't have a green juice, and I now felt an intense green-juice envy. I was keeping a tiny creature alive with nothing but my milk; I deserved a green juice more than anyone. Earlier that morning, I'd washed my hair for the first time in days, and now it was twined around whimsical felt rollers shaped like flowers that the hair stylist told me he'd made on a mushroom trip. They were souvenirs brought back from another state of consciousness. It felt like so long since I'd surrendered myself to another state of consciousness, which was what my book was all about: the siren call of disappearing into substances, and also what it felt like to give them up, to stay awake—acutely present—inside your own life.

If my whole book was a hymn to sobriety and sharpened attention and showing up and staying present, then why was I sitting here fantasizing about feeling whatever this hair stylist had been feeling when he made these luscious fabric flowers? If my whole book was about the vanquishing of ego, why was I consenting to the vanity of this photo shoot? My ego was still here, and it wanted a green juice. It wanted all the green juice. It wanted this book about humility to get on the bestseller list and stay there.

My body surged with hormones and their blaring, contradictory truths: I was a long-suffering juice-deprived saint, or else I was a monster ruled by vanity who barely deserved to be alive. My inner monologues sounded like an asshole talking too loudly to a non-native speaker. My mother spoke more foreign languages than I ever would, *and* she was keeping my baby happy while my postpartum body got dressed up like a doll in designer outfits spread across my rumpled bed. The tight waist of a pair of black Prada cigarette pants chafed against my C-section scar

and its overhanging shelf of flesh; a diaphanous Versace blouse rested against breasts that hadn't touched anything besides tiny lips and fraying nursing-bra cotton for weeks.

"I need to break at noon to nurse," I told the photographer and the stylists and all their assistants, and they nodded, *Yes, of course.* Noon came and went, and we didn't break, and I didn't say anything. The voice of the good student in me—the one who always needed to do what she was told, because otherwise maybe she wouldn't be loved—was louder than the voice of the good mother in me.

At half past noon, my daughter started crying in the bedroom, and the sound of her tiny voice turned my nipples electric, as if they'd just brushed against a power outlet. The milk came out in little spurts, like arterial gushes from a wound, soaking the Versace blouse that wasn't mine. The brief flash of disgust on the stylist's face when she saw the two dark patches blooming was nothing compared to the disappointment on my mother's face when I finally opened the bedroom door, thirty minutes late, to take my howling daughter from her arms.

My mom was no stranger to working motherhood. Right after my daughter was born, she'd given me a set of tiny white shirts, embroidered with intricate purple flowers, that she'd been saving for decades. They'd been hand-sewn by women in Pacatuba, the village in Northeast Brazil where she'd done her doctoral field research on infant malnutrition and maternal health.

These delicate white shirts—nearly impossible to button, prone to staining—made me desperate for acquaintances to ask where I'd gotten them, so I could say, *Well, now that you ask* . . . I always

wanted to brag about my mother, who had literally been trying to save starving children. But that's not all! She'd brought my brothers with her to Brazil, at five and six. They went to a small elementary school in Fortaleza. Sometimes all three of them went out to Pacatuba for overnights, sleeping in hammocks hung in the gazebo at the center of town.

My mom brought my brothers with her to rural Brazil because there wasn't another way her fieldwork was going to happen. Sometimes it seemed like I spent half my childhood hunched over coloring books in her various offices. Always gazing wistfully at vending machines full of Ding Dongs that she—literally a professor of nutrition—was never going to let me buy.

Her grad students flooded our living room for potlucks, bringing their homemade tabbouleh and casseroles, offerings at the altar of her mentorship. They were my babysitters; they said things like, *Your mother is truly amazing,* which didn't make me any less embarrassed when she wore long tribal-printed tunics to pick me up from school. She was often one of the last parents to arrive. Her presence was disrupted by the ways her life was bigger than me—work trips, meetings that ran late—but her mothering was electrified by everything else she cared about. I cannot remember a time I didn't understand the world as fundamentally structured by inequality. Remembering those tunics she wore, usually gifts from colleagues in the West African villages where she worked, I can still feel the way their rough fabric rubbed against my cheek when she pulled me close to her, which she did whenever I needed this—to be pulled close.

When I was nine months old, my mom went to Burkina Faso

for three weeks. Maybe it was the trip when she drove a woman in obstructed labor to Ouagadougou during a rainstorm. Or maybe it was another trip. Once she told me that story, all her trips contained that story.

After my daughter was born, I thought of those three weeks away with sharpened acuity, both their sting, for my mother—being away from your baby for that long—but also the grace of their permission: you can live a life apart from your child without damaging her.

When I thanked her for offering me this model of working motherhood, she said it wasn't so simple. Of course she felt guilt. She worried about the impact of those months in Brazil on my brothers—especially my middle brother, who was more naturally shy—and she'd felt such pangs returning to her baby (me) after those three weeks away. My father brought me to the airport to meet her. He was holding me in his arms, and when she reached for me, I started crying. She imagined how overwhelming it must have been for me, in that bustling corridor of strangers, to feel a strange pair of arms reaching for me—arms I hadn't felt in weeks, though they were the arms I knew best.

When she told me this story, I was struck by the fact that she told it from my perspective rather than hers. She felt indicted by my tears, took them as proof that she'd allowed herself to become unfamiliar to me. But I wonder if I cried not because she no longer felt familiar, but because she still did. With her, I was finally home. It was okay to fall apart.

When my daughter was two months old, my mom went back home to Los Angeles. Over and over, I told her, "I don't know

how I could have done this without you." This also meant, *How am I supposed to do it without you now?*

When she left, I cried uncontrollably, past all rationality—as if I were a child.

Once my mom was gone, it was mostly just me and the baby all day long. Three, four, five days a week we walked to the Brooklyn Museum. Going to the museum was a way to saturate our endless hours with beauty. And in the frigid depths of winter, it was warmer than spending all our time in the park.

The baby now consented to sleep in her stroller, as long as she was moving. So we never stopped. It made me think of the movie where the bus would explode if it ever slowed down. Or how sharks need to keep swimming to breathe. I was an art shark. I never stopped walking, except to nurse.

Sometimes I walked loops around Judy Chicago's *The Dinner Party,* her massive triangular table full of settings dedicated to historical women. My favorite belonged to the typhus-stunted astronomer who'd discovered Uranus. Blue waves curled off the plate, as if gazing hard enough at the sky could eventually pull you off the ground.

I wanted my daughter to wake up, so she could see this art; and I wanted her to stay asleep, so I could see it—or rather, so I could look at it without the interruption of her needs.

Where had I absorbed the notion that distraction only compromises attention—rather than, say, pivoting or deepening it? Sometimes your mind leaps away and when it comes back, it notices more keenly. Sometimes distraction sparks observation like

a rough surface striking a match into flame. My daughter distracted me from the rest of the world, but she also made me even hungrier for it. She made me want to hoard the details: the blossoming violet vulva on Sappho's plate, or the three faces on Sojourner Truth's—one crying, one angry, one masked. That third face, insisting on the parts of anyone that stayed hidden.

Judy Chicago once said, "I also understood that I would never be able to have the career that I wanted if I had children. I wanted to be unencumbered."

Unencumbered. That word never felt more physical to me than it did whenever I pushed the stroller down snowy streets with a shoulder bag full of diapers and wipes and—if I was really on my game—an extra onesie.

Of the female artists she knew with children, Chicago said, "Even if they did succeed, they felt guilty all the time. They felt guilty when they were in their studios. They felt guilty when they were with their children."

Marina Abramovic once said, "I had three abortions because I was certain that it would be a disaster for my work. One only has limited energy in the body, and I would have had to divide it."

It's true what I wrote earlier, that I cried when they rolled my newborn daughter to the hospital nursery. It's true that I didn't want her to be away from me, even for a moment. But it's also true that once she was gone, I pulled out my laptop from my duffel bag.

It was almost furtive, the way I glanced around to see if anyone was watching. No one was watching. It was three in the morning. It felt like I'd already done something wrong. Who brings a laptop with her to the hospital to give birth?

Once my daughter was gone, I pulled up my email on the hospital Wi-Fi and responded to a set of fact-checking queries on a piece that was supposed to close that week. A few days earlier I'd sent my editor a revision with a PS: *Water broke a couple hours ago.* I was half-asleep, fully determined, bleary with shame and pride. I was closing a magazine piece in the fucking hospital! After delivering a baby! Also, I was imagining my little girl sleeping down the hall, her jaundiced body in a tiny diaper, glowing under her strange blue sun.

When I told the story afterwards, I found myself stopping before I got to the laptop. *When they wheeled away her bassinet, I wept.* Somehow I preferred the version of myself that cried when she left to the version of myself that reached for my laptop once she was gone.

Somehow. As if I hadn't been conditioned to feel precisely this guilt.

Wheeling my daughter's stroller through the galleries just beyond *The Dinner Party,* I found a cluster of photographs showing a woman leaning over a crib in a bare white gallery. They were shots of the artist Lea Lublin's 1968 performance *Mon Fils,* when she cared for her seven-month-old son, Nicolas, at the Musée d'Art Moderne de la Ville de Paris, by installing a crib in one of the galleries. Explaining the performance in an interview, Lublin said, "The previous year, my great joy had been the birth of my son and I said to myself: the best thing for me to do is displace a moment of my everyday life to an artistic space, the Museum."

Sometimes the sharpest apprehension of beauty rises from estranging the familiar: the crib in the gallery. Lublin put

motherhood where we wouldn't expect to see it—making it transgressive, and public. She displaced the moments of her days. And when she explained her performance, she did not turn to theory, but to sentiment—*My great joy had been the birth of my son*—which felt transgressive, too, displacing the cool white walls of armored intellect with raw emotion.

So yes, the critic in me thought the crucial word was *displace*. But the mother in me knew the crucial word was *joy*.

May 1968. The streets of Paris were full of protesters and strikers demanding better labor conditions. Birth control had been legal in France only six months. Abortion wouldn't be legal for another six years. Lublin brought her baby into the museum to make a point—if a woman had to be a mother everywhere else, then let her be a mother in the museum.

But in Lublin's photographs I also felt a certain sleight of hand. They'd turned something ongoing and relentless into pleasing still-frames. Parenting didn't actually exist as crisply curated moments, but as maddening duration. The photos lost that. And they made Lublin look so happy. They made her baby look so happy! I wanted photographs of the baby crying. I wanted photographs of Lublin yelling at him, then apologizing, trying to calm him down, or else letting him cry, wanted these parts of parenting brought into the museum, too: the sense of failure, the unknowing, the frustration.

Joy was crucial. But it wasn't the only word I needed.

The first time I went to the Brooklyn Museum—five years before my daughter was born, shortly before I met C—I crouched

for a long time above a black-and-white video playing on the floor: a woman in a white gown, with acrylic nails and disco heels, kneeling in front of a triple-tier chocolate cake. She starts ripping off hunks and putting them into her mouth, until all that's left is a crumbling mess of dirt-brown layers and frosting. Her four-inch heels step through the wreckage. Memory says I crouched for hours, but of course time is distended by memory, by art rapture, by crouching. It was probably something more like twelve minutes, the length of the film—Wangechi Mutu's *Eat Cake*.

In the footage, Mutu looks unkempt and beautiful and hungry. In those days I was trying to convince myself that being hungry was something other than shameful. What was I hungry for? All the cake in the world, because I no longer drank. I still wanted to drink sometimes, too. I wanted a kid, so I could be grateful I'd gotten sober before trying to take care of a baby. Also, I wanted to be taken care of. I told people I wanted to enjoy my singleness, when really what I wanted was a partner. But I was embarrassed not to be enough for myself.

Whatever I was hungry for, I wanted to look mysterious and profound in my hunger, as this woman did, underneath a weeping willow, with cake caught under her long nails and smeared across her lips. It took me years to figure out that it wasn't her hunger that compelled me, but the fact that she was satisfying it.

After my mother left, I made mothers of my friends. Colleen arrived from Egypt, holding my daughter against her chest in a tiger-striped onesie, and cooking the "ancient grains" from Trader Joe's that we loved—the ones we'd eaten night after night, in

the apartment we shared above a smoke shop. We'd moved in together after the end of relationships we thought would last forever, near the beginning of a long cold winter we spent leaning on each other's shoulders as we stood in subway stations late at night, waiting for the Brooklyn-bound trains to take us home.

Colleen and I had been close friends for fifteen years, ever since we were both young and first yearned to be writers—swapping essays and giving each other feedback in a cavernous Midwestern coffee shop, eating cookies as large as our faces; and then, over the years, sending each other every essay, every draft, calling each other giddily when magazines sent handwritten rejections rather than form letters. Talking to each other through breakups, bounced checks, breakthrough revisions. "I found the right beginning," we'd tell each other, breathless.

Colleen's presence in those early, overwhelming, lonely months with the baby—her familiar blond hair, her freckles, the flush of her cheeks when she blushed—made me pulse with a gratitude so strong it felt illicit. It seemed shameful to need from a friend what I was supposed to need from my husband.

Sometimes I wondered if I would always feel more fully cared for by my friends than by my partner. With friends, I didn't have to get into stupid fights about whether taking out the trash was more or less work than doing the dishes. It was easier to avoid disappointment with friends, because I didn't expect as much from them. But I also wondered if there was something more primal at play. It had always been safer to need things from my mother than my father.

When my daughter was born, I'd asked Colleen to be one

of her godmothers. I'd also asked my friend Kyle, who was red-haired and soulful, and lived closer than Egypt, in a big brick apartment building on the other side of Prospect Park. We'd met ten years earlier, at a clothing swap she'd hosted in her attic apartment, when I'd spotted an intricate, sprawling outline for her novel hung on her wall, index cards arranged on corkboard, and thought, *I want to know you for decades.*

Kyle always offered sustenance. The meals she cooked—lentil soups and mushroom risotto, spicy greens dressed with gleaming oil and dark vinegar swirled together in jam jars—reminded me of my mother's meals from childhood. When I told stories about things that hurt, Kyle always listened closely, often asking questions that—lovingly but unapologetically—invited me to consider the other person's perspective, or reconsider my own motivations. While I was pregnant, we'd gone skinny-dipping one night—at her parents' house, down in Baltimore—gliding through the water under rustling trees, their leaves whispering and fluttering between our bodies and the moon. It was a lightness I hadn't felt since.

My understanding of godmothers was largely inspired by fairy tales, insofar as it held a sense of magic and gifting. I wanted these women to give my daughter their ways of being in the world: Kyle's acuity. Colleen's effervescence. Their loyalty. The seriousness with which they took the inner lives of others.

Kyle had stayed overnight with me in the hospital, right after my C-section, on the one night C had gone home. We'd gotten take-out pasta covered in thick sauce, steaming in plastic tubs. The crumbled meat was hot against our tongues in that dark room. The lights were off to help the baby stay asleep.

The quieter she was, though, the more frequently we needed to check her tiny swaddled body. Was she breathing? How could a creature just suddenly exist, when she had not existed—not like this, at least—two days before? How could she just keep existing at every moment? It seemed so improbable.

In April, I took the baby on book tour. She was three months old. My mother came with us. Four weeks, nineteen cities. We stood at curbside baggage stands in Boston, Las Vegas, Cedar Rapids, San Francisco, Albuquerque, with our ridiculous caravan of suitcases, our bulky car seat, our portable crib. The baby in her travel stroller. The unbuckled carrier hanging loose from my waist like a second skin. Everywhere we went, I carried a hand-held noise machine called a shusher. It was orange and white and it calmed my baby down better than my own voice.

We ticked away the flights in silent rosaries. Praying she'd nap on the plane. Praying the flight attendant would let me keep her in the carrier. Praying she'd nurse on the final descent so her ears could pop. Praying we'd remembered the shusher. Praying we could find a hardware store with the special screwdriver we needed to replace the dead batteries in the shusher. We needed that noise to survive. When my baby cried beside me in a Detroit hotel room at 4 a.m., the fourth time she'd woken up that night, I knew the four-month sleep regression had arrived. It didn't care how many state lines we'd crossed. It found us anyway.

In restaurants all across the country I shoved food into my mouth above her fuzzy head as she slept in her carrier beneath my chin. The receipts were headed to my publisher and I was determined to eat everything: trumpet mushrooms slick with pepper

jam, gnocchi gritty with crumbs of cornbread that fell onto her little closed eyes, her head tipped back against my chest. I was flustered and feral, my teeth flecked with pesto and furred with sugar. Then I pulled down my shirt and gave these meals to her. In Los Angeles, I nursed in the attic office above a bookstore lobby. In Portland, I nursed among cardboard boxes in a stockroom. In Cambridge, I nursed in a basement kitchenette beneath the public library.

Taking my baby on tour was a way of saying, *I can be the father who goes away, and the mother who stays.* It was only because of my mother that I got to do both. She held the baby whenever I wasn't holding the baby. She made it possible for me to approximate some version of the thing I'd always admired her for doing, crafting a self that understood work and motherhood as forces that could feed rather than starve each other.

Everywhere we nursed, everywhere I read, everything I ate, I imagined someday telling my daughter the story of these days—every stockroom cardboard box I perched on to breast-feed, every hotel lobby chair I used to change her diaper, every night I returned from a reading to watch her body sleeping in the dark, swelling with each breath. I imagined the tour as a set of memories I was embedding inside her, like sewing jewels into the hem of a coat. But it was tiring. Sometimes I wondered if I was asking too much of the baby, demanding that she sleep in all these strange hotel rooms so I could prove something to myself about work and motherhood making room for each other.

Reading at the front of a bookstore one night, I glanced up and saw my mother holding the baby snug against her chest,

behind the crowd. They were rocking slowly back and forth. The Saskatchewan shuffle. For a moment it was as if the distance between our three bodies collapsed, as if there was nothing else in the room.

Sometimes the baby woke in the night and started crying, as if startled to discover she was neither on a body nor inside one. Sometimes I woke in the middle of the night and shone my cell phone light on the swaddled burrito of her body, just to check that she was breathing. Sometimes I joked that my editor was stressed about book sales while I was stressed about which airlines would let me leave my sleeping baby in her baby carrier. But this joking was just an easy humblebrag, *Now that I'm a mother, I don't care about ambition! I only care about baby carriers!* Of course I cared about book sales, too. While my daughter napped against my chest, I sat there wondering if the sales had disappointed my editor, my publisher, my agent—if the book had disappointed its readers. If it had been, somehow, enough. If book sales could tell me if I was enough. If the baby girl dreaming against my chest was going to someday become a woman who would spend the hours of her days wondering if she was enough.

My book told the story of my sobriety, which was also the story of how I'd become a woman who could imagine becoming a mother—living for something other than intoxication. The woman in my book was made of need, while the woman breastfeeding in all these bookstores was meeting the needs of another, this tiny creature with her own hungers.

We told people my mother came with us to take care of the

baby. But really she took care of me. Nursing my daughter, I was also a daughter. Still needed in this way, from her.

The tour felt like wearing a straitjacket made of nerve endings. It was full of constraint and overload at once. The baby cooed in a Seattle park so bright with sunshine it seemed like rain was just a story people liked to tell about the city. The baby cried in a Minneapolis park full of the ruins of old flour mills.

At an amphitheater in the Nevada desert, I paced the aisles with the baby strapped against my chest, watching the setting sun glow across the sandstone cliffs, while a singer crooned a song I'd adored as a teenager: *You got / What you want / Now you can hardly stand it...* The dry breeze, the cliffs on fire, this singer's sexy croaking voice, it all entered me more fully because I was tired, and saturated with hormones, and because something about my daughter's body attached to my body made me feel doubly alive, not in an abstract sense but a literal one. Every sensation I experienced through my own body, I then imagined experiencing through hers. I wanted her to absorb all this beauty through her pores like some blessed oil. I also wanted her to stay very, very quiet.

She slept against my chest until she wasn't sleeping anymore. When she started crying, I turned my back on the beautiful crooning and the desert night and walked toward the visitor center, which hopefully had a changing table, and a trash can to throw away the tiny shitty diaper sandwiched between my baby's body and my own.

In bookstore signing lines, my daughter's tiny face hovered in my mind's eye while strangers told me their secrets. A woman

asked whether I thought moderation ever worked. A man asked if he would ever stop dreaming about booze. I told him I still did, but I dreamed about a lot of other things, too. These strangers wanted something from me—compassion, or kinship, or solutions, or witnessing—and if I was honest, I wanted something from them, too: some sign that I'd said something that mattered to them. But I also wanted to nurse my baby. My breasts leaked drops of milk. They could feel the gravitational pull of her tiny body across town.

In Minneapolis, a woman told me that 'my book had helped her feel a little bit closer to her son, who was still shooting heroin but wanted to stop, had *tried* to stop. She asked me, What should she do? It wasn't a rhetorical question. I wanted so badly to say something that might help her. But I was also thinking of my baby in our hotel room. Was she crying? Was my mother walking her around the block in the carrier, checking her watch, wondering when I'd be back to feed her? This woman's son had been a baby once too—nursing, or refusing to; sleeping, or refusing to. No matter what I said, it wouldn't be enough to get her son clean. No matter what I said, my baby would still be hungry. This mother would walk into the night, and I would walk into the night. She would keep loving her child, and I would keep loving my child. Our love couldn't promise anything to anyone, but we both knew we would never see the end of it.

In Los Angeles, it was easier to breathe. It always was. My hometown made me feel at ease in a way no other landscape ever would: the strip malls and cloverleaf freeway exits, the rush of salt

wind on the Pacific Coast Highway, the dark silhouettes of palm trees against those startling, smog-brightened sunsets. This was where I'd gotten high with my high school boyfriend, sixteen and not a virgin anymore, driving the dark back roads thinking, *not a virgin not a virgin not a virgin.* These streets were the first streets I ever drove with my friends, late at night, with the radio cranked up, imagining our futures.

I'd daydreamed so many versions of myself, but in all of them I was writing, and mothering or someday-mothering, and desired by some powerful man: either I was the willowy artist girlfriend of a professional tennis player who'd proven his love by converting one of the bedrooms on his yacht into an office; or else I was tucked away in a rambling old Victorian with a typewriter in the attic, and a brood of five or six kids, all named for herbs and explorers, laughing in the rooms below, their father a silver-haired professor-husband who looked suspiciously like my eighth-grade English teacher.

When I drove these streets now, it made me nostalgic for that plural state of being—imagining multiple possible lives. Now I just had this one life—with this baby, this marriage.

When I was a teenager, even daydreaming about heartbreak felt pleasurable, because I always imagined heartbreak as something ultimately provisional, the necessary threshold to an even deeper love on the horizon. I had never imagined heartbreak as something ongoing and hopeless and daily—the rocks in my stomach as I climbed the stairs to my apartment on the other side of the country, in snowy Brooklyn, trying to figure out the right tone to ask my husband how his day had been. No matter what tone I used, we had lost the bridge.

Twenty years earlier, no pain had seemed irreversible. Every mistake could be corrected. Now I sensed the contours of another wrongness. Some broken things could never be fixed. Some harms could not be undone.

When people said, *It must be exhausting to take a newborn on a book tour,* their assumption made me feel like a liar. How could I tell anyone the truth, that it was more exhausting at home? The secret relief of our travels gnawed at me. It seemed like a sign that I had chosen the wrong life, the fact that I spent so much of my time figuring out how to get away from it—kept wandering the chilly winter sidewalks, kept getting on airplanes. On flights across the country, I spent hours standing with the baby by the lavatories, blocking the entrance to the little snack pantry, trying to make both of us as small as possible every time someone reached past our two-headed body to get a Coke from the little fridge. I'd say, "I'm so sorry, I'm so sorry." Who was I apologizing to? Maybe my faraway husband, for being gone.

In every city, there were little things I noticed—the couple at my reading, on a date that didn't seem to be going well, or the selfie takers at the abandoned flour mill—that I wanted to text C about, but didn't. I felt possessive of this life away, and guilty for it—as if it were something I'd stolen from him. He felt left behind. I felt overwhelmed. Neither one of us was alone, but we were both alone.

We'd fallen from the false paradise of narrative, the idea that I might save him from his tragic loss, into the dirty nursery of our days, him alone in the back room while I did photo shoots in the front, leaking breast milk onto Versace, and retreated into my

own cloister with the baby, whose needs were simpler than his. Harder to refuse. Easier to meet.

Unless you say otherwise, people assume the end of a marriage involves an affair. So I am saying otherwise. This one did not. Just the mistake of two people believing they could make a life together, when in fact they couldn't. Which is its own betrayal.

My parents' marriage left me more allergic to affairs than to endings. But I knew there were people who felt otherwise—who believed the worst thing was giving up too soon.

I was certainly capable of infidelity—had inherited some version of my father's capacity, even as I judged him for it. In the past, I'd cheated on two boyfriends—could still remember waking up in the beds of other men, trapped inside my own body like a rumpled, foul-smelling outfit I could not remove.

For me, cheating had been a way to avoid the work of either fixing a relationship or ending it. This time, with C, I did not want to avoid that work. But I was scared of myself. I had no illusions about my own innocence. Whenever I heard myself saying, *I'd never do that,* I heard a false promise. We can't imagine ourselves doing many things until we do them.

C had always been one of my best readers. We'd always believed in each other's writing. The first time he read my book about drinking, he'd said, "You're the truth."

But when the book came out that spring, I could feel him struggling. He wanted to support me, but there was a thorn in every interview. Two years earlier, he'd published his second novel,

acutely observed and vibrating with devotion, about a young husband and wife navigating her leukemia diagnosis. Much of the book was based on his own life, and it held so many of the parts of him I loved best: his loyalty through crisis, and his unflinching compassion; his awareness that everyone is more than his best or worst moments.

But when the novel was published, it didn't get the reception he'd hoped for. He'd devoted his whole self to making art from the hardest thing that had ever happened to him, and then it felt as if the world had simply shrugged its shoulders.

At first I tried to convince him to feel a different way. What about the amazing radio interview everyone had heard and loved? Or the oncology nurse who'd written to tell him she'd never read a more tender account of illness?

Eventually, he asked me to stop offering these pep talks. "This is hard," he said. "Just let this be hard."

Just before I realized I was pregnant, a year after the release of C's novel, my students came over to our apartment for a final class at the end of our semester. This was a ritual of mine. I loved watching my students take stock of my bookshelves and my fridge full of seltzer. I imagined them chatting with C, charmed by his wit and his sharp mind, laughing at some joke he'd made about the cat. But C said he didn't want to intrude. He'd go somewhere else for the morning.

I baked chocolate chip cookies with crumbled potato chips inside them, a recipe I'd stolen from the Iowa State Fair. My students brought Tupperware containers full of homemade muffins

and elaborate salads. One guy brought the same tiny hot dogs he'd described in an essay about an awkward threesome. We'd gotten meta. Now we'd get sentimental.

When C returned, expecting to find our apartment empty, he found it full instead. I'd let the discussion run long, and all twelve of us were still gathered in our circle of chairs, everyone balancing paper plates of food on their knees. I'd been anxiously checking the time on my phone—not wanting to run late, but also loving how much my students had to say.

When C opened the door, he was flustered. He seemed irritated. Without even coming inside, he said, "I won't get in your way," and then wheeled around and shut the door. My students looked at one another, confused. One asked, "Should we go?"

I said, "No, no! Just give me a second," and stood up to run after C, calling out his name as I got to our vestibule and saw him heading down the steps of our stoop. I kept calling his name. He kept walking away.

In therapy a few days later, we talked about my part in things—we'd agreed on an amount of time my students would be there, and then I'd broken the agreement—but this wasn't what I wanted to talk about. I wanted to talk about his storming out. About why it felt like everything I did or loved was somehow an offense to him; why I couldn't even have my students over without pissing him off; why he couldn't stay for a second and say hello.

I was so righteous that I could barely see his hurt—how invisible he'd felt, like an outsider in his own home. Or I could see his hurt, but was tired of letting it call the shots—his suspicion that my students didn't want him there; that I didn't even want him

there. Because I *had* wanted him there. Or at least, part of me had. The other part of me was afraid that our tension would be visible. The other part of me was ashamed to realize how much I preferred the version of myself I gave my students to the version of myself I gave to him.

When my book came out, two years after his, we both felt the way its publication summoned the specter of how difficult his experience had been. But I didn't know how to translate this awareness into care. Or rather, it always felt like I was doing it wrong. I wished there was a way to say, *Your work matters,* that didn't involve muting my own. I did say versions of that, over and over again. But I didn't say it enough, or else I said it so much it started to sound rote.

At an event back in New York, we decided C would watch the baby while I went onstage. This was an unfamiliar configuration. I was used to these rhythms with my mother. I wasn't as comfortable depending on C. Years earlier, before a party, he'd told me, "I'll be damned if I'm going to stand there holding your purse," and I'd never forgotten it.

We all sat in the green room—literally green, its walls like apple-zucchini baby puree—while I nursed. I wore the only kind of dress I wore in those days, the kind that was easy to pull down over my breasts.

The whole time I was reading onstage, bright floodlights in my face, I wondered if the baby was crying. And when I came back to the green room, she was. C held her in his arms like a wailing bag of groceries. He glanced up at me with an expression that seemed almost angry—searching my eyes for disappointment, or

judgment. I'm sure he found both. As if she hadn't cried with me, just like that, a thousand times. My daughter. Our daughter. I was always forgetting that plural pronoun. Not making space for him in our bond.

Looking back on that night, I think his expression must have held less anger than loneliness—realizing we hadn't figured out a way to do this together.

Four years in, it hurt to hold the things I loved about C alongside everything that had soured between us. But these things stubbornly remained: His wit. His loyalty. His belly laugh. His razor vision. One of my favorite things about being married to C was the company of his gaze. The things he noticed. His deep love for the ridiculous humans of this world. That's why I wanted to text him about the selfie takers, and the couple on their awkward date. Some part of me loved his rough exterior—his many tats, his gruff candor, his quick temper—because it made his interior seem like a gentleness meant only for me. Me and shih tzus. Me and the characters in his novels. Even when things between us were falling apart, I always craved that feeling of wandering through the world with him—hearing what he noticed, seeing what he saw.

A year before our daughter was born, we went to San Diego on vacation. Things were not going well, but I still had real hope they could go better. One morning we drove across the border to a little town on the Baja Peninsula called Puerto Nuevo. Named for a Newport cigarettes billboard. Full of tiny lobster restaurants. We plucked the wet salty meat with our fingers. We ate buttered corn gleaming in the sun. On the way back, we waited in a line of

cars that stretched farther than we could see. Men stood between the lanes of traffic, selling rosaries, antibiotics, border-wait burritos. C's gaze always went right there, to the men standing in the heat—to their discomfort, to their burdens. He felt a deep, frank, unsentimental tenderness for people that others looked past, or away from—people whose daily grind was hidden in plain sight. Not hidden to him.

By the time our daughter arrived, we'd already been in couples therapy for three years, all but the first year of our relationship. Once a week, we went to a basement office and sat together on a loveseat that never felt large enough. The harder our home life got, the more guilty I felt for wanting to leave it. This was the same deluded faith in difficulty that made me starve myself at eighteen, running seven miles on the treadmill after six saltines for dinner. This same voice rose up again to say, *The harder it feels, the more necessary it must be.*

One of the sly reveals of couples therapy was that each way I found our marriage difficult—which I'd imagined as my own specialized arenas of suffering—actually had its own corollary, like a lost twin, in his experience. I felt like I was always walking on eggshells; so did he. "Each of you is working so hard in your own separate corners," our therapist said. "Both of you feel like you are doing everything."

At the time, I felt disappointed. I wanted her to confirm my belief that I was actually the one doing everything. But even then, I could see she was right. We were both doing a lot. This was the essential bait and switch of couples therapy. I went to get my narratives confirmed, and instead they were dislodged.

The fact that we both felt so many of the same painful things didn't help me believe the marriage was more possible to save. It became more and more difficult to convince myself that our good months in the beginning mattered more than all the friction that followed. It seemed like the good place we were trying to get back to was just a small sliver of what we were.

After the book tour, it was mainly just me and the baby, once again, spending our days at the museum. Sometimes we ducked into the Egyptian rooms, pausing at the mummy mask of Bensuipet, with her kohl eyes and her crossed arms. She looked exhausted by the pageantry of the afterlife. Why couldn't you just die and be done with it?

Instead, she faced the long messy business of rebirth. The ancient Egyptians believed that every fetus was created inside a man's body and then transferred to the woman during sex. (Why not give men credit for the fetus, even that?) After she died, a woman had to briefly turn into a man, just long enough to create the fetus of her next self. Then she became a woman again, so she could incubate it. Only then was she reborn into the afterlife.

In this ancient ritual, this vision of one body doing everything, I found a distorted version of my own delusions of autonomy: becoming a man to create the fetus, then becoming a woman again to incubate it; then finally giving birth to herself. Not needing a man, but becoming one. Doing everything necessary.

In those early days with my daughter, I was compulsively drawn to stories of rebirth. Reincarnation helped me understand better how this little person might have arrived in the world

with such eerie integrity. She was a scrap of fabric from a cloth I couldn't source. She seemed to have a kind of patience with the world. She gazed at me with tender forbearance as I named the objects around us. This is a mummy. This is an apple. This is a door. *Yes,* her eyes said. *I know.* She let me tell her anyway.

One Chinese myth describes an old woman sitting at the exit to the underworld, serving the Broth of Oblivion to all the souls about to be reborn. It lets them forget everything that came before, so they can pay attention to the particular knowledge of this next life: this cotton blanket, this too-soft avocado, this mother's voice.

Why were we spending so much time at the museum, anyway?

One friend suggested that it had to do with wanting to feel more present in my own life—that maybe beauty helped me feel like I was actually there.

In my early twenties, the first time I moved to the city, I worked as a temp in a Midtown office building, passing my days in a grim cubicle, on a floor without windows, running database searches on high-asset clients to make sure they didn't have criminal records. At the holiday party I got sloppy drunk on cheap wine and asked everyone if the rumor was true, that we didn't have any windows because a temp in Miami had jumped from one. Sometimes on my lunch breaks, I'd go to MoMA, just for twenty minutes, just to stand in front of a Seurat painting of the ocean and the sky at twilight. It helped me remember the size of the world—his horizon full of shimmering dust, those tiny points of paint. Those twenty minutes of beauty felt more important than all the hours around them, but they also made me crave a

life whose ordinary hours I wasn't running away from. That life wasn't something I felt entitled to. It was just something I wanted.

At the very beginning of my pregnancy, before I even knew I was pregnant, I was invited to speak at an electronica festival in a quaint Alpine town. Why had I been invited to speak at an electronica festival? I couldn't quite figure it out. But I was happy to be there. Every night we piled into warehouses and watched tall, skinny boys in hoodies and bulky headphones make nearly unbearable music on their laptops.

One afternoon I got on a stage and talked to another writer about narcissism and empathy. That night, she and I kept talking beside a shipping container filled with old furniture you could splinter with a hammer. She smoked a cigarette and told me the long saga of her open relationship, and I didn't smoke a cigarette and told her about wanting to be pregnant.

On the surface we were talking about two very different ways to be a woman—married with a child, and childless with many lovers—but underneath I think we were both talking about ways to find relief from living trapped inside ourselves. We were both looking for the freedom that lay on the other side of surrendering control.

In my twenties, I sometimes stayed up all night writing. This was mostly in Iowa, where I drove out to a truck stop on I-80 and wrote in its all-night diner. There was one story I wrote almost exclusively during these nocturnal hours, about a group of veterans who lived together on a houseboat. It was clipped and opaque, like a stenographer's transcription of a dream.

The night I finished a draft of that story—facing three empty mugs of coffee and a half-eaten plate of sticky French toast—I was buzzed on caffeine and the adrenaline rush of trying to capture something that I could touch but not contain. I was imagining the loneliness of strangers and the gentle rocking of a boat beneath them, the breakfasts they cooked one another on propane camp stoves. This story was, I suspected, the best thing I'd ever written.

In workshop the next week, when it was my teacher's turn to speak, he simply shrugged. It was definitely *odd,* he said, but what did it amount to?

The deflation stung—coming down from the vinyl dream, to his casual shrug—but it turned me stubborn. I wanted to keep finding my way back to those nighttime hours, when I'd scraped the edges of something secret and important.

A decade later, when I held my tiny baby in my arms, it was hard to imagine what those secret hours might look like. Every hour, now, was arranged around her bodily needs. Even my solitude was something I had to plead or pay for.

If writing was my great love—and I was starting to believe it was, perhaps more than any man would ever be—I often wondered if it was ultimately a form of self-love, a kind of poison. Maybe submitting myself to another's needs—becoming a wife, and then a mother—was precisely the antivenom I needed.

The first day I left my daughter to write, when she was four months old, it felt like planning the logistics of a coup. I put extra plastic pouches of frozen breast milk in the freezer, so C had backup for the backup, and made sure he knew when she'd last nursed, and

when she'd woken up from her morning nap. The lightness of my bag felt like a crime, without all the diapers and blankets, as if I were climbing out the bedroom window just before dawn.

Sitting in a coffee shop around the corner from our apartment, I had my ringtone set on highest volume so I wouldn't miss a call from C. I had an overpriced ham and cheese croissant on a plate—almost too stale to eat, but I was going to eat it anyway.

In my excitement about not needing to bring everything, I hadn't brought much. Not even a computer, or any paper. So I grabbed a stack of napkins to write on and laid them across my table. *Yes, I'll be using this entire four-top.*

For fifteen years, I'd been trying to write an essay about my eating disorder. Every version seemed trapped in the same fallacy it was supposed to interrogate—the idea that a starving body could speak with an eloquence the healthy body couldn't manage. Now I was wondering if this essay about my eating disorder also needed to be an essay about pregnancy—my expanding body limned by the spectral outline of a prior, skeletal self. I scribbled details onto napkins: the scale tucked into my dorm-room closet, and the slick purple gleam of my daughter's new skin, her eyes screwed shut against the fluorescent hospital lights. Then I shifted the napkins around like puzzle pieces, trying to get their points of contact right. Some were torn, where I'd written too quickly on their thin crepe paper. A block away, I imagined C carrying our daughter through the rooms of our apartment, singing songs, rocking her, telling her, *I'm here, I'm your father.* It was one of the first times I'd left her with him like this.

It felt like biblical logic: to write her, I had to leave her. *The best thing for me to do is displace a moment of my everyday life to an*

artistic space. These napkins tried to bring the crib into the gallery. They fumbled their way toward the memory of her face right after she was born. The alchemy was energizing—this jigsaw interlocking of my anorexia and my pregnancy, each arc sharpening the other into focus. It was weirdly like the first time I tried cocaine and thought, *There's just so much to say.*

This coffee shop full of parked strollers wasn't anything like the truck-stop booth past midnight, but the sensation of surrender was right there, waiting. I just had to accept that it would come in different packages: a few hours at a time, negotiated or paid for, haunted by the ticking clock, flooded with ruthless sun.

In those early months, my daughter slept in a bassinet beside my pillow. The first thing I saw when I woke up was her sleeping face on the other side of the white mesh: the slight pucker of her lips; her sloped nose like a gob of raw dough; her veined eyelids fluttering. Sometimes the desire to press my skin against her skin was so strong it was like hunger, and a weird, low growling sound came from my mouth.

In the past, it had never resonated when women talked about wanting to eat babies. But once it was my own daughter, her perfect body, I felt this hunger in a primal way: the impulse to bring her back to where she'd come from.

One afternoon my therapist told me, "I think your daughter is your refuge in your home."

This wasn't too much to ask of a five-month-old, right? That she be my refuge in my home?

My daughter's first summer, we went to a wedding down in

Maryland, on Tilghman Island. My friends Casey and Kathryn were getting married on a grassy knob of land jutting into the Chesapeake Bay. The air was thick with salt and mosquitoes. A cart parked on the wet grass served double scoops of lemon ice cream. The first reading at the ceremony felt like an indictment: "Love as distinct from 'being in love' is not merely a feeling. It is a deep unity, maintained by the will and deliberately strengthened by habit."

I'd come to believe in this vision of romantic love—as something durational and daily, made of intentionality as much as overwhelming emotion, fueled by willpower—and it was moving to hear it spoken. But I'd also come to believe that at the core of my marriage, there was not a compatibility that could support this work. All our hours of couples therapy, long tearful conversations with friends in which I tried to buoy myself to stay—it had come to feel like hurling effort at a center that could not hold.

The two women getting married that day had met just days before our own wedding. It hurt now to remember the beauty of that day at the creek: the dangling flowers, the faith in his eyes. Standing in the rain-dampened grass, mosquitoes swarming my ankles in the twilight, I whispered in my baby's ear about our wedding: the triple-decker cake streaked by tiny fingers, the poem made of text messages, the gas-station candy.

I wanted her to have these splinters. They'd once felt like the beginning of a life.

I told her, There was a barn strung with lights. Everyone loved the cornbread. Your uncle brought his own single-malt to the reception and the caterers asked him to put it away. Your father

and I drove through the night with enough jelly beans to feed an army. We loved each other. We really did.

The first time I taught after my daughter's birth, it was a weekend workshop in Denver. She was six months old. C stayed with her in our hotel room down the block. This was still unusual for us—her spending a few hours with him, like this. We hadn't started her on formula yet, and had no frozen milk away from home. So we were on the clock. We had to time my fifteen-minute class break just right.

At the beginning of class, I told my students, "My baby's just down the street," as if I were confessing some exotic medical condition they all needed to be aware of. They just nodded and smiled. Many were mothers. They knew the deal.

Before class, I'd been afraid I'd be distracted the whole time I was teaching—my mind levitating above my body and slowly skulking back to my daughter down the street. But in fact, something more like the opposite happened. I felt intensely, almost ferociously present. My students were too committed, too full of desire, for me not to be right there with them: the marine from Florida writing about the laundromat on his base in Afghanistan, soldiers bringing back their bloodstained uniforms; a woman with full-sleeve tattoos writing about trying to explain her depression to her Japanese lover; and an Australian mother who kept insisting her postpartum depression wasn't interesting, even though those were the two paragraphs that people kept pointing to and saying, *Write more of this.*

It felt like I was growing larger, gaining layers, just by spending time with these students. Maybe I could bring some of that

largeness back to my daughter; could mother her as a woman who contained the residue of all these strangers. It was like a stoned epiphany from college, except I hadn't been stoned in more than a decade.

When my phone buzzed with the third text from my husband, *She really needs to nurse,* I called our break a half hour early and ran down the block, breasts hard and heavy as stones, my flip-flops slapping against the hot asphalt. I began to feel the dizzying vertigo of role-switching, draining and propulsive at once, flicking back and forth between selves: *I'm a teacher. I'm tits. I'm a teacher. I'm tits. I'm a teacher. I'm tits.*

"Sometimes motherhood seems impossible to write," one of the mothers in that classroom told me. "It's just so tedious."

"Nothing is tedious, as long as you're asking the right questions," I said. Everyone wrote this down.

On our flight home, as we taxied down the tarmac, my daughter took a massive shit all over me. We hit turbulence right after takeoff and it was a half hour until the pilot turned off the seatbelt light. So my daughter and I sat there, both of us covered in her shit, until I could finally get up to change her diaper and put her in a clean onesie. Then she slept across my chest and I tried to eat sour gummy peaches without waking her up. Something about it all felt profound, that hour smothered in the warmth of her shit, but when I tried to record it, it was hard to figure out why. *She took the biggest shit,* I wrote. *It got all over us both.*

How many plane flights did I take with her that first year? Thirty? Forty? It was hard to know if I brought her everywhere

because I constantly craved her presence, or because I wanted to keep living as if she didn't exist at all. Every work itinerary was like a hall pass in school: a reading, an event, a college visit. Part of me was always looking for reasons to be away. The tides might tell themselves stories about why they're rushing in and out, but it's ultimately the moon that's in charge.

At a reading in Toronto, I was interviewed on a stage directly across from the room where a Canadian publicist was watching my baby. The walls were glass. They blocked the noise but not my view. It was like watching a silent movie in which another woman was actually the mother of my child.

At first my daughter was happily slamming her fists against a wooden conference table, but then she started to get fussy. *Put her in the carrier,* I thought. The woman picked her up and started bouncing her around the room. *Nope,* I thought. *You gotta use the carrier.* My daughter started crying. But the glass was thick! I couldn't hear a thing. It was like someone had pressed the mute button on my daughter. The woman picked up the carrier, clearly confused by it. *You have to clasp the buckle around your waist before you do the shoulder straps,* I thought. The woman interviewing me asked a question about how I excavated profundity from banality. *No, the BIG buckle,* I thought, as the woman tried to put my daughter in the carrier before she had the waistband fully cinched. I had to force myself to look away, and when I looked back my daughter was settled in the carrier. She looked peaceful.

It was hard to say which stung more: watching the silent movie

in which she was unhappy about being mothered by another woman, or the one in which it was going just fine.

That summer, our apartment was invaded by flying ants. Their licorice bodies clustered around the windowsills, leaping and zooming in jumpy bursts. The Internet said it happened every summer, queens and workers sprouting wings to mate in the air. They seemed to congregate with particular density in the nursery, like they were conspiring to take over. Its surfaces teemed with their glistening, larval wings: the wooden crib bars, the white dresser drawers, the changing table pad. I pictured them perched on my daughter's perfect doughy cheeks as she napped. I put out sugar-water traps and crossed my fingers.

Sure, the Internet said these flying ants were an annual phenomenon. But with their lurching, grotesque attempts at flight, wasn't it just as likely they were an elaborate metaphor for my own impulse to flee? They oozed from the joints and crevices of our apartment like a dark fluid secretion. C and I could spend as many hours in therapy as we wanted, but they'd still be here, wriggling and bottomless, a reminder that something was not right in our home.

Over and over, I read my daughter a picture book about a little girl named Maggie, who wishes for a boat of her own and then wakes up on a little wooden ship called the *Maggie B*. She finds a toucan perched on the prow, an orange tree on the poop deck, and a cozy cabin lit by oil lanterns. She gives her baby brother a counting lesson. She paints his portrait. They have a picnic. As soon as lunch is done, they start thinking about dinner. A fish

stew simmers all afternoon. Maggie pulls steaming biscuits from the oven while a storm rages outside their warm cabin. After dinner, she drizzles honey over peaches and gives her brother a bath in the sink. She sings lullabies to ease him into wave-rocked sleep.

It wasn't a mystery to me why I loved this book so much. I wanted a home that was not the home I was living in—a home shellacked and silenced by resentment, full of curdled hope and grudging tallies. When Maggie sweeps the floors with a "joyful hustle-bustle...since it was her own little cabin, in her own little ship," I imagined setting up a home of our own, just me and my daughter. That home would feel more accurate. It would express the solitude I already felt. And in that solitude, there would be more room for beauty: The honey peaches. The storm outside. The songs at night.

After bedtime, the baby was waking up every hour. The four-month sleep regression lasted until five months, and then six. The Internet did not offer solutions. Or rather, it offered too many. I kept thinking it would just pass. But finally, I gave in. I would sleep train. Not for me, but for *her,* I told a few friends, until one said, "It would be okay if it was for you."

But still, I felt guilt when another mother told me, "I wish I could sleep train! But I just can't stand the sound of my baby crying." As if the rest of us were just like, *bring it on.*

I found a method that recommended going to your crying baby every five minutes and repeating the same reassuring mantra. It also recommended having a mantra for yourself. So in the four-and-a-half-minute intervals between visiting her nursery, I sat on my bed, squeezed my eyes shut, and repeated one of

the phrases from the book, *Your baby is protesting a big change, and that's okay.* Sometimes just, *You are okay, You are okay, You are okay.*

Once the baby started sleeping through the night, C and I watched *American Ninja Warrior* after she was down. In sweatpants and Lycra bodysuits and shiny capes, the contestants navigated elaborate obstacle courses: the Dancing Stones, the Jumping Spider, the Double Salmon Ladder. The show felt like another planet, far away from our days. It was a place where we did not need to sort through our endless accumulating resentments. We gasped in delight when the cocky rock climbers messed up early, when the announcers yelled, "Stop playing around, it's not RECESS yet!" Or, "DON'T go downstairs and answer the door for lactic acid!"

One friend described marital tension in terms of oil and vinegar. You couldn't necessarily dissolve the oil of resentment, but you could cut through it with the vinegar of something else—shared pleasure, laughter. Our joy at that obstacle course was a streak of vinegar. I looked forward to my nightly bowl of ice cream with a devotion that reminded me of looking forward to drinking.

We sat on our scratchy red couch, with little holes like empty eye sockets where the cat had torn off its buttons, and watched the Island Ninja from Hawaii, the Eskimo Ninja from Alaska, the Papal Ninja who was training for the priesthood, the Kingdom Ninja who was running for Christ.

We watched a teacher compete only a few months after completing her last round of chemotherapy. C knew she probably

wouldn't make it far. He knew her body must be wrecked. He knew the toll of chemo, the weight loss into gauntness. He knew about filling the fridge with everything you thought someone might possibly be coaxed to eat. He knew the way a walk around the block could feel like an extraordinary victory.

When I first met C, I ached because I could not change what he'd endured. But later I ached because I wasn't ultimately able to offer him the life we'd both wanted—a life that would arrive on the other side of all that suffering. Not its redemption, but perhaps its salve.

That summer, I listened to news reports of family separations at the border. Postpartum hormones under a Trump presidency. I read about a breastfeeding woman in handcuffs crying out for her baby while I nursed my daughter. I listened to descriptions of the detention centers while I washed dishes, pulled ant traps away from the chubby fingers of the crawling baby, filled the garbage with strawberries wearing little gray hats of mold, and cucumbers squishy as water balloons. What a gift it was, this home. I didn't deserve my own unhappiness.

A week into Trump's presidency, after his first immigration ban, C and I had headed down to the protest at JFK. Terminal 4, International Arrival. We scribbled phrases from the Statue of Liberty on drugstore poster board as the A train rocked us back and forth, making our handwriting jagged. *Give me your tired. . .* The protest slowly joined us on the subway, people with thick beards and wool beanies and signs of their own. *I've got sandwiches!*

At the AirTrain station, a line of cops began forming on the other side of the turnstiles. "Ticketed passengers only," they said.

C shouted back at them, and I wanted to be a person shouting back at them—though I was too self-conscious, too cowardly.

We ended up taking a black cab to the terminal, with a few other protesters, all of us piled into the back seat. Once we arrived, we joined crowds that stretched all the way back to the parking lots, where someone had projected the word "Resist" across the concrete wall.

It felt good to be out there on a cold night with C, holding signs we'd written with our stinky-sweet drugstore markers. He was not afraid to be adamant. There was a clarity to him—to his passion, and even to his anger—that felt clean and stark, like a rugged landscape with all the fog burned off.

Near the end of her first summer, C and I took the baby to western Maryland, where my aunt had a cabin on a lake full of teenagers whizzing past on NASCAR inner tubes, and pontoons blasting Phil Collins. Going on vacation with a baby just meant doing all the things I usually did, only I was doing them beside a lake: dangling a whale rattle above her eager face, trying to keep her from hurting herself, trying to keep her from hurting herself *out in the sunshine.* Counting the hours until nap time, under a big blue sky.

The cabin was thick with the shadows of prior versions of myself: playing pool with my best friend from college at the Black Bear Saloon across the street, or getting drunk by noon on Midori sours because my boyfriend wasn't falling in love with me as fast as I was falling in love with him—or at least, he hadn't texted for a couple hours. The last time I'd come to this cabin, I'd come alone, driving straight from a West Virginia prison where

I'd interviewed an incarcerated ultramarathoner. This was for the first magazine piece I'd ever been commissioned to write. It felt so consolidating, this commission—proof of being wanted. At the cabin, I lived on seltzer and saltines and chocolate chip cookie dough ice cream, loving the exhausting, unhinged sensation of disappearing completely into work.

On those visits in the past, life had been Big Feelings and Big Projects. Now it was Big Hours, the endless ticking of minutes across the day. When I sat with my daughter in that humid sunlight, with pontoons blasting soft rock on the lake, my spectral prior selves seemed far away: the woman who got blissfully or disconsolately drunk, who lost track of the hours of the night; the woman who woke up at five in the morning to make instant coffee and hurl herself into work, who lost track of the hours of the day. These days I never lost track of time. I always knew how many hours of the day had passed, and how many were left.

That fall, I returned to my teaching job. Though I felt a certain pressure to tell people I hated going back to work, in truth it felt sturdy and *right* to start teaching again. It felt good to wear something besides the same frayed pair of jeggings I'd been wearing for months, with flannel shirts that were easy to unbutton for nursing.

Each morning I brought two bags on the subway. One was packed with teaching supplies—my laptop, my printed lessons for a seminar called Writing the Body—and the other was full of pumping supplies: flanges, tubes, plastic pouches, plastic bottles, and the hard-shelled yellow engine of the pump itself, which purred contentedly until I cranked it up to the highest setting and

it started to wheeze like a little old man, pawing at my nipples with his plastic flange-hands.

In class, I spoke to my students about breaking open the anecdotal stories we all tell ourselves and others about our own lives. You have to dislodge the cocktail-party version of the story, I said, in order to get at the more complicated version lurking beneath the anecdote: the anger under the nostalgia, the fear under the ambition. I didn't want their breakups summarized, I wanted specifics—wanted them stress-eating cookies as big as their palms, their fingers smelling like iron after leaning against an ex's rusty fire escape.

In breathy monologues, with aching breasts, I told my students I believed in the empty pilsner cans and bunched-up masturbation tissues of this life; the Clorox tang of semen in the back of the throat; the tenderness of a mother making apple crisp in foil packets over an open fire. Digging underneath the cocktail-party version of a story was like turning over a smooth stone to get at the moss and dirt below. Or perhaps it was like standing next to me at a cocktail party, when I gave you a twenty-minute reply to a perfunctory question.

It felt almost like drag, going to work and becoming a better version of myself for my students: generous, enthusiastic, always giving them the benefit of the doubt. I knew I wasn't offering these things to C anymore, that I was hardening myself in order to summon the resolve to leave.

After class, I pumped at the desk in my shared office and then washed the supplies in the tiny sink of our two-stall communal bathroom. A line always formed behind me, students who were

running late for class. "I'm so sorry," I told them, and sometimes just let them cut in to wash their hands among the clutter of my milk-streaked instruments. Once I was done, I shook off everything, little droplets flying everywhere, then tore off enough paper towels to level a small Nordic forest, and cradled all the wet supplies in my arms like an unruly baby made of ten different pieces. Back in my office, I covered my desk with paper towels and held conferences with students as the plastic parts dried between us. This was hardly professional, but there wasn't a clear alternative in sight.

The first time I nursed my daughter, I finally started to understand why Communion involved eating Christ's body—why flesh as nourishment could feel sacred. Pumping was harder to understand in these divine terms. It involved the absence of my daughter's body rather than her presence. It was all plastic tubes and flanges sticking out of holes in my milk-streaked hands-free pumping bra; it was sharp sudden pangs of pain and milk dribbled onto the desk. But it was also a way of telling my body, *Do not forget her body,* and a way of telling her body, when she drank, *Do not forget that my body has never forgotten yours.*

That term, a very nice male professor was scheduled to occupy our shared office during the hour following my three-hour workshop. This was just when I most needed to pump.

For a few weeks, I tried using another office, but after a colleague walked in on me with my shirt off and the plastic flanges heaving against my bare chest, I decided to ask the male professor if he'd be willing to use another office for that hour. *Whatever you do,* I told myself before I approached him, *don't apologize.*

When I finally stopped him in the hallway, I started by saying, "I'm so sorry." Then I asked if I could use our office to pump.

He frowned slightly, then his features arranged themselves into a genial, accommodating smile. "It's tricky, right?" he said. "We're all in the same boat."

I was quiet for a moment. Which boat did he mean?

"We're all dealing with this office shortage," he said. "We're all trying to make the best of it."

I wanted to say, *Yes, but I'm making the best of it with my breast pump.* Instead, I said, "It would really mean a lot to me." As if it were a personal favor. When I knew it wasn't my fault, or his fault. It was the institution's fault, making women run around begging for the basic things their bodies needed.

He was quite gracious about it, and I was grateful. But I was suspicious of my gratitude, which seemed like the product of a system that makes it difficult for mothers to work, and then asks them to feel grateful every time it's made incrementally less difficult. I tried to imagine being a student looking for space to pump, or an adjunct teacher worried about getting asked back. Or a maintenance worker. Which is to say, We aren't all in the same boat.

Still, it made me smile to conjure a version of this impossible boat: men and women alike hooked up to breast pumps all day long, tits out in the sun, squinting against the salt breeze, fortifying themselves with granola bars, pumping and pumping away.

When I was working, my daughter spent her days with Soraya, who wore bright silk scarves wrapped around her hair and had a sixteen-year-old daughter of her own. They lived in Crown

Heights, but Soraya was originally from Trinidad. Her politics were closer to mine than my own brothers' were. She was easy in her laughter and meticulous in her care, in her precise oatmeal ratios and her Olympic capacity to clip infant fingernails, in her refusal to take no for an answer when it came to winter accessories. While I always capitulated so easily to my daughter, telling myself some story about refusal-as-autonomy but really just desperate to avoid her tears, Soraya just got two rainbow mittens onto two tiny hands, done and done. Soraya watched my daughter at another family's apartment; their daughter was just a week younger and childcare was easier to afford this way—just a couple afternoons a week at first; then four.

The first afternoon I left my daughter with Soraya, I wasn't yet using formula. I'd brought plastic bags of frozen breast milk, but not enough of them. On my way home, I got Soraya's text on a Midtown subway platform, still forty-five minutes away. *She doesn't have any milk. She's hungry.*

On my way! I texted back. *I'll be home in half an hour!* As if underestimating by fifteen minutes would get me there any faster.

When Soraya opened the apartment door, she was smiling kindly, knowingly. "I guessed you'd be crying," she said, and gave me a hug. Even the feelings that were most primal, that felt most like *mine*—this love for my daughter, this shame—were ones another woman knew better than I knew them myself. She'd seen them before. She'd see them again. This was part of the labor I was asking of her, to assuage my guilt about the labor she was providing.

In September, when my daughter was nine months old, I took her to Oslo, where I was speaking at a literary festival. It was

an exhausting trip that I often narrated to myself and others in terms of adventure, starting with an evening pilgrimage to find the mop-headed baristas of Grünerløkka. This neighborhood was called the Williamsburg of Oslo, though my host assured me it was no longer truly hip, which meant it really was the Williamsburg of Oslo. As dusk settled over its rustling trees, I drank a single perfect cappuccino in the velvet gloaming while my daughter cooed in her travel stroller, watching leaf shadows and sucking her two fingers. Her efficient self-soothing made me feel lucky and superfluous. It was just her and her two little fingers, getting by in this world.

When I told this version of the Oslo trip—dusk cappuccino, Oslo neighborhood punch line, etc.—it was meant to suggest a certain vision of motherhood, as expansion rather than claustrophobia. This vision didn't require sacrificing work at the altar of my daughter, or sacrificing my daughter at the altar of work. I generally told this version of the Oslo story to men, or else to childless friends who moved through the world without caring for babies. Which is to say, I told it to people to whom I was trying to prove that my life had not "gotten small," a phrase I put in quotes in my mind, though I did not know whom I was quoting.

But there was another version of my Oslo story. It started on our plane ride across the Atlantic, when my daughter would not sleep and I paced the aisles endlessly with her strapped to my chest, and it continued in our hotel room, when I still had no idea how to make her fall asleep, or really any right to ask her to. Of course her tiny body was confused. We'd crossed an ocean and however many time zones. I'd already tried holding her and

nursing her and rocking her in the little pink space suit she wore to sleep in the particular microclimate of seven to ten months. So I sat in the bathroom and let her cry, stress-eating gummy candies from the gummy megastore we'd visited earlier that day. In a whisper, I repeated mantras from my sleep-training book, *Your baby is protesting, and that's okay.*

This was the other version of Oslo: crouched by the toilet under fluorescent bathroom lights, mouth ragged from all that sugar, my baby crying and crying in the dark room beyond.

Four years earlier, I'd gone to Oslo for another literary festival, as a thirty-year-old woman invited alongside a slew of middle-aged men, mainly high-profile book critics who made their living judging other people's writing. We all got paid in envelopes of cash. Some envelopes were notably thicker than others, as we got paid per event. Most of the men had been slated for three or four panels, while I was doing just one: a conversation with the only other female participant. Our event was called "The Strength to Be Kind." I thought of making a little joke onstage, saying they should have called it "The Strength to Be Paid Less and *Still* Be Kind."

But I didn't make that joke, only tried my very best to sound smart—because I wanted to prove myself to all these men, just as I'd spent my whole life wanting to prove myself to my father and my older brothers, and eventually my older boyfriends, and then my older husband.

In recovery they talk about the God-shaped hole inside us all. But you don't have to believe in God to recognize that feeling of

an endless drain—no matter what you pour inside, or how much, it's never enough.

For decades I tried to impress my father at the dinner table. At first I did it at our actual dinner table, whenever he was in town, before he moved out. Then I did it at the yakitori restaurants where he took me after the divorce.

At those dinners I never knew what to talk about. I didn't know which parts of my life he'd find interesting. It seemed like my loneliness—the fact that I was the quietest girl in my seventh-grade class, eating lunch alone on a patch of carpet outside the faculty lounge—was a secret I had to keep from him. I was sure he'd be disappointed. Who wanted this person to be their daughter?

At one of those dinners, he told me I'd gotten quite sarcastic. Did I know that I wasn't particularly pleasant to be around? From then on, I assumed this was part of why we didn't see each other more, that I wasn't particularly pleasant to be around. But I didn't say that out loud. I didn't say much during those dinners. Didn't say much in those days, at all.

And then, for many years, I kept trying to impress my dad even when I wasn't having dinner with him. Even when I wasn't anywhere near him. No matter who I was with, I was still just a seven-year-old trying to say something accurate about bed nets and malaria, my dad's favorite subjects, or else sharing what I'd learned about FDR for my president report. Did you know he was in a wheelchair? Yep, he knew. When everyone in your family is at least a decade older than you, they already know FDR was in a wheelchair.

At first, there were late-night phone calls with my high school boyfriend, the curly plastic phone cord looped around my fingers—believing that if we had this much to say to each other, if I could keep him listening, he'd never stop loving me. Then there was college, breaking into tears in a dining hall, over waffles, when my boyfriend's eyes glazed over as I described—at painful length, I'm sure—the "intellectual plotline" of my senior thesis about claustrophobic family intimacy in Faulkner. My boyfriend's boredom came as a personal rebuke. Couldn't he see that it was a rejection of my entire being?

Now I think back on him with such tenderness. He was dutifully listening to my endless monologue and maybe itching for another waffle, or a nap, and then bam! I was crying.

As we drunk-stumbled home from a barbecue in my early twenties, my poet boyfriend—my first poet boyfriend, but not my last—leaned close to my ear and whispered, "Tonight I was in love with every single word coming out of your mouth." He loved me because I'd said all the right things. It was the great victory I'd been working toward. But there was a stubborn sadness waiting for me on the other side of finally being good enough. Turns out it didn't guarantee anything. You could spend your whole life becoming as interesting as possible ("With your father, at least I was never bored") and love still might not last. This left me with a dizzying sense of vertigo. If being good enough wasn't the answer, what was?

There was something manic about my time in Oslo with the baby, fueled by an insistent desire to prove that my life had not been foreclosed or even narrowed by her presence. One day I pushed her stroller uphill along the side of a highway for several

kilometers until we reached a sculpture garden overlooking the city, where a nervous art student in the information center recommended the Louise Bourgeois sculpture. "It's very nice," he said, then looked down in shame. "*Very nice?*" he parroted his own words. "What does that even mean?"

The art student told me he was trying to write art criticism that read like poetry. The room smelled doughy and sweet. It turned out he was making waffles, right there at the information desk, in a little griddle hidden among all the pamphlets, and this seemed like a kind of poetry too. He served me a steaming-hot waffle with strawberry jam, and I ate it beneath the Louise Bourgeois sculpture, which *was* very nice. Two gleaming silver lovers dangled from a massive tree branch, their bodies like spires of soft-serve ice cream with arms and legs sticking out.

Looking at those lovers, gleaming and entangled, I remembered the first time C and I went to dinner, at an Italian restaurant tucked inside a brownstone. As C walked me to the subway afterwards, it started raining. Dark spots speckled the sidewalk.

C offered me his jacket. I refused, saying it was my own fault I'd forgotten to bring a coat. He shook his head, amused. "So you deserve to be cold? Ridiculous."

He draped his coat over my shoulders. "Just take it."

He knew the universe didn't give people what they deserved, anyway. You might as well stay dry while you could.

After the baby fell asleep in her stroller, I could not pause at any art because I was scared she would wake if we stopped moving. At a sculpture shaped like a street lamp, a voice emerged from hidden speakers, saying, "You are now ready to receive information

that you were not previously ready to receive," but I couldn't stick around to hear it, because I was afraid the information would wake the baby up. So I never received what I was ready for, and five minutes later the baby woke up anyway.

On our last day in Oslo, the baby and I visited a mausoleum nestled on the edge of town, a squat brick building that had once been the studio of a painter named Emanuel Vigeland. He'd decided to turn it into his tomb, painting the walls with scenes of birth and sex and death. People were making love on piles of skeletons. Skeletons were making love. The acoustics were so sensitive that visitors were required to remove their shoes and wear special soft slippers. I knew that if my baby cried in the room with the sensitive acoustics, it was going to be very, very loud.

And she did cry, and it *was* loud—or rather, she whimpered a little bit, but the space magnified her whimpering into something that sounded like it could shatter glass. I nudged a pacifier into her mouth and apologized to the twenty-year-old hipsters standing near us—a bit farther away, now—even though I knew that her crying belonged in that room of life and death more than the rest of our careful silences.

Back home, I invited my students to our apartment for a potluck. In class I'd told them to *get specific* so often that I decided to get it written in red frosting across the top of a chocolate cake. When one student saw it, he told me about a drinking game they'd all invented. Everyone took a shot whenever someone used a Leslie Word. Interiority? Take a shot. Granular? Take a shot. Complexity of consciousness? Take two shots! Three!

We arranged ourselves in a circle in my living room with our cake slices and our manuscript pages. My daughter was eleven months old and part of the circle too, bouncing in her Jumparoo, pulled back by red elastic tethers whenever she reached for the dangling plastic monkey. I fed her little teething crackers while I scrambled to reread the notes I'd written on my student's essay: *When you write about swimming, or even heroin, I wonder if you are exploring the fantasy of forgetting the body entirely?* These were the insights that another version of myself—less baby-distracted, less crumb-covered—had once had.

I imagined someone taking a photo of our circle, with my baby bouncing there amidst my students, proof of my nimble working motherhood. Perhaps if I assembled enough of this proof, it could fill whatever space inside myself I'd once imagined filling with happiness. It was as if I lived every moment of my life with the sense that it had to be good enough for someone else—perhaps my husband, to show him the life I was trying to give our daughter.

Get specific? Okay. The teething crackers were banana flavored. My daughter started to fuss halfway through class, and I was frustrated by her fussing—why couldn't she play her role in this afternoon I'd scripted? I sat beside her little jumper, jamming the crackers at her tiny hand. What more could she possibly want? My *attention*?

There is a photo of that day, actually. My daughter looks happily blurred by jumping and my students are leaning forward, listening intently, and I do look like both a mother and a teacher. But I never felt doubled. I felt more like half a mother and half a teacher, constantly reaching for each identity as if it were a

dangling toy—mother, teacher, mother, teacher—until the elastic tether of the other self snapped me away again.

That fall I took the baby to a college reading, at the invitation of an old friend who was now a professor. Back in our college days I'd had a crush on this friend. There was a night we kissed back then, though I was so drunk I couldn't exactly remember. What I did remember was slow-dancing on a sticky wooden floor, and how the straps of my dress kept falling down and he kept gently pulling them up again. The next morning I woke up wondering what would happen next, because I was a daydreamer and in my daydreams many things had already happened between us. But nothing happened next. Or rather, this happened next: we were friends for twenty years; we were never together; I married someone else. Being an adult meant watching many possible versions of yourself whittle into just one.

On this trip, my friend picked us up—me and the baby—from our retro motor lodge on a hill. It was raining, and our room stank faintly of urine from a trash bin full of wet diapers. There was a burnt smell from the hair dryer blowing on my sopping canvas sneakers. My friend took us to a museum, and when I nursed in its elegant restaurant—my daughter smearing pasta sauce across the crisp white napkins with her tiny fingers—it almost felt like squandering an opportunity, that during all these years he'd only seen my breasts when I was nursing or drunk.

On the stairs outside the museum, a woman stopped us to say we had a beautiful son, a beautiful family. At the time we joked about how much she'd gotten wrong in a single sentence. But in the dark hotel room that night, with my daughter sleeping beside

me, it ached to let myself glimpse, just for a moment, that alternate reality she'd seen—the possibility of another life.

Every day that fall I asked myself some version of the same questions. Did honoring my vows mean figuring out how to make a daily home with C's anger? What did I owe his pain? What did I owe my daughter? When I told myself she would get better versions of both her parents if we did not live together, was I simply telling myself a story that would justify the choice I already wanted to make?

While I was pregnant—and before that, when we were trying—I'd hoped that having a baby would force us to find a better version of our relationship. But it seemed to be doing almost the opposite: clarifying my sense that this home was not the home I wanted her to know. In therapy, I started saying this to C, trying to let him know how far away from him I'd gotten, rather than keeping it to myself.

During a conversation two years earlier, when I was already unhappy enough to consider leaving, I told Harriet I was worried about the harm I would cause if I left. She told me I was right to worry. I would cause harm. She also told me no one moves through this world without causing harm. I'd wanted her to say, *Don't be crazy! You won't cause any harm!* Or at least, *You're in so much pain, you deserve to cause harm!*

But she hadn't said either of these things. What she said instead was neither condemnation nor absolution. It was just this: You have to claim responsibility for the harm you cause. You have to believe it's necessary.

At a literary festival in Austin that fall, I met an advice columnist I'd admired for years. We ate tacos from a truck, and the baby lay against my chest while I tried not to drop shards of radish onto her head. She had a cough. Was her body trying to tell me it was all too much—all these flights and hotel rooms, all these strangers? Whenever she coughed, she gave me a little smile afterwards, as if to reassure me that everything was okay. Did she somehow feel this was her job, to reassure me that everything was okay? Had she overheard my therapist saying she was my refuge in my home?

I fed her eyedropper doses of bright pink medicine that smelled like bubble gum, and bought a humidifier from the drugstore—lugged it back to the hotel in a paper bag that bumped against my knees, while the baby coughed her little coughs against my chest.

The advice columnist and I talked breathlessly, excitedly, with the adrenaline rush of raw disclosure, the way I'd talked to high school friends for hours at night on the phone. When it was time for my daughter to go to bed, I invited my new best friend back to my hotel room and we kept talking in the bathroom, tailbones against the tiles, while my daughter slept in the darkness beyond, the cheap drugstore humidifier wheezing and puffing beside her travel crib.

This was my version of an affair: not bringing a man back to my room for sex, but bringing a woman back to my room for disclosure.

In that hotel bathroom, I wanted the professional advice-giver to give me some advice. Honestly, I wanted her to tell me that

leaving was the right choice. Whenever I asked someone I trusted if I should stay in my marriage—and by trusted, I guess I mean had tacos with—it was like stumbling across a mysterious figure in the forest and asking her to point me toward the path. And if she said, *Stick it out,* it felt like she was saying that this life was as close to a path as I was going to get. I couldn't hope for it to get better than this.

In a recurring dream that autumn, I had a terrible pain in my mouth, and a metal bulge beneath my gums. My voice slurred whenever I tried to speak. When I finally looked in a mirror, I saw a large emerald brooch wedged inside my mouth, like a blossom with green petals. The pin stuck straight through my gum. It was gorgeous, but it hurt like hell. Since I'd been the one to put it there, I felt I had no right to take it out.

That winter, I officiated Colleen's wedding at a lodge in the Canadian Rockies. C did not come, which was a bittersweet relief. I wouldn't have known how to sit beside him and listen to other people declare their faith in a shared life.

Over the previous months, I'd had many conversations with Colleen about her vows. Traditional vows said, *Till death do us part,* but she wanted to promise something closer to this: *I will do everything I possibly can to keep creating a version of this marriage that will work.*

Talking about wedding vows was like donning a hair shirt. Some inner voice—or was it his?—shamed me, over and over again. Don't get married if you don't mean it. Don't get married if

you are only capable of meaning something for a week, a month, a year. Five years.

Colleen had officiated our wedding ceremony by the creek, and as we talked about her vows I remembered my own—kept asking myself, How do you know when something is no longer worth saving?

Up in the mountains, I ran out of baby-food pouches the day before the ceremony. So I walked into town to buy more, the baby snug against me in her carrier, bundled in an eggplant-purple snowsuit, swiveling her head like an owl to look at all the snowy trees. On the walk back, she cried because her cheeks were red and burning from the cold. Why hadn't I packed more pouches? Every time something went wrong, it was only my fault. I wanted a life that was 90 percent thinking about the complexities of consciousness, and only 10 percent thinking about pouches of puree. But this was not the life I'd signed up for.

That night, I got a sitter and went with friends to hot springs in the hills. Thick swirls of steam curled from the water into the dark night. The water felt sustaining and primal and womb-like. Near us, a man held his daughter in the deep end, supporting her from the armpits. She was making joyful sounds, enjoying the contrast between the steaming water and the chilly air. It was like a Bible parable—her father moving his daughter through the water with such tenderness, both bodies leaving ripples in their wake.

At the ceremony, I gave a speech to the assembled crowd. "Marriage is not just about continuing, but reinventing. Always

being at the brink of something new." Delivering this ode, I felt like a fraud. I had reached the end of reinventing.

But there was a painful continuity between believing in my friend's marriage and deciding to end my own. Both convictions were born of a stubborn faith in what marriage could be. A week later, I would tell C—in our basement therapy, on our too-small couch—that I was done.

At that wedding in the mountains, my words were an elegy disguised as a homily.

A voice inside me said, *You are a liar. You have not done enough.*

SMOKE

Why can't a Scorpio Moon ever let go of anything? Who said that everything you hold onto will die in your hands? Is an order of protection different from a restraining order? Why is the Worm Moon called the Chaste Moon? Why are people born on the summer solstice always falling in love? Which STDs are transmitted through breast milk? Sturgeon Moon mating. Sturgeon Moon harvest. Sturgeon Moon madness. Time zone Cardiff. Time zone Turin. Time zone Barcelona. Gray hairs curlier than normal hairs. Is scrying the same thing as hydromancy? Do tarot card apps give you bad cards at first so you keep coming back for better ones? Why is the Hanged Man smiling when he's hanging upside down?

On the first night my daughter stayed with C, cold wind whistled against the brick walls of our firehouse sublet. She was thirteen months old. This was the first night we'd ever spent apart. A friend said, "At least you won't have to wake up with her at six in the morning." But I woke up at six anyway, and at four before that, and at two.

I'd woken to her crying so many times I'd developed a special kind of hearing like a phantom limb. Now I heard her crying in the silence. But when I woke in the middle of the night, and checked the crib beside my bed, her tiny body wasn't rustling in the darkness. Her fleece sleep suit wasn't sending up sparks of static. I brought it close to my face anyway, smelling fresh-baked bread and the faint tang of urine, the ghost of her perfect skin.

She would spend two nights a week with C, Wednesdays and Sundays. I'd dreaded this first Wednesday as we approached it, these dark hours alone with the empty travel crib, a series of absences: *not*-coaxing her to eat another slice of orange, *not*-getting her tiny arms into her tiny pajama sleeves, *not*-washing the high-chair tray in the too-small sink.

I started making plans for every Wednesday and Sunday on the horizon. These were holes that needed to be filled, gaps in the wall of myself, spackled with dinners, work events, whatever I could find.

"Just think of it like free babysitting," a friend suggested, which made sense but wasn't possible.

That first night, everything was so quiet—and it was impossible not to think of this quiet multiplied across the years, every night we would spend apart.

It was a few weeks after we moved out that I got the flu, my mouth full of sweet saliva, following my daughter as she crawled from room to room. I kept picking up my phone and staring at the same text from my mother, *You need to ask someone to come over and help you.* If I stared at this text for long enough, maybe my mother's body would materialize from the screen.

When I finally texted a few friends to ask if anyone was free, I placed the phone face down again after I was done—couldn't even stand to look at it, repelled by how much I needed help. My shame surprised me, flushed my feverish cheeks, this conviction that there were some ways it was okay to need—from your family, from your spouse—and other kinds of need that felt unseemly. Needing too much beyond the boundaries of my home felt like asking for more than my fair share.

In our last session of couples therapy, the week after I asked to separate, I told C he could keep everything in the apartment. All I wanted was the furniture in the nursery.

Our therapist nodded. "But she'll need somewhere to sleep when she's staying with him."

The fact that my daughter and I would spend two nights apart each week, for the rest of her childhood, was unthinkable. A trapdoor inside me swung open and now some tiny person was in

free fall—grasping, clutching—and I couldn't see if this falling person had her face or mine.

Often I wondered if my daughter ever woke up calling for me on the nights she was away.

My therapist had something to say about this wondering. "You can recognize the trailheads of these thoughts," she told me. "But you don't have to follow them."

She also told me, "All this will have an impact on her. You need to accept that."

I sat there waiting for the *but,* for its balm.

"There will be an impact," she said again. "And your response will sit beside that impact."

Her balm was not *but,* but *and.* She told me that people often place too much weight on the immediate impact of an event, and too little weight on how we respond to that impact. I pictured impact and response perched side by side, two birds on a wire.

"It's good for her to have a relationship with her father," she said. "You know that."

And yes, I knew. The reasonable part of me knew. But the reasonable part of me sat far away in a distant, quiet chamber. The animal in me traced the scar on its abdomen and said, *She was in here. She belongs with me.*

There was only one time I got on my knees and begged. It happened in our living room, when I knelt beside the wooden coffee table and pleaded not to be away from her two nights each week.

My desire for her was irrational and unapologetic. It had no ethical code to speak of. It was made of those nine months when

there was no space between us at all; made of those early days of milk breath and sliced sweet potato, her skin against mine; made of the memory of her newborn pajamas when she wasn't big enough to fill them, and the bootie feet dangled.

The memory of begging is all right there: the rub of my knees on the carpet, the sweat of my palms clasped together, and the expression on his face, which looked like disgust, but was surely—must have been, I see now—mainly pain.

A few days later, he reminded me that he'd been the first one to hold her—at the hospital, right after she was born, when I was lying on the gurney with my belly open, body shaking. I was *there*, he said. He was reminding me that he was just as much a part of her as I was; that she was just as much a part of him.

When my own parents divorced, there were no questions about custody. My father had ways of showing his love, but wanting custody was not one of them. Over the next six years, I spent the night at his apartment only a handful of times. I was never sure how to spend the hours of the evening, or even where to *be*, or what to pack myself for lunch in the morning. A hunk of parmesan? A few day-old sushi rolls, coated with hardened, brittle rice? An almost empty bottle of chardonnay?

My therapist asked if some part of me felt comforted by the prospect of parenting without my partner. Sure, it was lonely, exhausting, guilt-stricken. But maybe it also felt...familiar?

We started to talk about the ways my closeness with my mother had subconsciously felt contingent on the absence of my father. Maybe I wanted to re-create the absence, because I thought it was the only way my presence could feel as total to my daughter as

my mother's presence had felt to me. I recounted these insights breathlessly to friends.

"Yep," they said, nodding. "That's what therapy is *for*."

It was like finding a pair of lost keys sitting in the middle of the kitchen table. Right in front of me the whole time.

On one of the last nights before we moved out, I practiced letting C do bath time—stood there washing dishes in the kitchen, listening to her cry on the other side of the wall. *Let her point out all the animals in the puffy bath book,* I thought. *Show her how each different plastic boat makes a different waterfall.*

I kept washing dishes. She stopped crying. He'd let her point out all the animals in the puffy bath book, or else they'd found a new trick together.

You're not the only one she needs, I told myself again and again. Sometimes I was even starting to believe it. Loving her meant wanting something for her that was different from what I'd had, a life in both parents' homes; and different from what I wanted for myself, which was all of her, a total claim.

When I moved out of our apartment, I took very little: my clothes, the baby's clothes, the nursery furniture. The bags of hand-me-downs stuffed in the back of a closet. She would grow to be these larger sizes somewhere else.

I did not take the scratchy red couch whose buttons had been pulled off by the nervous calico cat. I did not take the black Ikea bed my water had broken in.

Other things I took because there was no way to leave them behind, like the memory of our first date: the spring rain, his

bemused tenderness when I refused his jacket, and then its weight on my shoulders. *Ridiculous,* he'd said. *Just take it.*

The offices of my lawyer's firm occupied two floors of a sky-scraper so big it had its own subway stop. To get there, I walked by the Kings County family court, where young couples argued back and forth over strollers on the sidewalk, and thought, *We can't do that to her.* And then wondered, *Are we already doing it?*

In the waiting room, I binged on chocolates wrapped in purple foil. They sat in a large crystal bowl on the receptionist's desk. The chocolate was cheap and dark and I always wanted more of it, balling the foil wrappers into little glinting nubs that filled my pockets. If I ate enough of them, thousands of them, maybe I would earn back something close to the massive retainer I'd paid. It felt like all the times I left the dentist's office in my twenties, after a long string of root canals, thinking that I'd just paid thousands of dollars I didn't have for an experience I never wanted.

Years later, I taught a seminar right after getting an emergency root canal. My mouth was numb and heavy and my students said they were sorry I'd gotten a root canal. I wanted to tell them I'd been begging for the root canal. The hard part was what came before.

Sometimes what I wanted from my lawyer was impossible—her assurance that I was justified in ending my marriage. She had given me no sign she felt this way, or that it was her job to feel any particular way about my marriage at all.

Still, sometimes I wanted to believe that in taking this case, she was somehow—like lawyers in the movies—fighting for my innocence. As if I needed to prove that my leaving was justified in order to deserve any kind of happiness.

In my heart, I knew there was no such thing as innocence. Only the choices I'd made, and the life I built in their shadow.

Once we moved into our firehouse sublet, I never wanted to turn on the lights. I lit candles instead. I bought a mosaic lamp that shone spackled jewel tones across the walls—sapphire, crimson, tangerine—until the day my daughter tugged on its cord and the whole thing toppled, splintering into kaleidoscope shards all over the hardwood. My daughter stood on the couch cushions, safely perched above the broken glass, simultaneously terrified and delighted by what she had done.

A friend told me a parable about a Zen teacher holding a glass of water in front of his students and telling them, *To me, this glass is already broken.*

The Zen masters also said, *Lighten up.* I knew that too.

Once my baby knocked over a water glass, and I reached to grab it, terrified it would break. But she just put it on her head and smiled wryly. *See, a hat.*

After my daughter was asleep, I took baths surrounded by flocks of scented candles. Honey vanilla. Apple pie. Balsam pine. I was a walking punch line. *A woman walks into a divorce...* If a cup of Epsom salts felt good, wouldn't the whole bag feel better? It was the logic of an alcoholic who no longer drank. My muscles turned to noodles. If I melted right into the water, and honey

flames licked up the shower curtains, I knew the firehouse boys would save me. Code vanilla. Another divorcée candle fire.

Another punch-line thing I did was look up all the names of all the moons. Wolf Moon. Worm Moon. Buck Moon. Sturgeon Moon. Cold Moon, also known as the Mourning Moon. The Balsam Moon, I learned, is what they call the waning crescent just before it disappears. You might think this is a time of despair, but lo! it is a time of restoration and replenishment.

Born with my moon in Scorpio, I found solace in this diagnosis: *These natures seem to attract emotional upheaval, and their lives appear to consist of plenty of dramatic ups and downs. However, when accepted as an emotional need, rebirth and change don't need to be so dramatic and overwhelming.* But then I kept reading. Turns out if I was Scorpio rising, on top of all that, this meant I was totally fucked.

My search for a more optimistic version of my astrological destiny delivered me to a plot summary of *Moon in Scorpio*, a 1987 straight-to-TV horror movie that ended with three married couples dying in a bloodbath on a yacht off the coast of Acapulco. Whenever I read about a married couple who died together, I thought, *Well, at least they made it to the end.*

Every time a friend googled anything on my computer, my armpits prickled with sweat. What would emerge from the confessional booth of my auto-complete? Maybe those late-night hours spent watching YouTube videos of the Mormon Tabernacle Choir. All these white men in suits singing "Amazing Grace," like an office of mortgage brokers summoned for the rapture.

Sometimes I imagined my therapist saying, *Maybe you should just start drinking again?*

But I couldn't help it. Their music opened a little door inside me. Their jowls and their comb-overs, their matching gray ties, their voices reaching toward God—it was some kind of alien grace. They surrendered themselves to a larger beauty.

For the first few weeks of our separation, whenever I tried to speak to C *amicably*—that word you only ever hear in the context of divorce—he experienced it as a kind of cruel politeness. It was as if I'd stabbed him and then offered him a plate of cookies. The questions his eyes asked were astute ones: How much of my goodness was performance? How much of my desire for civility came from a desire to assuage my own guilt?

At night, I kept replaying something he'd once told me—that people called me kind because I'd surrounded myself with yes-men. Perhaps everything I'd understood as "good" in my own nature was just part of an elaborate internal machinery designed to secure praise and affection from other people.

Eventually, he said it was best if we didn't speak. So for years we said nothing.

Sometimes I still felt a surging tenderness for him, but now there was nothing to do with it. It was a river blocked against a dam. Frustrated, it turned into petty catalogues of our disputes that I'd recount to friends like tedious tales of flight delays, hating the sound of my own voice. When really what I wanted was a way out of this embattled script, this pull-and-tug; a way for there to be, someday, some care between us again.

On Sunday afternoons, right after I dropped the baby with C, I went to a twelve-step meeting in a vinyl-sided clubhouse across the street from a sprawling cemetery. It was only women. The walls were hung with wooden whales painted with slogans. *Feelings aren't facts. One day at a time.* Things I'd heard before. Things that didn't help, until I woke in the middle of the night and needed them—not as a woman needs wisdom, but as a thirsty person needs water.

In that room, when I described my husband's anger, my voice got hard and smooth as a shell. When I described the nights my daughter was away, it cracked in two. One piece of me said, *It's unbearable.* The other piece said, *It's fine.* Both pieces were lying. Nothing was fine, and nothing was unbearable.

The women sitting in that room were a loose net, holding pain but not absorbing it. They'd heard worse. They felt a grace that had nothing to do with getting everything they wanted. It was the grace of surviving things they hadn't believed they could survive. The grace of one day at a time. The grace of washing stained coffeepots, cracking a bad joke in a dark time, putting one foot in front of another.

Some people called this grace recovery. Some people called it the love of strangers. Some people simply called it God.

The first time I got sober, I hated praying. It made me feel like a liar—full of greed rather than faith. I got on my knees and asked for things from a being I didn't believe in.

The second time I got sober, I felt forgiven by prayer. It didn't require belief. You could just get on your knees. You could do this anywhere. My bath mat became a church pew when I stared

114

at shampoo bottles and tried to picture a force beyond my imagining. If I heard the word "God," I pictured squinting at a nearly empty conditioner, thinking, *Where are you?*

Prayer didn't require certainty. It could take root in all this wondering. It could take root in the honesty of wanting things. Years later, my sponsor told me I didn't have to worry about asking God for the right things, carefully editing out all the requests that felt frivolous or selfish. Who did I think I was fooling, anyway? Might as well bring all my yearning.

In the early days of separation, it was hard to let go of the idea that I needed to prove that I'd been justified in leaving. For much of the twentieth century, most US states required proof of wrongdoing in order to grant a divorce. In New York, women hired actresses to play their husband's mistresses. In Illinois, a visible handprint on the cheek was sufficient. The "clean hands" doctrine stipulated that the complaining party had to be completely innocent. Ending a marriage was a privilege available only to those who had not contributed to the problem. It wasn't until 1969 that California legalized the so-called no-fault divorce.

No-fault divorce? More like, Everyone's Fault divorce. Fifty years later, the language on my own settlement did not say "irreconcilable differences," but "irretrievable differences." It was as if our love was something we'd dropped down a storm drain, and we couldn't reach in far enough to get it back. No one's hands were clean.

The rise of the no-fault divorce suggested that you didn't need a justification for ending a marriage beyond the desire to be happier. There was still a waft of shame around saying this

directly—that my reason was wanting to be happier. His anger was a more legible reason.

Being a mother made me feel as if every choice had to be framed in terms of what was best for my daughter. I'd started to think of my own happiness as a resource I could spend on her. If I was happier, there would be more of it—more to give.

Sometimes I caught myself enumerating the ways I thought divorce would give my daughter a better life, which was ultimately not a provable claim. It would always involve comparing an apple to a counterfactual orange. The impulse to make this claim arose from the same part of me that had been compelled to say sleep training was for her, not for me; the part of me that had eaten freely, voraciously, during pregnancy—because it was for her, not for me.

But eating a stack of lemon pancakes in Louisville, my third breakfast that day—powdered sugar sprinkled around my mouth, fingers sticky with syrup, skin taut around my growing belly—I knew the truth. It was also for me.

After I'd become a mother myself, my mom told me a story about an argument she'd had with my father near the end of their marriage. "You don't know me at all," she'd told him. "For all you know, I might want to become a priest."

At that point, my mom had been working in public health for nearly two decades. This argument was the first time she'd ever articulated—to anyone, even herself—that she felt another calling. A decade later, she was ordained.

It was compelling—the idea that by telling someone, *You don't*

know me at all, you might see some buried part of yourself more clearly, or for the first time.

At my father's second wedding, I remember feeling the wrong things at the wrong times. When I hugged my mom goodbye at the airport, her body stiff with sadness, I did not cry, even though I wondered if my tears might have offered her a sense of solidarity or shared grief.

But at the wedding itself, I could not control my crying—when it was only an inconvenience, a burden on everyone else.

The third time my father got married—fifteen years later, when I was twenty-eight—the ceremony was officiated by my mother. Now she was a deacon, capable of marrying anyone, and she and my father had grown close again—to everyone's surprise, even their own.

People often marvel at this: "Your mom officiated your dad's third wedding?!" And I've always loved their marveling. I've always felt proud of my parents for finding this way to an improbable closeness, something you might call friendship. It's more than friendship, though. It holds three children and fifty years of joint-custody memories, their shared ability to hold contradictory feelings, their shared impatience with resentments as a waste of energy. It's not a pale simulacrum of their marriage, but its next chapter. This bond of having once been married fits them more comfortably than marriage itself did.

So when my father got married, for the third time, on a bluff overlooking the Pacific, he asked my mother to officiate.

Years later, though, she told me, "It might have been a bit much, agreeing to that."

In couples therapy, when we were talking about the possibility of separation, C told me, "If you think we're going to get divorced and then have what your parents have, think again."

The way some people romanticize their parents' marriages, I started to romanticize my parents' divorce. I never thought their marriage was a failure because it ended. It just gave way to something else: an aftermath that doesn't live easily inside familiar scripts.

For years, I clung to one truth about their divorce—that they'd gotten close again—and scrubbed away the others. Ignoring the hard road it had taken them to get there. Ignoring that I sometimes pulled out an old photo from their wedding day, like a talisman, and studied my father's curly hair in the backyard sunlight, his gray suit, his swirled tie; and my mother's white cotton dress, with long wide sleeves, her witchy dark hair, her high cheekbones, her hope. Ignoring how I ached for the pair who lived in this photo—for all the pain they didn't know was coming, and for the version of them that might have made it all the way.

When I was a kid, my favorite song was "Our House," by Crosby, Stills, Nash & Young. We used to play the vinyl record in our living room, singing the lyrics in ragged half-step, not quite aligned: "Our house is a very, very, very fine house / With two cats in the yard..." My dad was allergic to cats, and my favorite

thing about our yard was shooting a BB gun at our lemon tree, but the song captured what I loved about our family—that we all genuinely *liked* each other, my parents and brothers and I, and that on good nights laughter swelled the wood-paneled walls. "Our House" isn't about the stormy surges of falling in love, or breaking up; it's about domestic rhythms, and the quiet pleasures of building a home with a partner: "Come to me now / And rest your head for just five minutes."

After my parents split, that song came to hold an alternate version of our family: one in which my parents stayed together, kept resting their heads on each other's shoulders.

When I was a kid, my mom and I used to play a game where one of us would give the other one six words that had to be woven into a story. For example, I'd say: Treehouse. Princess. Waterslide. Peanut butter. Popsicle. Flamingo. Then she'd tell a story about a princess who lived in a treehouse with a faithful pet flamingo who had lost all her pink coloring, and they had to go in search of the frozen forest of magical peanut-butter popsicles that would grant your deepest wish, but once they found it, the flamingo realized her deepest wish was not to get her color back, but to find some way of making other flamingos happy, especially all the blind flamingos who could no longer see the sky...

"Blind flamingos!" I'd say, "I didn't say anything about *blind* flamingos!"

My mother would remind me that once I gave her the terms, the story was hers. And in my mother's story, the princess and the flamingo built a massive waterslide in their treehouse, so that all the blind flamingos could slide down it.

It was an early version of this lesson—I didn't get to write the story on my own.

My sublet life was: Firehouse. Ramen. Cold nights. Gummy cherries. Lawyer bills. Baby. Really it was mainly just: Baby. Baby. Baby. Baby. Baby. Baby.

What was its moral? Where was its waterslide?

When I read stories to my daughter at bedtime, it became clear that all our picture books were actually about divorce. They were ostensibly about endangered animals having picnics, and an invalid filling the world with flowers, and two little girls riding their bicycles to a secret forest concert. But every story seemed to be, at its core, about leaving or staying.

Some of our stories chided me, and some applauded me. But they all *knew*.

The one about the little starfish who couldn't appreciate the ocean creatures all around her because she was too busy wishing she were up in the sky? It knew. The one about Goldilocks and the three dinosaurs, where the little girl escaped alive because she realized she wasn't in the right book? It *definitely* knew. On the last page, it offered a moral so full of absolution I wondered if I'd misread it: "If you ever find yourself in the wrong story, leave." It didn't say anything about who you left behind.

Sometimes motherhood tricked me into feeling virtuous because I was always taking care of someone. But it didn't make me virtuous at all. It made me feral and ruthless. It steeled me to do what needed to be done.

No matter how many plans I made, Sunday and Wednesday

nights were still too quiet. If I didn't fill the evenings with a jig-saw of plans, the dark would swallow me up—those long hours staring at her empty sleep sack. Sure, some part of me was desper-ate for relief from all the dawn wake-ups and snack-whining, the mess and clutter, the endless requests, the moment-after-moment of it. But once the sublet was silent, my body ached for hers.

Making myself busy was one way I tried to hush the voice in-side me that whispered, *If she is with you only five nights a week, you are not fully her mother.* Friends told me this was ridiculous. But this didn't do much to convince the part of me that imagined her tiny body rustling and turning in a crib I'd never touched.

I could still remember holding her in my arms at six weeks old—when the nurses drew her blood from the tiniest but-terfly needle I'd ever seen, when my tears and snot cloaked us both—how those moments felt like being part of the same body again.

Mornings when she was gone, I woke up at 5:30 just to take advantage of the silence before dawn—the chance to drink three cups of coffee without interruption, my laptop open on the kitchen table with no tiny hands trying to close it.

How many times since her birth had I thought, *I'd kill to be alone.* How many times since the separation had I thought, *I can't stand to be without her.* How many times, across the course of my life, had I wanted contradictory things from the universe and then convinced myself I could solve the contradiction by naming it?

My life vacillated between the sting of her absence and the overwhelm of managing her presence without help. Spending

time without her felt like one of those body-switching movies from the early 1990s: a woman in shoulder pads at the top of the corporate ladder swaps bodies with her housewife sister. The sister wants a day without packing lunches, then misses every slice of sandwich meat. You get what you wished for, but then it's not what you wanted. You wish your house were empty, and then suddenly it is.

For the first six months of her life, my baby's mass was made of nothing but my milk. I was shedding pieces of self that became her. But eventually my daughter was made of a thousand things other than me, including her father's home. When she sang the songs he'd sung to her, these splintered tunes were flashes of that other world. *"C" is for cookie, it's good enough for me...* Hearing his inflections embedded in her voice was like feeling the slight wind of an apparition in the hallway. That shiver.

On subway commutes, and in my lawyer's waiting room, I began rereading Lewis Hyde's *The Gift*. At the core of this book was the idea that art comes to the artist as a gift, inspired by a force beyond her grasp, and should be circulated to others like a gift as well.

In my lawyer's office, however, I was thinking less about art and more about possession. Hyde writes that "the spirit of a gift is kept alive by its constant donation." He writes about the Kwakiutl tribe, whose honored elders were named for what they'd given away: Always Giving Blankets While Walking, or Whose Property Is Eaten in Feasts.

I might have been reading *The Gift* during the early months

of my divorce, but my lawyer was not. The spirit of her office was kept alive in other ways.

Hyde describes "a graceful perishing in which our hunger disappears as our gifts are consumed." This sounded like a more graceful perishing than bingeing on cheap chocolate in a divorce lawyer's waiting room, which did little to relieve my hunger.

Hyde's invitation to surrender everything was a tall order. I heard it as prophecy. Everything you hold onto too tightly will die in your hands. That sentiment was simultaneously liberating and punishing. Weren't there some things it was okay to hold onto? Like a toddler? Loving someone didn't mean possessing them. I *knew* that. I did. But when I nursed her—every morning she was with me, and every evening—she felt like part of my body, still.

On a frigid winter night, my friend Anna and I went to the Russian and Turkish Baths on Tenth Street. They were in the basement of an old tenement building in the heart of the East Village. We stopped for bone broth on the way, and by the time we descended underground, we were all set for rebirth. Our rubber slippers were large and loose. Our bellies were full of melted bones.

Anna was a magical person—a poet who also flipped silver antiques, a caster of spells, a woman who needed beauty as if it were food—and her son was just a few months younger than my daughter. She was married to a man she loved. At any given moment, I felt both the convergences and gaps between our lives acutely. That night, we both had babies who were somewhere else. At every moment they were not drinking from us, our breasts were filling up for the next time they would.

The basement baths were a den of saunas and steam rooms surrounding a blue-tiled plunge pool of icy water. At the end of the hall was a heavy wooden door that led to a dark cave called the room of radiant heat, lined with wooden benches that had absorbed the sweat of strangers for more than a hundred years. Now they were absorbing ours, and also the sweat of our silent companions: the tattooed hipster with a handlebar mustache who left occasionally to dunk his body in the icy plunge pool with haughty nonchalance; the impossibly thin old woman who looked like a once-ballerina, or a once-junkie, and seemed to need that hot room like a goddess needs a myth—a context in which she made sense. Laid out across the highest bench, a swarthy Russian grandpa with salt-and-pepper hair groaned under the sway and crack of oak branches slapped across his back.

Tucked away from the February chill, we were all strangers sharing the heat and the darkness, sweating and exhaling into the same thick air, our bodies shrugging and sighing, our toes curled and our foreheads beaded with sweat. None of us needed to speak. We were part of something together, something big and silent and many-headed. It held us all.

At the center of the room of radiant heat was a basin of cold water with a wooden bucket. Whenever I got unbearably hot, I filled the bucket with icy water and poured it over my head. How good it felt to need something so badly, then reach for it.

Oak branches and wet tiles and clanging pipes—all of it quivered and vibrated with pleasurable intensities. And still, none of it approximated the smooth globe of her little belly, the soft hiss of her breath just before her giggling began.

In those early months of separation, my friends became my family. Or perhaps it was truer to say they always had been. I'd often been a creature turned like a compass needle toward the intoxication of falling in love. Even in sobriety. Especially in sobriety. But the weave of my everyday life had always been girls and women: bean stews and freeway commutes with my mother; a tight crew of girlfriends in high school, when I felt utterly invisible to the brash, cackling boys leaning against their SUVs in the parking lot; a college best friend with whom I stayed up until dawn drinking Diet Coke and arguing about God.

Romance was what I'd always felt most consumed by, but my relationships with women were the ones I'd trusted more. They built and rebuilt my inner architecture. The version of myself made possible by conversations with friends was the self I most readily recognized—the self that demanded the fewest contortions.

My close friends were not all versions of my mother. Each was no one but herself. But with all of them, I found a version of the safety my mother first introduced me to: You don't have to keep earning me. I'm here.

One winter night I sat in the firehouse sublet with Kyle, my daughter's red-haired godmother, drinking licorice tea, our legs curled underneath us. The baby was asleep in her Pack 'n Play behind the closed bedroom door, her face buried in the sleek caramel fur of her stuffed fox. The front windows flooded with sudden splashes of liquid light from ambulances speeding to the hospital nearby.

Kyle had been one of my closest friends for a decade—from novels outlined on our walls, to that night together in the hospital, after my daughter's birth—but since my separation I'd sensed a subtle chill between us, like a winter bedroom with a window left open.

Tonight, I asked her about it directly. She explained that she'd needed to pull away. There was something upsetting to her about the divorce itself—she worried for my daughter, and for C, although she understood why I'd left—but it was more than that.

She explained this next part carefully. It was that she felt, in certain ways, fatigued by our friendship. I was always in the midst of some dramatic transformation: getting sober, drinking again, giving up booze for good; breaking up with Dave, getting back together with Dave, breaking up with Dave for good; falling in love with C, getting married, becoming a mother. Now getting divorced. I was always either poised at the threshold of some major change, or reeling in its aftermath. She said, "It gets exhausting."

As she spoke, I nodded—feeling hurt and also, recognized.

She was generous with me. She told me I'd been there for her, too—through novel drafts, breakups, loneliness. But as she spoke, I could only remember the times she'd been there for me, those long conversations in dark apartments, bringing the mess of myself toward her thoughtful questions, the solidity of her tender intelligence—expecting her always to be solid. After my final breakup with Dave, a year before meeting C, I came to stay in her Brooklyn studio and she played me silly music videos as we clutched our stomachs laughing. Why did a broken heart make Rihanna need to smoke *eight cigarettes at once*?

In her confession of exhaustion, it was easy to hear the echoing sirens of my own crises—how the volatility of my life was a noise that drowned out other frequencies.

Reading a biography of Susan Sontag that winter, I put three exclamation points in the margin next to a quote from her diaries: "I'm only interested in people engaged in a project of self-transformation." It summoned the pattern Kyle had described. But what did this pattern mean? Why did I keep pursuing these thresholds, even as I told myself I wanted something else? Maybe every rupture offered the chance to emerge as someone else, slightly altered, on the other side of each crisis.

Or maybe I wasn't seeking what lay beyond each threshold but the experience of threshold-crossing itself. Maybe it was easier to keep living with the fantasy of stability glowing on the horizon, perpetually elusive, than it was to dwell inside the experience of stability itself—its vexations and claustrophobia, its permanence.

That semester I kept talking to my students about revision. I told them, "Revision is like tossing sandbags off the side of a hot-air balloon!" I wanted them to stop thinking of it as tinkering and start thinking of it as flight.

In Elizabeth Hardwick's *Sleepless Nights,* perched on my nightstand like a jinx, one character asks another, "Don't you see that revision can enter the heart like a new love?"

Some writers hate revision, but I've always appreciated its clarifying adrenaline. It's like plunging into a cold lake, or a basement plunge pool. A challenge. A scouring. Not comfortable, but exhilarating.

There's a visceral buzz that comes from removing an unnecessary sentence from a draft. In its absence, everything else is crisper, starker, more alive.

In writing, these removals were a form of rigor. But in life, they felt like cruelty.

Before work each morning, I dropped my daughter with Soraya at the apartment of another couple: two warm, practical women whose marriage I began to worship, quietly and furtively, in ravenous glimpses. I was fully aware that my self-pity was turning their marriage into something more perfect than it was, as I observed them swapping fondly exasperated glances at their toddler's escapades—pulling books off the shelves, perching a teddy bear in the potted plant—and noticing small domestic tasks the other one had taken care of. "Thanks for sending my mom those sledding photos." Or, "Thanks for replacing the batteries on the turtle nightlight."

There were mornings when Soraya saw me crying, just for a minute, as I unpacked the Tupperware full of sliced avocado and the baggies of Goldfish for snack, or explained a shift in our weekly schedule. How had I arrived in a life that required these explanations? A life where I would not exchange fondly exasperated glances with my partner?

It wasn't a passive arrival. I'd been part of every choice that made this life.

The first time Soraya saw me coming out of the bathroom after splashing cold water on my face, she said, "I hate to see you cry. You have a good heart." I heard, *You surround yourself with yes-men.* The second time, she said, "Don't cry. I know you're strong."

The shame of crying in front of her was as much about privilege as exposure. The shame of feeling sorry for myself while paying another woman to take care of my child. The shame of expecting this woman to take care of me.

One afternoon on my walk home from the subway, I saw bitter melons at the fruit bodega, and bought a bag for myself, and another for Soraya, who liked to cook with them. That night she sent me a video of a swordfish stew simmering on her stove, with bits of bitter melon rind floating in the thick curry, and then laughed the next day when I showed her the disks I'd fried. I'd thrown away the most important parts, she explained, and cooked the parts I should have thrown away.

On my subway commute one morning, a guy with a guitar started playing earnest cover songs in the middle of a crowded car, eyes glistening as he hit a falsetto, "And I'LL BE your crying shoulder." Beside him, a teenager in regal red-and-black Air Jordans gave him the side-eye, shaking his head, and put on his bulky headphones.

For a moment, I let myself imagine C standing beside me. He would have loved all of it: the kid's raised eyebrows, his gorgeous sneakers, his quiet sigh as he slipped on his headphones to block out this terrible crooning.

Of course, I wouldn't tell C about any of it. We didn't have that anymore. But in that moment, I yearned to be his conspirator again.

Before our baby arrived, before we knew what we would name

her, we called her Baby TK. Like the publishing notation, TK, that signifies content that hasn't yet arrived. She was a character between us before she ever existed.

And after our divorce, I sometimes imagined Baby TK was living a parallel life, in an alternate world where we stayed together—where we were people cobbled together from all our best moments.

I could still see his grin when we entered that motel room full of Siegfried and Roy. We'd hit the road together when we were practically strangers, because we just knew. We knew what we felt for each other would change our lives.

Years later I thought, what do I do with that knowing now?

My daughter and I had our firehouse sublet for just a month. We needed a home.

In early March, I found a third-floor apartment nestled above a little café. The windows faced a massive American elm. The whole place felt like a treehouse. The sidewalk below was dotted with bistro tables like a rom-com set.

When I first saw the apartment, it was cluttered with cat towers dangling tattered strips of gray carpeting. The parquet floors were covered with hotel-hallway rugs. The floor sloped so much that the fridge and dishwasher were propped on wedges of wood to correct for the slant. But all this only made me love the place more. I would save the treehouse from these cat towers. I would save its parquet floors from those rugs. I was in a saving mood.

Once it was ours, I brought my daughter to the empty space and let her crawl around. I sat with my back against the wall, staring at the elm branches outside, heavy with green buds, thinking

it felt right to be moving into our new home in the spring, this season of rebirth—and then I heard wet muffled sounds coming from my daughter. She was chewing with a closed mouth. I pried open her little teeth and felt around. She gave me an accusing look and bit my finger, hard.

When I pulled out my finger, tiny bite-marks welling with blood, her mouth moved again in that odd way, almost circular, like a machine. Something was in there. I put my finger in again, swept the lining of her cheeks, and felt metal. Pulled it out. An inch-long screw.

The moral of the story was: Forget about the story. Just take care of your daughter.

That spring, my friends Casey and Kathryn, the ones who'd gotten married on Tilghman Island, drove up from Maryland with a set of power tools and helped me assemble my new furniture. They took me to Target for a knife block and a dish rack and cheap water glasses and everything else I needed to replace all the things I'd left behind.

Forget wedding registries, we joked. What about divorce registries?

Back in the treehouse, I covered the glass door leading to my daughter's bedroom with blackout blinds and dark paper, sprayed WD-40 on the squeaky hinges. I needed to make it dark enough for her to sleep. I was obsessed with her sleep. Her sleep was my freedom.

After her bedtime, the three of us curled up with our legs tucked beneath us on my striped brown couch and talked until we were yawning so wide we couldn't understand each other's

voices. It felt important to fill this new apartment with company, their bodies anchoring this new space like stakes pitching a tent into the ground.

For my own sleep, I bought a new bed with a beautiful head-board striped with diagonal bars of wood. It was the first bed I'd ever gotten from someplace besides Ikea. I got a violet duvet covered with dark-green palm fronds. The name of the pattern was "Boca." Nearly every married friend who saw it said, "My husband would never want to sleep under that," and there was envy in their voices, and underneath that envy, something else. The relief of living their lives, rather than mine.

A friend brought sage to burn, and we made wishes for my new home. I felt obliged to wish for something selfless—for my daughter to hit all her developmental milestones, or at least learn to shit in a toilet. But my friend proudly carried the burning smudge stick into the bedroom and said, "May great sex happen here."

Years earlier, I'd done a ritual with friends under a full moon in Wyoming, all of us standing in a circle, holding out empty purses and wallets, making requests of the universe. I asked for something that seemed mature—wishing for creative fulfillment, rather than external markers of success; something like that. Then the guy beside me asked for a motorcycle.

Which is to say: Don't want what you're supposed to want. Want what you want.

That spring, I took the baby to see Garry Winogrand's color photographs at the Brooklyn Museum. We parted a black velvet

curtain and stepped into a long gallery as dark as a cinema, with color slides projected onto both walls. A dark-haired teenage girl in a white bathing suit silhouetted against a bright blue sky. A little boy in tiny shorts putting his coins into a vending machine to buy a Coke. Old ladies playing cards in folding chairs on the sand. A woman propped on her elbows on a beach towel, with a blurry Mickey Mouse stick-and-poke tattoo on her arm and cat's-eye sunglasses hiding her mood.

It was a church of regular life, the slides like stained glass windows. Instead of showing saints, or biblical scenes, or the stations of the cross, they showed daily existence, quiet moments of loneliness, inscrutability, and pleasure. Winogrand had taken some of the early photos during the weekends he spent with his children after his own divorce, on outings to the New York Aquarium and Coney Island.

Winogrand once asked, "How do you make a photograph that's more beautiful than what was photographed?" But I didn't think he was making the world more beautiful. He was excavating beauty that was already there.

When I went to church as a girl, its beauty always seemed to belong to other people. The believers. They saw the same stained glass I saw, but when its jagged light fell on their skin, they belonged to that light in a way I never would. They could feel the lilt and soar of the hymns as a tin-can telephone connecting them to God.

Some version of that girl I'd been in church—with legs too long for her denim overalls, palms covered in half-moon crescents where she'd dug her nails into her skin—was summoned by these

photos, years later, for a different rapture. Some version of that girl felt that this was beauty she belonged to.

During my first weeks getting sober, when I was spending many evenings each week in church basements, I fell in love with these words from G. K. Chesterton: "How much larger your life would be if your self could become smaller in it. You would find yourself under a freer sky, in a street full of splendid strangers."

In that dark gallery, I found myself in some version of this street. On one side of me, clowns gathered beneath a sign advertising Dallas's finest hamburgers; on the other, flight attendants clustered on an asphalt divider in their powder-blue suits. These ordinary people literally gave off light. It glowed across the faces of the ordinary people watching them.

The otherworldly-but-lifted-straight-from-*this*-world beauty of Winogrand felt like relief from the ugliness and mess of my own life. Drop-offs were still volatile; a game of Russian roulette. My apartment buzzer was broken, and whenever C brought her back, he would text from the stoop to let me know they'd arrived. One day his first text didn't reach my phone, and I only got his next one, ten minutes later. It said, *been waiting downstairs for ten minutes.*

When I got downstairs and knelt beside her, he walked away, then turned back abruptly and spat. His spit landed just beside me, glistening on the red brick stoop.

Staring at it, I remembered our midnight vows in that absurd chapel: the silk upholstered walls, the golden cherubs. How had that faith held this rot?

It seemed clear that C's anger was protecting him from grief. It was like smacking your finger with a hammer to distract yourself from a migraine.

It took me longer to wonder if his anger was protecting me as well. Not in the obvious ways, of course. Being the object of his anger—silent and wide-eyed, fists white-knuckled and clenched—made me vigilant all the time, my shoulders hunched around my neck. But his anger saved me from looking directly at his pain, which would have been like staring at the sun.

More than anything, his anger buffered me from doubt. The angrier he got, the harder it became to imagine another version of my life in which I'd stayed.

It became a form of emotional hibernation, taking refuge in that binary: He's angry. I'm sad. But it was a lie. Under the Worm Moon, my anger blossomed everywhere.

In the shower, I ranted at the student in my program who was alienating the rest of his workshop. *I know you're hurt!* I said to him, tugging out my tangles. *But don't you see how your pain is hurting everyone else?* Slicing my daughter's cherry tomatoes, I raged at the newspaper editor who had changed all my sentences and then told me she'd need my edits by ten the next morning, London time. When I got up at four in the morning to work, the crackle of the electric stove woke my daughter in her crib. She was ready for breakfast. The moon was a crescent in the dark window behind her high chair.

"Bib," she said patiently, reminding me of the next step. "Boo-berries. Nana with peenbutter, *please.*"

How was I supposed to keep doing this on my own? I wanted to shake something, throw something, break something. Break something more, I guess. What did I really want? Help.

My daughter calmly sucked her two fingers, in and out.

I grabbed an apple from the table and hurled it against the wall. It hit with a mushy thud.

My daughter smiled, delighted, pointing: "Apple."

My daughter didn't seem cast in my image, but like a different creature entirely: sturdier, kinder. Better equipped to take a joke. She was a toddler, sure—but a selfless toddler. She was more like my guru than my child. But of course I couldn't say that to anyone.

To my mom, I said, "I think she's a lot more stoic than I am." After a pause, my mom said, "That's probably true."

What had I been expecting? A little pushback, maybe.

In a feedback letter to one of my students that semester, I wrote, *My daughter is my teacher.* Wtf? It wasn't just a parenthetical. It kept going. *Sometimes she feels like a river—and I'm the rock she's flowing around, shaping.*

Boundaries were not my strong point during the early days of my divorce.

Winogrand. I must have visited that exhibit thirty times. Mostly, I went with the baby. But I also brought anyone else who would come. I wanted to bring my friends, my friends' babies, my mother, my aunt, the exes I hadn't heard from in years. I wanted to bring my grandmothers back from the dead, so I could go with them.

Most often, I sat on a bench in the section called "Women."

In the early months of my separation, I told everyone in my life I lived on Planet Women. The women in these photos were a refuge, a solace, a womb. A flock of mothers I'd never had. One sat solo at a grimy diner table, hunched over a plate of eggs and toast. Another perched on a barstool between a slot machine and a Jack and Coke. Another smoked in her convertible, with the sun setting behind her and the wind whipping her hair. She made solitude look liberating, while others made it look like a grind. I knew the truth everyone knows, which is that it's both.

Whenever I told people I was living on Planet Women, I didn't just mean I was spending all my time with women. I was also trying to convince my friends, and myself, that I didn't want to fall in love. At least not for a while.

In truth, some part of me always wanted to fall in love. I was a creature designed to fall in love, over and over again. If it were possible to fall in love every single day, I would. I didn't understand why everyone else didn't feel this way, just like I didn't understand why everyone else didn't want to get drunk every single night.

But it was also true that I wanted to believe in another way of living—one that didn't lean so adamantly, so insistently toward romance.

Before my marriage, I used to tell people, "I've ended all of my relationships except for one," as if I were confessing to a shameful pathology, my inability to stick it out. When really it was a confession still caught in the claustrophobic logic it was trying to purge—this belief that there was power, or safety, in leaving before I was left.

Through all those departures, I held the Russian nesting dolls of prior selves tucked inside—the girl who'd watched my father mark his trips on our whiteboard calendar with a squeaky dry-erase marker; the sullen teenager, embarrassed to cry at his wedding to a stranger.

Sometimes I counted the men of my past like rosary beads. He loved me. He wanted to sleep with me. Even just, he looked at me. Even just, I came into being, for a moment, because I was visible to him. It was as if I'd won by making these men want me. But what game? For what prize?

After leaving my marriage, I felt—for the first time—such deep shame when I told people that I'd been the one to end it. I felt no safety, or power, in being the one who'd left. For many months I was like a deer frozen in the middle of a field, holding perfectly still. And when I stopped being a scared animal and looked around, I saw nothing but open winter fields, bleak and withered, full of all the pain we'd made.

It would be simpler if conviction burned away everything else. But it doesn't make consequences disappear; it just straightens your spine when you force yourself to look at them. Over time I came to wonder if my shame was actually just sorrow in disguise. My divorce was slowly teaching me that grief did not have to wear the clothes of guilt.

Near the end of high school, my father and I had a series of conversations about why there was so much distance between us. He told me, "At a certain point, when it was so difficult with you, I just said, *Fuck it.*"

It felt good to hear him say that. Not easy, but good—like the

bracing shock of cold water. At least we shared the same reality. And once we shared that reality, we could figure out what might happen next. People don't talk enough about this particular gift that parents can give their children, when they say honestly, *Here is what I did.* His honesty gave us oxygen. It gave us a way forward, a chance to outlive our distances.

So much was ahead. My dad showed up for the reconstructive jaw surgery I had at eighteen—he was crying as I was wheeled into the OR on a gurney, in a fizzy haze of nitrous-oxide cheer—and he showed up for my eating disorder in college, printing out stacks of scientific studies to help him understand. He showed up for my heart surgery, years later, when I came out of anesthesia in a foul mood and he sat beside my hospital bed anyway.

On the other side of childhood, I got to have my father—smart, funny, honest, flawed, loving, curious about the world, about the stars, about incredible feats in engineering, like the tower in Malmö called the twisting torso. He wondered about parts of the world I'd never thought to wonder about. He was always talking about retiring but never getting any closer to it. He pushed my writing on his colleagues like a second publicist.

In time, I came to see that our difficult years were just that. Years. Neither more nor less. They weren't everything. They were part of a longer story that we got to keep living.

When I told him I was getting divorced, he said, "What do you need?"

For weeks after my daughter and I moved into our new apartment, packages kept arriving from him. Kitchen supplies. Though he'd never really cooked in his life, he knew I'd left the contents of my old kitchen behind. So he sent a rainbow set of knives, a

rainbow set of spoons, a rainbow set of nested mixing bowls. My daughter was giddy—it was all the toys she'd ever wanted, in her favorite color, which was all the colors at once.

So there *was* a god. She knew it now, for sure.

That April, four months into my separation, my daughter and I went to Savannah to spend the weekend with a friend of mine, Jamie—a writer, a mother, a woman married for twenty-eight years to a man she was still in love with. To me, her marriage was like an exotic jewel. I wanted to inspect it from all angles. Twenty-eight years. What do you talk about? How often do you fuck? The fact that you fuck at all! They felt like gods to me, she and her husband. Gods walking upon the earth. Married for this long and still happy. That kind of happiness, I knew, was not pure. It was something better. It held the splinters of old struggles.

They lived on Lookout Mountain. It sounded like a place plucked from myth.

On the way to the airport, our Lyft hit every red light on Atlantic Avenue. The gray sky drizzled all over a windowless hourly motel. Our driver was named Linda. A few minutes into the drive, she said to me, "You seem sad."

"I'm doing okay," I said, then playfully tugged the baby's little foot, just to show how okay I was. The baby looked at me from her car seat, confused, as if to say, *This foot is mine.*

I asked Linda, "How about you?"

She wasn't going for it. "You sure?" she continued. "You seem really quiet." As if I'd been keeping something from her.

My daughter sucked on her two fingers beside me. Her bright

eyes tracked raindrops pearling down the window. Was I too quiet? Would most mothers spend the whole ride talking to their babies?

I said, "I'm just thinking."

"Yep," said Linda, confirmed. "You seem really down."

Just before getting in the car, I'd told my mother over the phone, "Today is a good day." But Linda had sniffed me out in a second.

"I'm splitting up from my baby's dad," I said. Why did I say it like that?

"I left my son's dad, too," she said quickly. "He hit me when I was pregnant."

"I'm so sorry," I said. "It sounds like you did the right thing."

She eyed me in the rearview mirror. "Did he hit you?"

"No."

"He in prison?"

"No."

"He drink?"

"Not for years."

She was quiet. I was quiet.

Finally, I said, "He's just really angry."

At the blue cottage we rented in Savannah, Jamie took cell phone videos of my girl taking fumbling steps toward walking. Jamie was a mother of four grown kids, an expert, so fluent in baby-everything it took my breath away. Watching her instincts with my daughter, her deep pleasure at my daughter's company, I wanted to absorb her motherhood by osmosis; maybe her marriage, too—take it like a Communion wafer on my tongue.

There was something nearly religious about the way I worshipped long-term marriages, especially marriages that still held not only love but genuine delight. When I saw what Jamie had given her children—two parents in love, raising a family together—it made me ache to know I would never give this to C, or to our daughter.

Still trying on that *our*. It lodged in the back of my throat—not something to dissolve, but something to abide.

Back home, as the weather got warmer, I took my daughter on long walks around Prospect Park, past the charcoal smoke and sizzling hamburgers of other people's barbecues. She rode like royalty in her stained and fraying carrier, close to my heart. She was getting heavier. She was almost a toddler. When we got home and I lifted her out, the dampness of her back and the dampness of my chest were matching continents of sweat. The residue of our bodies in proximity was an echo of all those months when there was no skin between us at all.

On the subway, I found myself leaking tenderness toward the unknowable strangers sitting across from me, playing *Candy Crush* on their phones and picking up their kids' dropped popsicles. Someone in a church basement quoted Plato: "Be kind, for everyone you meet is fighting a hard battle," which was not actually something said by Plato, but by a nineteenth-century Scottish minister. The quote's false attribution made me love it even more; like it had been trying to play dress-up in fancy clothes. I wanted to tell everyone on the Q train during rush hour, *I know you are fighting some battle! And you! And you!*

On days when I found myself locked in endless internal

arguments—the kind you keep litigating, even knowing you can't win—I would take my daughter back to Winogrand. His photographs let the world get large around my resentment. This felt more possible than "letting go" of it, and certainly more possible than resolving it. I could just show up in the hallway of strangers and let them surround it.

In recovery, people like to say, "Sometimes the solution has nothing to do with the problem," and Winogrand's photographs had nothing to do with my problems. They just reminded me of the ordinary, infinite world—how it was still out there, waiting. In that dim gallery, I knelt beside my daughter's stroller, feeding her Cheerios to keep her happy, and it felt so *right* to be on my knees in that darkened room, amidst strangers. Every one of them was fighting a hard battle.

The first time I went to see the Winogrand exhibit without my daughter was on Mother's Day. It was a Sunday afternoon, so she was with her father. I missed her seashell toes, the wispy brown curls at the back of her neck, her Cheerio breath. At the museum entrance, I reflexively went to the special stroller door. The lobby was full of mothers with their children. The world was always full of babies whenever mine was somewhere else.

The Winogrand photographs were also full of babies. A tattooed hand holding an infant in a periwinkle coat. Twins in a double pram, wearing matching white hats, wrapped in matching white blankets, their matching blue eyes staring wide—staring at me. A toddler in the park clutching a baby doll of her own. Even the baby wanted her baby close! Other photos showed the girl my daughter might someday become—hoisted up to see a city

parade, with long, coltish legs and double-buckled Mary Janes; or drinking a Coke in the shallow end of a swimming pool.

The faces on those walls were faces I would never know—now they were elderly, or dead—but on that day I needed them. Sometimes the solution has nothing to do with the problem, and missing my daughter was not a problem to be solved. It was something to be met with stunning, ordinary beauty, and then left intact—pain living behind the radiance, both its shadow and its spine.

On the days when I dropped our daughter at his apartment, C was usually waiting for her on his stoop. As soon as we reached his block, she would run to him, grinning, her tiny feet pattering along the sidewalk. He leaned down to swoop her up, then held her aloft and spun her around. He was delighted to see her. She was delighted to see him.

This joy, their joy, was part of her. It was part of our story, too.

One night at bedtime, my daughter told me solemnly, "Now I have to sing my little song." She grabbed the bars of her crib, standing in her pink sleep sack, and started jumping up and down. "Maaaaama's *wurk*-in! Maaaama's *wurk*-in!"

Where had she learned this song? From me, I guess.

She wasn't wrong. After she went to bed, I pulled out my computer. Often I read my students' essays. Sometimes I got so tired I could feel the blood pulsing against the inside of my skull, but their minds were good company—their intelligence and humor, the details of their lives, their voices struggling to figure things out. It all felt like abundance, like crouching inside the fullness of the world.

To a woman writing about living with chronic pain after a car crash, I wrote: "To me, the most compelling dilemmas here were the challenge of finding meaning in pain, the daily drama of ongoingness (life just keeps *happening*), and the elusive, maddening, absurd nature of maturity itself, especially this last idea—what it means to be an adult, to be self-possessed, to take care of yourself."

Taken out of context, this could have been an entry from my diary.

Some nights after bedtime I just spent a couple of hours returning emails. I would never return them all. Could I write a memo? Could I teach an independent study? Could I mediate a dispute? Could I stave off a walkout? There was always some legitimate need I wasn't fully meeting, and someone I was disappointing, as I clicked away at my keyboard in the darkened room outside my daughter's open door. She no longer liked it closed now. She wanted some of the living room light trickling into her bedroom. There wasn't really any part of the three-room apartment that felt separate from her. Sometimes I took my laptop to bed.

M. F. K. Fisher's daughter once said one of her strongest memories from childhood was the *click-clack* of her mother's typewriter after she went to bed at night. For the rest of her life, that sound made her fall asleep better than any other—made her feel at peace, at home.

Whenever I spent hours of childcare writing nothing but terrible sentences, I always felt like I'd failed my daughter—*wronged*

her, even—by squandering the time away from her. If I'd spent those hours with her, there would have been a moment, at least one, when she laughed so hard it lifted me out of my own body.

The goodness of being her mother felt absolute. The goodness of making art was trickier, more like quicksilver, marbled with vanity.

Every moment I spent away from her felt like a moment that needed to be redeemed—justified by making money or making beauty. Sometimes all I could hear was this unforgiving arithmetic. But sometimes I could hear something else, like static-crusted music between radio stations: the song of other mothers making. Their art was easier to believe in.

One Sunday afternoon, I went to a Wendy Red Star exhibition in Newark. One of my favorite parts of Red Star's art was the way her daughter, Bea, kept showing up in it. They posed together in living dioramas, and collaborated on gallery tours as performances; Bea wearing a docent's outfit that she designed and her mother sewed. A video shows Bea, maybe seven or eight, handling a pair of Crow moccasins as her mother says, totally matter-of-fact, "She's a working artist doing her thing."

Some of Red Star's early collaborations with her daughter rose from the simple fact of Bea hanging out with her in the studio. While preparing for one exhibition, Red Star found a stack of archival photographs that Bea had colored over. "When I saw them," Red Star said, "I immediately thought that it was the next step for the historical ideas I was working with." That was the beginning of Red Star's most famous work, archival photos covered

with wry annotations. *This strap holds my hair extension. I am not a fan of the white man.*

Imagine: your daughter draws on your images, and you don't think, *Fuuuccccckkkk.* You think, *What if?* Almost superhuman, but inspiring.

A friend of mine from recovery told me about getting frustrated while trying to meditate in his downtown apartment amidst the constant blaring of ambulance sirens. At a certain point, he decided to imagine himself *as a siren,* moving through the streets, turning in circles.

Rather than letting the noise derail him, he moved toward it.

On the train ride home from Red Star's exhibition, rattling between the sprawling factories of North Jersey, my friend and I discussed how much we'd both fetishized intensity in our twenties. Back then, intensity meant passionate love affairs and epic road trips, chugging Red Bulls in McDonald's parking lots at dawn while my boyfriend marked fart tallies on our dusty dashboard. In my thirties, intensity meant something else—figuring out how to teach a seminar when Soraya was home sick, and my daughter wanted every part of me; or figuring out how to keep ringing the buzzer at couples therapy, week after week, even when its shrill chime gave me a Pavlovian pang of anxiety.

My friend and I agreed that intensity had felt more cinematic in our twenties, but the intensity of our thirties was so much more layered, so much deeper, so much more... *intense.* We kept agreeing more and more emphatically, trying to convince ourselves.

In truth, though, part of me missed dashboard fart tallies. I missed highways at dawn, love so electrifying it made every radio pop song feel like a church service.

The full name of Wendy Red Star's daughter, I discovered, was Beatrice Red Star *Fletcher*. Right. She had a father, too.

As it turned out, she'd started collaborating with him at the age of three. This was in the bio I found on her artist's website. (Her website! She was eleven.) Her first collaborations with her father had been interviews. Bea told him about her dreams, "My brain doesn't go away when I go to sleep. Someone ate a molded carrot. Mama is arting in her workroom."

Mama arting in her workroom. Baby arting in her dreams. Papa arting in his interviews.

At first her father felt like an interloper, intruding on my fantasy of a mother and daughter on their own. The old delusion hummed inside me, somewhere—the more you were loved by one parent, the less room existed for the other's love.

But ultimately, her father arrived to say I didn't even understand my own fantasies. Because my deepest fantasy had always been a family. My deepest fantasy had always been a home where everyone was living, everyone was making, everyone was arting. This home was just harder to picture. It wasn't a place I'd ever lived.

Some part of me had always wanted an unbroken family—two cats in the yard, a fire in the hearth, heads resting on shoulders—but it always felt beyond my reach. So I clung to another fantasy instead, the mother-daughter dyad, because it was what I'd seen. On some level, it was what I believed was possible.

The night of my students' graduation reception that May, I couldn't find a sitter so I took my daughter with me uptown. We rode the subway to Harlem, and she sat in her carrier against my chest the whole time—for the rumbling train ride, the reception small talk, and even when I went onstage to give a speech. Once we arrived, my daughter didn't want to be anywhere but strapped to my chest.

On that wooden stage, under a vaulted marble dome, I blinked against the bright lights. My daughter was alert and curious. Her body vibrated in the carrier. Her eyes flicked around the room, absorbing all these people staring at us. Just before the end of my speech, she pulled the mic toward her and gave a sly little slow-clap, like she was telling me it was time to wrap things up.

Standing with my students afterwards, my daughter still perched below my chin, I talked about attention. I told my students how motherhood was sharpening my gaze, every single day, deepening my appreciation of the mundane, asking me to focus on the smallest—"Leslie," one of my students interrupted, "I think your daughter might be choking on a grape?"

That summer, there was suddenly a musician. It sounds absurd to say it like that, but there he was. One day Colleen texted to tell me about a friend of hers who was a fan of my work; he was coming to the city and he wanted to have coffee. I told Colleen I had no time for coffee with this guy. She could tell him I was a single mother and I was teaching full-time and taking on extra gigs to pay my divorce lawyer and I never had enough time, etc. etc. She

said, google him. I googled him. I wrote back to say I was free for dinner that Sunday.

When I walked up to Veselka, the East Village pierogi joint, he was standing outside with two suitcases. He was taking a red-eye to London that night. He was six foot five and his chest was all ink under his flannel shirt. His Vans were checkered and old. His voice was tar on gravel. It was sex. He called himself a professional tumbleweed. He played torch songs in dive bars all over the world. When he wasn't doing that, he lived in Phoenix.

This was June. I was wearing cutoffs for the first time in a long time, even though it wasn't quite warm enough. It was an aspirational gesture.

Over sauerkraut, the tumbleweed told me he was headed on a six-week tour through Europe, staying with fans along the way: an innkeeper on a remote Scottish island; an earnest young fan in Barcelona who'd offered his couch. The tumbleweed wrote songs about being a ne'er-do-well bachelor with a restless heart. He had a guitar in pieces in one of those suitcases, just waiting to get reassembled. He had a tattoo of a mermaid covering the pale white cutter scars on his arms. He had the name of a married woman tattooed on his collarbone, and some kind of hobo symbol tattooed on his ring finger. It was a way of saying, *Never*. He was a quilt of red flags stitched together. He seemed almost pathologically honest. He said that whenever he toured, he always ended up in a bunch of strange women's beds. He used the word "tour" as a verb more than anyone I'd ever met. For example, he asked, "What's it like when you tour?"

"Less sex than your tours," I said. "More baby food."

He was interested in that reply, neither bored nor dismissive.

He wanted to know about nights of sitting on toilet lids in hotel bathrooms, eating plastic tubs of salad and listening to the gravel waves of sound coming from my baby's white noise machine. He wanted to know about purses smeared with green paste when I forgot to screw the cap back on a food pouch. He wanted to know how I managed mothering and traveling. It surprised me that he cared. I cared—surprise!—about him caring. He confessed that he was nervous. He wanted to make a good impression. He told me about the stray cats he'd nursed back to health, the tiny baby mouse he'd found and adopted (a *mouse?*), how he'd fed it droplets of milk from the end of a toothpick, watched it suck the tiny wooden tip like it was nursing.

He made me laugh so hard that I tried to remember the last time I'd laughed that hard. He said he never wanted to have kids, because he knew he wouldn't be a good dad. I thought, *How could you know? That's just a story you tell yourself.* But he loved being an uncle. The summer before, he'd taken his four nieces and nephews in a camper van to a big family reunion up in Saskatchewan.

Improbably, he and I were both descended from Saskatchewan farmers. Now all this sturdy agricultural DNA had arrived in the vessels of our matching lanky bodies, as we turned "tour" into a verb and ate our East Village pierogi.

After dinner, we hugged for a long time in the bike lane on First Avenue. His hand was almost obscene on the small of my back.

As I watched him load his suitcases into a cab and drive away, everything I needed to know was right there: the chemistry like a line of cocaine, the suitcases announcing his imminent departure.

I didn't realize how long I'd been standing in the bike lane until a man whizzed by and shouted, "Get out of the way! You're going to get hit!"

He texted from the cab, *Well, that was amazing.* He texted from the plane before takeoff, *Still thinking about you.* Each text was another hand on the small of my back. He sent me one of his music videos, *in case you're curious.*

A few days later, Kyle watched it with me, smiling. "It's all footage of him with his shirt off, being kind to animals!"

I was protective, protesting. He was also driving through the desert! He was also on a tense cell phone call in a laundromat! He had many layers, I was sure. Many selves. I wanted to know them all.

Kyle wasn't wrong, though. I remembered his stray cats, his suckling baby mouse.

Sometimes the world is heavy-handed like this: the straight hit of sex and the suitcases, the hobo tattoo on the ring finger, the stranger literally yelling, "Get out of the way!" The blaring marquee telling us which movie will play.

Except that's the easy narrative. The truth was something more complicated. I liked his mind, his voice, the way he laughed. He woke up something still alive in me, ready to thaw.

The tumbleweed kept texting from the road, sending dispatches about the night he played to a living room full of middle-aged smokers sitting on plaid couches in a haunted hotel on a Scottish island; the night he made a towering, burly bearded man cry; the night his dinner was just an avocado sliced in half with a

credit card. *The road is pure loneliness,* he wrote. *Or rather, dying of loneliness & dying to be alone. It's perfect for a sober alcoholic because you only feel bliss or terror.* He was a self-dramatizer who was aware of his own drama. I recognized myself in his preemptive self-awareness.

We started texting every day, every hour. We had simultaneous threads running on text and WhatsApp and Gmail. *We are deep down the garden of forking paths,* he wrote, *where everything you send to me makes me want to respond with three other things. You make me go into some woo woo shit like we were twins in a past life.*

The first thing I did each morning, before allowing myself to check for a text from him, was nurse my daughter. Although she was almost eighteen months, we still nursed when she woke, and before she went to sleep. It was only after I'd begun the day like this, with her, that I let myself read his messages.

It felt shameful to be only half-present with her because I was flirting with a man across an ocean. Like I'd forgotten what decade of my own life I was inhabiting. Often, I would put my cell phone in another room and not check it for hours. But keeping my phone in another room was also a way to increase pleasure by delaying it, like the experiment where kids who waited to eat their marshmallow got a second one. If I delayed checking my phone, it would be full of marshmallows.

Back when I drank, the anticipation often felt even better than the booze itself—knowing I'd get to start drinking at the end of a shift, or when the sun went down, or before the sun went down, or when the apartment was empty. It felt so good to have a horizon of relief. A reward.

The tumbleweed was sober, too. But his sobriety involved mushrooms and acid and ecstasy and sometimes DMT. At a certain point, I said, "Maybe it's easier if you just tell me what you *don't* do?" But I didn't judge. I'd been humbled enough by dependence to realize it worked differently for everyone. Everyone survived on his own terms.

Plus, I still felt addicted, too—addicted to playing emo songs on repeat like a teenager and fantasizing about the impossible life that the tumbleweed and I would never live together. In this life, he would decide that instead of getting the vasectomy he'd wanted for years, he would marry a single mom raising a toddler, and maybe even have another kid with her. I still carried this fantasy—having a partner, and raising children together—like a secret stowaway. But it felt dangerous to let myself want it, because I wasn't sure I'd ever get it. Some part of me didn't think I deserved it.

Still, I fantasized about the tumbleweed playing songs for our kids on his guitar, telling them the story of the night we first met. Even my daydreams hit a wall pretty soon, though. I cringed to think of him hating the tedium of meeting a child's needs, over and over again; cringed to think of him longing for the road again, the beds of strangers.

At twenty-two, I would have been desperate to make him want all the things he'd never wanted. By thirty-five, I'd learned you can't make anyone want anything. That was what I told my therapist, anyway. In my heart, I said, *Maybe you can? Let me try.*

On my birthday, my phone buzzed as I was walking away from a tense handoff, and I was sure it was an irritated text from C.

But it was actually the tumbleweed's tiny face in a square with a play button. I played his video right there on the sidewalk, leaning against a metal fence, too eager to wait. He was wearing a blue flannel shirt. His voice was goofy and warm; I could see the streaks of silver in his hair. "You're older today than you've ever been!" he said. "So am I." He pulled out his guitar and played a song for me, a stripped-down cover: *I see you all the time in airports / In the windows of the shuttle trains...*

His voice cracked with tenderness. It was so good to remember that someone could still think the best of me. To see the gaze of someone I hadn't yet disappointed.

That June, Colleen and the baby and I went away to a cabin in the Catskills. Driving up on a Friday evening, we were flagged down by a group of Orthodox Jewish men walking along the dirt shoulder of a country road. It was the Sabbath, and they needed help turning on a light. They asked if I would come with them, and gestured toward a narrow path that disappeared into the woods. I glanced at my baby in the back seat, sucking on her fingers like a lollipop.

We were tucked inside the logic of a fairy tale: two roads diverged in a wood. One led to a mitzvah and the other to gang rape. But I wanted to believe that the universe was an entity with benevolent intentions. That was one of the things Colleen and I shared—an instinctive, sometimes foolish faith in people; permitted by the ways in which the world had generally been kind to us. So I went with the men, lighting our way through the woods with my cell phone. My stomach was clenched. My palms were clammy. I hated that I'd been unable to simply say no. Instead,

I'd left my baby in order to walk into a dark forest with a group of men I'd never met.

As we stepped into a dark barn, tucked beneath the trees, one of the men pointed to a cord hanging down in the middle of the room. When I tugged it, the room was flooded with light.

During our days at the cabin, Colleen wrote while I followed my daughter around all day and watched her pull tampons from our toiletry bags. "My little bars!" she cried, spreading them across the floor. I texted friends a photo of her standing up in her travel crib, with greenish water barely visible behind her. *Today she's not-napping by a scenic lake.* I looked at Colleen writing on the deck and thought, *That used to be me.*

One morning, I took the baby to a trail that was supposed to lead to a waterfall. We Were Going For A Hike. Wind rustled the oak leaves above us, rattling their lacy shadows. No more than five minutes after we started, she was crying. She wanted out of the carrier. Specifically, she wanted to return to the basketball courts near the trailhead. She wanted to run the length of the asphalt over and over again, beside a rusty chain-link fence, under the ruthless sun.

She ambled along a faded line of white paint, swaying like a drunk taking a straight-line test. "I have feet!" she said. "I have two feet!" Her tiny sneakers stuck to the melting seams of tar oozing in the midday sun.

I considered texting my mother a photo of the bright green hillside, *Went for a hike.* Because we had, for a few minutes. Texting photos was a way of offering evidence to the world that I'd managed to keep my child alive for another day, that I'd tried to

bring her close to something beautiful. Her living body was evidence, too—and it would survive to be kept alive for another day, and another day after that.

Midway through the week, I drove down to Brooklyn to take the baby to C. Then I turned around and drove back to the cabin. The next morning, I got up before dawn, made coffee, and stared at the document on my laptop screen. I thought about texting the tumbleweed in Scotland. Then I put my phone in the other room, and stared at my laptop screen a little more. *You are not picking up twenty tampons from the hardwood floor,* I told myself. *You are not searching for a trash can to throw away a diaper bundle heavy with shit.* It was time to be a fierce and wild creator.

When I eventually got my phone from the other room, I didn't let myself return any texts from the tumbleweed. Instead, I pulled up a video of the baby pulling the shower curtain in front of her face. *Where's the baby, there's the baby. Where's the baby, there's the baby.*

Down in Brooklyn, was she narrating her life in the third person to her father, as she did for me? *Baby having a little avocado. Baby having a little fart.* She would spend her entire childhood having another home that wasn't my home.

Then my therapist's voice arrived, *You can see the trailheads of these thoughts, but you don't have to follow them.* I literally cocked my head to hear my therapist better, as if she were calling to me from the other side of the lake. *Trailhead* took me back to the green hill, the claustrophobia of that heat, running back and forth after her little swaying body, along the chipped white line of

paint across the asphalt. It all seemed unspeakably beautiful, now that it was no longer happening.

I hurled myself at the computer screen with compensatory fervor. If these hours were not being spent with my child, they had to earn their keep. I chugged seltzer after seltzer and periodically checked my word count. It was only because of C that this solitude was possible, and it was a strange sensation—to feel grateful to him; to know that we were raising this child, in this broken way, together.

For the first time in years, I was writing fiction—scenes with an artist father and his estranged teenage daughter. She was staying at his run-down house in the Texas desert. When she opened the fridge, I pictured the empty fridge in my father's apartment. A prior version of me might have been entirely swallowed by the girl's perspective, her resentment and desires, but now I found myself curious about both characters: the daughter's discomfort at waking up in a bachelor's house—quietly opening all the cupboards, not sure if there was anything to eat for breakfast—and her father's anxious uncertainty. How much did he need to entertain her? Did he need to buy her tampons?

To lose time, to lose myself, to lose the tight orbit of my own looping thoughts, just for an afternoon—these were the things I'd once wanted from booze. But it was always writing that offered the purest version of this surrender.

Eventually, though, I always texted the tumbleweed.

Wanna hear your voice, he wrote. So he called. My feet dangled in the wind-rippled lake as the low vibrato of his voice rumbled

through my body. He had a cold, and his congestion felt impossibly close, like humidity. I imagined taking care of him, feeding him spoonfuls of steaming broth the way I fed my daughter little spoonfuls of yogurt. Every once in a while, I glanced over my shoulder just to make sure my daughter wasn't stumbling down the hill, as if she'd driven three hours from Brooklyn just to scrape her knee while I wasn't looking.

It felt tender, almost intoxicating, to imagine taking care of the touring tumbleweed—wiping the cold sweat from his tattooed chest, urging him to ease off the torch songs until he got his voice back, bringing him trays of chicken noodle soup and psychedelics. All the resentment baked into my marriage had made me yearn for a partnership in which it felt easier to take care of each other, to access that part of myself that knew how to accept help, and offer it.

It started raining as we were talking on the phone, and I ran for cover under the awning of our cabin—stood there with my wet hair as the rain brought smells from the soil, from the grass, from the trees; bringing out the secret, earthy odors of the world.

The tumbleweed kept telling me that he couldn't believe how hard he was falling for me, and how hard I was falling for him, despite the raw wound of my divorce, which I'd told him plenty about.

"I really admire how open you are," he said.

But this praise, or whatever it was, made me feel a twinge of shame. Being a bit aloof, or withdrawn, seemed like a more elegant response to pain. Instead, I was like a child who'd been burned by a hot stove but hadn't learned anything. I just kept touching it.

Later I texted, *Sorry to bring you into the Chernobyl wreckage of my divorce.*

Not exactly Chernobyl, he said. *Everybody's got something.*

When I texted him a selfie from the dock, he texted back immediately, *gonna finger you in that lake someday.* The message banner momentarily blocked my daughter's eyes in my lock-screen photo and I swept it away, insulted on her behalf, but also wanting him to text again, to say the other things he would do. He always texted. He always texted back quickly. These were the forms of presence he was good at. I would learn about the others.

At dusk, I sat with Colleen as the sky darkened over the lake. We read each other what we'd written that day, just like we'd traded paper-clipped essays fifteen years earlier. Back then we'd been kids in our early twenties, drinking instant coffee in attic apartments after long nights soaked with booze and smoke, but also sliding those manuscripts across crumb-covered café tables, saying, *I think this might be, I don't know, something?*

Being with Colleen helped me feel composed of something besides the brute, tedious particulars of my divorce. In her company, all my prior selves were present—that twenty-two-year-old stabbing forkfuls of scrambled egg into a smoky mouth, the single woman living above a smoke shop, getting by on the apps and an adjunct teaching salary, perched on the kitchen counter eating ice cream during our midnight talks. With Colleen, these prior selves got to exist, too, reminding me that I was more than a mother following a trail of tampons like bread crumbs, or a divorcée full of looping and reiterated grievances.

That night, Colleen read me an essay she was writing about

settling into a new married life in Egypt, where her husband worked as a photographer—how he was teaching her Arabic, how they were finding ordinary daily rhythms after their winter wedding in the mountains—and I felt her prior selves gathered around us, too, like a spectral dinner party: the heartbroken thirty-two-year-old, newly single and very gaunt, subsisting mostly on green apples; the exuberant twenty-four-year-old who had better winter boots than I did, because she'd grown up in Buffalo rather than LA.

Almost every part of me was right there with her, following every cadence of her voice, except for that one small part of me that was still standing on the basketball court, in the ruthless midday sunlight, watching my toddler follow the faded paint, wishing I hadn't taken any of it for granted—her gleaming pigtails, her drunk-person swagger, the holy pitter-patter of her tiny Velcro sneakers as she hopefully, fruitlessly chased her own shadow.

That summer I was ravenous for the world—for stoop chats on hot nights, and endless seltzer at my kitchen table, next to the open window, listening to the anonymous soap operas of strangers on the sidewalks below. I'd never felt more seduced by the city, more grateful to it. I was determined to treat the divorce not as life paused, but as life happening. Every feeling was a fucking miracle. I wanted to believe that maternal love could be bolstered by everything else you longed for—friends, work, sex, the world—rather than measured by your willingness to leave these longings unanswered.

Wednesdays and Sundays started to feel less like proof I wasn't

fully a mother and more like freedom. Maybe it was okay to want what I wanted: long nights with friends, or solitude for work, the stillness of a Thursday morning spent drinking coffee at my kitchen table, chewing on pen caps and listening to strangers' voices rising from the café tables below, where twenty-somethings drank cortados and read Nietzsche before their restaurant shifts. Someone said, "It didn't end when colonialism ended." Someone replied, "Who said colonialism ended?"

Sometimes the sudden sharp cry of someone else's newborn reminded me my child had woken in another home. As if I'd ever truly forgotten.

Our custody schedule made me feel as if I were shifting back and forth between the spectral bodies of my parents. Most of the time I was my mother, the bedrock of our baby's life; but two nights a week I was my father, or how I'd come to imagine him: untethered, able to stay out late, or throw myself fully into work, rather than carefully arranging my time, my energy and attention, around the endless needs of another. It felt like cheating. It also felt good. Expansive. Intoxicating. Free.

One Sunday night, a friend took me to a drag show in Astoria. We arrived at a packed club humming with sweat and celebration. We watched a towering queen in a black lace corset fellate a long red balloon. We watched another queen strut with fake pearls and a teakettle, wearing a curly mint-green wig like an eighteenth-century French aristocrat. When a big-busted femme with dark eyeliner held up a sign that said, *Ask me about my tuck,* I absolutely wanted to ask a thousand things. I wanted to ask the

162

world, *What's happening next?!!!!* And I imagined my question as a text studded with emojis: a comet, twin dancers, an exploding brain.

When the queens towered above us in fringe dresses and plastic heels large enough to be fish tanks, sweating and dancing in leopard-print skirts and pink capes, it all felt like permission and exhortation. *You are alive. Be alive.*

Many nights that summer, friends came for dinner after bedtime. As my daughter murmured herself to sleep in her dark bedroom, curled up with her stuffed moose, I pulled my kitchen table away from the window and dragged her high chair into the bedroom. I cooked whatever dishes I could make quickly and quietly: coconut fish stew, or roasted vegetables that left the whole room pulsing with oven heat. I'd crack the window and listen to bantering teenagers and squealing garbage trucks on the streets below; I'd watch the line cooks smoking outside the Chinese restaurant across the street.

My friends stayed late, ate lots, drank seltzer, told long stories about accidentally pulling the fire alarm at a Montreal bathhouse, or watching saltwater cowboys herd ponies across a bay, or getting stopped by a customs agent for having too much jam. Was too much jam a crime? It was thrilling to think so.

Once everyone was gone, I washed the dishes in a bleary trance, letting the hot suds run across the backs of my hands, balancing the dripping dishes in jigsaw formations on the wooden rack. *Since it was her own cabin, in her own little ship, she tidied it up with joyful hustle-bustle.* Then I pushed open my baby's bedroom door—still squeaky, no matter how much WD-40 I used—and

watched her sleeping body curled like a chubby comma in her el-
ephant sleep sack, her chest rising and falling with the rhythms of
her breathing, the shuddering of her invisible dreams.

Meanwhile, the tumbleweed and I kept building our
popsicle-stick castle. Anytime one of us didn't hear from the other
for more than a couple of hours, we immediately got anxious.
We were like two babies who hadn't learned about object perma-
nence. Or really we were just a pair of sober alcoholics. Without
booze or drugs, how else was I supposed to feel intoxicated besides
falling in love? Without a new dopamine hit of affection—every
hour, every minute—how was I supposed to keep existing at all?
He wrote, *It feels impossible for us to do anything but wake up and
frantically check our phones.* We fed our WhatsApp thread like a
fire in the hearth.

When I told him about C's anger—the cursing, the
spitting—he got angry in response. "It makes me so mad I want
to punch something," he told me. "I just get this deep, boil-
ing rage."

Yes, I'd think. *More.* I wanted someone to rage on my behalf.

Then we'd hang up, and I'd feel as if I'd binged on junk food
but was still hungry for something else—for whatever anger
reached toward, but couldn't quite touch.

Whenever the tumbleweed sexted, it was like getting a message
from the hot junior who sat in front of me in trig class back in
1997—as if he'd traveled through time, into the depths of my ado-
lescence, to tell that invisible girl she wouldn't be invisible forever.
The tumbleweed sent me an article called "Hot Cat Daddies,"

which featured a close-up of him holding his disabled calico cat in a tight embrace against his tattooed chest. *Lol,* he said. But he loved it. He was so committed to his own mythology—living in the well-worn jeans of a certain sense of self—that I had trouble believing it.

The tumbleweed joked that he liked me so much he would even be willing to watch bad Michael Crichton adaptations with me. He teased me for being so charmed by their cheesy impossibilities—breathing thick fluid at deep-sea research stations, or resurrecting dinosaurs from mosquito blood trapped in amber. When would we watch these movies? When would we even be in the same city? This was a question we started asking each other all the time, though it felt easier to exchange forty text messages a day than answer it. He was thinking about coming to New York at the end of July, on his way back from Barcelona.

Talking to him felt cozy and illuminated, like settling into the passenger seat for a long road trip, the car packed with gas-station snacks, rolling prairies beyond the windows, the buzz of everything ahead. Sometimes I flashed back to that early road trip with C, eating salty bacon at a roadside diner and rushing back to our table from the bathroom, because there was so much to say—because I wanted to keep listening to him describing his Vegas childhood, driving behind Caesar's Palace with his dad as they listened to boxing matches on the car radio, or building his own makeshift boxing arena in the backyard of his parents' home. Whenever I imagined that young boy, scrawny and dreaming, my breath caught in my throat. I'd wanted to protect him, and instead—in the end—I'd only caused him more pain.

The endlessness I'd felt in that roadside diner had seemed like

a promise. Now I knew better. Almost every sense of endlessness had an ending.

In addition to our gushing WhatsApp exchanges and our breathless phone calls, the tumbleweed and I also had an email thread that effectively became our emotional superego. *I'm aware that you're a single mother with a small child,* he wrote. *And that I'm a quasi-homeless touring musician who has worked his entire life to avoid the same responsibility that you've taken on.* We both believed in the drama of our own anxiety as a talisman that might stave off disaster. He wrote, *It's like that Borges story where the guy tries to prevent his execution by imagining every possible scenario for the execution that ends in his death, knowing that things never turn out to be how we imagine them.*

But who were we kidding? The doom embedded in our premise was also fuel. We both liked turning ourselves into stories. Even our impossible future was a story we were writing together. *I want your morning breath and your however-many-scars,* I wrote. *I want the messy five-hour truth under every dime-store gag you've got for all the things that ever hurt you.*

When I talked about the tumbleweed with friends, I'd say, *Oh, I know we're doomed,* but only because I imagined us in a movie where the main character says, *I know we're doomed,* and that means they aren't doomed, after all.

That summer, I was invited to a literary festival on Capri. This invitation was like the universe answering my emoji-studded text, *What's happening next?!!!!* Back home in Brooklyn, my mother stayed with my daughter. Once again she made it possible.

It was early July and the island was almost comically beautiful: lemon trees beside the funicular railway, white laundry snapping in the salt breeze, a dirt path covered in fallen bougainvillea flowers, a set of stone stairs down to the sea. At night, I stuffed myself with tender fish full of tiny bones, then let my sunburned skin slough onto the cool white sheets. At the hotel breakfast buffet, I scooped honey from an actual slab of honeycomb. Thirty-six years old and all I wanted was dessert for every meal.

Near the central piazza, off a cobblestone alley, I found the only shop on Capri that sold cigarettes. I smoked them at dusk on my balcony, counting yachts in the harbor. The largest one glowed blue at night and belonged—I was told—to the richest steel baron in Russia.

I'd started smoking again, maybe a few cigarettes a month, always on nights I was away from my daughter. The part of me that smoked—that still needed this last, slender vice—felt far away from the parts of me that took care of her.

Each day at dusk the piazza filled with tourists sporting Prada bikini cover-ups and visible facelifts. Young honeymooners captured the same sunset for their respective Instagram feeds. There was a time I would have judged those couples, fixated on their separate screens, but on the cusp of my divorce I was humbled by any functional romance. I just thought, *Whatever works.* I wished them well in their relationships to social media, and to each other. I thought, *However you fucking survive this.*

The tumbleweed called it a holy terror, the way we were falling for each other so fast. Back in New York, I'd been having conversations with my therapist about escalation, how I used it

as a buffer against the fear of being left. Then I'd leave her office and talk to the tumbleweed about how we'd probably known each other in another life. If it was a holy terror, I wasn't terrified enough.

Amidst the honeymooners of Capri, I was selectively forgetting how many ways falling in love could go wrong. My heart was a dumbstruck amnesiac sailor who'd been shipwrecked in paradise. My fingers smelled like smoke. My mouth felt full of little fish bones even when it wasn't. My body could still remember leaning into the tumbleweed's tattooed chest when he hugged me in the bike lane, both of us full of pierogi and blind hope.

He was trying to be honest with me, he explained one night on the phone. He'd struggled with monogamy for years, and finally given up on it. And I heard him, but I also didn't hear him—or else I thought, perhaps, I would be the exception. That stubborn desire to be the one who breaks the pattern is like Chekhov's gun hanging on the wall in the first act. You know that a few acts later, this desire will end up hurting someone.

In an Amichai poem I loved, about two lovers trapped inside an apple, one tells the other, "I trust your voice / because it has lumps of hard pain in it / the way real honey / has lumps of wax from the honeycomb." I trusted the singer because his arm was scored with scars he'd given himself. When I gorged on the honeycomb at breakfast, the wax got stuck in my teeth. When I smoked on my balcony above the sea, I couldn't get enough of the singer's disembodied voice telling me about the things he was going to do once his plane landed in New York. "I'm going to take your body to the edge of what you can handle," he told me.

It wasn't a phrase any man had ever used with me before, but I was sure he'd used it with lots of other women.

He did a lot of ecstasy somewhere in Wales and texted me heart emojis all night long. I tried to give myself the same permission I'd given those honeymooners Instagramming sunsets on the piazza. *However you fucking survive this.*

The tumbleweed told me he loved the Welsh word *hiraeth*, which—like many of the best words, it seemed—could not be fully translated into English. But *hiraeth* meant, loosely: yearning for a home that no longer exists, or maybe never existed at all. The musician said it was how he felt about me—like I was some long-lost home he hadn't even known he had. I heard the sense of homecoming in his sentiment, more than the impossibility.

But really *hiraeth* felt less like a description of our relationship and more like a description of the way I grieved my marriage: missing not what it had been, but what it hadn't been—what we'd both hoped it would be.

On Capri, my breasts ached for my daughter. They were swollen with milk meant for her. Everything that felt like freedom about being away from her also felt like recrimination. It was like I didn't deserve her, if I ever enjoyed being away from her. But I did enjoy it. Alone, released from gravity, my body floated on the moody blue sea. Afterwards, I lay across the flat, hot stones, letting my hair dry in sticky clumps like salted pasta. All around me, the Mediterranean was brazen in its blueness. It was not apologizing to anyone. It wasn't justifying why it deserved to absorb sunlight or reflect it.

The stink of having harmed another person felt like a body odor I couldn't wash away, no matter how long I swam. It was the smell of my survival.

My ears rang with the words he'd yelled at me in vestibules while I held my baby. Our baby. The pronoun itself—the truth it held me accountable to.

It was easier to think about the man of many emojis. Our holy terror. The two words in that phrase were like a pair of scared kids clutching each other in the dark. What I felt for him wasn't holy despite the terror, but because of it. Pleasure couldn't wait until pain was done, and the honeycomb wouldn't last forever. I had to grab it while I could.

My last night on Capri, I found myself sitting at the end of a long dinner table with three older Italian women, all wearing bright silk blouses—scarlet, coral, indigo—that rustled against their sweeping, gesticulating arms. All of them were smoking. All of them were divorced. It was nearly midnight, and the table was covered with the remains of our feast: vermicelli tossed with sea urchin, ravioli stuffed with zucchini flowers, sea bream with stewed cherry tomatoes.

One of these women, an artist, heard I was getting divorced and told me: "You'll get to the other side eventually, and you'll be glad you are there." It was something I'd heard a hundred times, but I'd never heard it from an Italian artist by the sea, this sudden godmother, her silk sleeves murmuring in the wind. It felt as if I were getting inducted into a secret, sacred order of divorcées. We smoked everlasting cigarettes and ate tiny breaded sea creatures. We listened to water breaking and shushing against the rocks.

The artist told me she was painting the women of Dante's *Divine Comedy*. She told me about her portrait of Manto, the fortune teller who'd been punished for predicting the future—which was God's job, not hers—by having her head twisted around to look backward for eternity. In the portrait, you could see her bare torso, and—where her face should have been—a dark, animal curtain of hair.

It made me think of all the ways I'd turned away from C—even as I'd shown up like a diligent student for our years of counseling, picked up the clutter in the living room, given birth in the middle of a blizzard. But behind that woman showing up for daily life there was always an apparition lurking in our home. It was the back of a woman's head, her long straight hair, her gaze seeking another life, one she couldn't quite see.

When the tumbleweed finished his gigs in Europe, he would fly to New York. It would be the first time we'd seen each other since that dinner at Veselka, six weeks earlier. He was arriving at the Newark airport on a night my daughter was with C, so I took three trains to meet him, whisking through the darkness while my earbuds pulsed with the music I loved that summer, the sadcore dream pop where subtlety went to die. My life was barely my own anymore; I shared custody of all my feelings with Spotify.

In the International Arrival lounge, I got teary watching families reunite—their long embraces, their bodies hungry from absence. The tumbleweed and I texted constantly as he got off his flight, went through immigration and customs. I hadn't known it was possible to feel this young and silly again. It was a gift.

It pleased me to take care of him, even in the smallest ways; bringing him a bottle of water from the airport gift shop.

When he finally put his arms around me, it felt less like *hiraeth,* and more like I'd drawn a door onto the wall of my life and stepped through it. It hardly mattered what the other side was like. It just mattered that there was more behind the wall—that it was possible to draw the door.

During our two days together in New York, it was thrilling to see the unfamiliar tumbleweed in all my familiar places— sitting in his flannel pajama pants beside my treehouse windows, or walking toward me on Flatbush with his arms full of bodega seltzer. He was for sure the largest human being who'd ever sat at my kitchen table. When we ordered take-out sushi, he said, "Get me the lumberjack special." What? He just meant the order that came with the most rolls. He sat on one side of me—with his hazel eyes, the long scars on his arm—while my baby sat on the other side of me, in her BABY BLUE CHAIR, which she referred to only in an all-caps voice, digging her baby spoon straight into the peanut butter jar.

We had only forty-eight hours before his flight back to Phoenix. The days were sticky with heat. Nights came late and lasted a long time. A stick of burning sage had asked the universe to bring me sex, and here it was. Here was my motorcycle.

The first night, we slept like forks in a drawer, long and thin and tucked together. The second night, he curled away from me partway through the night and I immediately took it as an omen. I treated every moment as an omen. When we started watching *Sphere,* the Crichton film we'd been joking about, it was even worse

than I'd remembered. Where was the part where all the underwater scientists train themselves to breathe liquid? Turned out it was from another movie entirely, though I could recall the scene vividly, the scientists' panic at feeling their lungs fill with fluid, and then their surrender into a new type of breathing, a different kind of survival.

Maybe that's what giving up monogamy would be like. You don't think you can breathe fluid, but then you do—and it means you can go where you've never gone before.

A few weeks later, I went to Phoenix for thirty-six hours. My daughter stayed in LA with my mom. The tumbleweed brought Safeway roses to the airport—which was called, unbelievably, Sky Harbor—and then we holed up in his little green house in a neighborhood called Villa Verde, across the street from the State Fairgrounds. The temperature was over a hundred by eight in the morning. His living room was crowded with vintage guitars and a leaning tower of amps. There was a big jar of spicy pickled cauliflower on the kitchen counter, off-brand grapefruit seltzer in the fridge, magic mushrooms in the freezer.

I spotted a to-do list on his kitchen table, full of all the tasks he'd wanted to get done before I arrived. *Hang stuff on walls,* it said. He was renovating an old house down the block so his mother could live above the garage, and he had a guide to home renovation sitting on his dining room table. When I flipped it open, I saw a sidebar titled "Nesters Beware!" Apparently it was possible to trick yourself into buying an unsound house by imagining all the possible memories that could happen there.

The tumbleweed showed me the plastic water bottle I'd given him at the Newark airport. He'd kept it for weeks; it was battered

and crinkly from being jammed into backpacks. He showed me a shrine he'd made to his cat, who'd died splayed on the yellowing grass of his yard. Maybe artifacts were easier than relationships. Cats were easier than relationships. In a way, dead cats were the best of all—the easiest to love.

He picked an unripe date from one of the trees lining his driveway and we nibbled the tiny bits of brown sweetness around its edges. At night we went to a strip-mall multiplex, like teenagers; and ate too much candy, like sober people. We watched a terrible movie about a book of scary stories that came to life. "Stories hurt," the nerdy heroine said. "Stories heal." Oh, we knew.

Later we sat on his couch and he showed me photo albums from his childhood, full of pictures of the twiggy boy he'd been, before he was six foot five and covered with tattoos. In one, he leaned against his father—an ordinary guy with a mustache who'd become myth, the way dads do. The tumbleweed told me that when he was a kid—even before his father left the family—he always felt like his dad didn't want him around. I remembered leaning against him, the first time we met, and considered how leaning is a way of saying, *Tolerate my weight.*

The tumbleweed told me that he'd always wanted a child, but refused to have one—never wanting his kid to feel unwanted, the way he had.

We drove west on Interstate 10, back to my daughter in LA, with a cooler full of bell peppers sitting in the back seat. We talked for hours about why he'd cheated in almost every relationship he'd been in. Some part of me believed that if I were just perceptive enough about his wounds, I could liberate him from

them. The same fallacy I'd applied to myself. Some part of me believed that if he loved me enough, he would be capable of fidelity again.

He told me about the first time he'd cheated on his last girlfriend, fucking some fan who'd driven him across England. He hadn't *meant* to, he said, but after she went swimming in the North Sea, in the middle of a lightning storm, she rose up naked from the stormy waters like a glistening nymph. His syntax suggested infidelity was something that happened *to* him. My father had used these passive verbs as well.

The tumbleweed told me that he never wanted to lie to me. I could already imagine the conversations with my therapist: the box of tissues, the taste of salt tears in my Dunkin' Donuts coffee, the residue of my father. *Aren't I good enough for faithfulness?*

Describing his relationship with a much younger woman, he'd once told me, "I taught her how to do her taxes, she taught me how to use emojis."

I thought of that girl all the time. She was older now. I hoped she was nailing her income taxes every fucking year. I hoped she remembered her time with the tumbleweed fondly. I frequently found myself having these tender, almost maternal thoughts toward other women he'd been with, the ones he'd cared about and wounded. I wanted to take care of them. I wanted to take care of everyone.

On that drive, we ate more bell peppers than I'd ever eaten in one sitting. The Mojave Desert lasted a long time. The conversation about monogamy lasted a long time. The tumbleweed didn't seem . . . entirely convinced.

In truth, I envied his clarity. He could tell me exactly what he was capable of offering. I couldn't tell him that. I couldn't even tell him exactly what I wanted. I wasn't even sure I wanted the daydreams in my head; they just felt easy to long for because I sensed they were impossible.

Somewhere near the California state line, the tumbleweed played me a clip from one of his favorite comedians. It was a shtick about miracles: "The miracle I experienced was that I burnt my laundry...a meteorite that used to be my favorite T-shirts. I didn't even know that could happen. All a miracle is...it's the world letting you know it can still surprise you."

The drive took longer than we expected and my phone vibrated with increasingly irritated texts from my mother, who wanted to know when we'd arrive. She was feeding my daughter green disks of cucumber while I slipped off my own motherhood like a pair of cutoff shorts. Just for a day. Two days. After enough irritated texts, I put my phone away.

The freeway unfurled between sunbaked strip malls that stretched like a lawn before the city itself. Part of me yearned for my daughter. But another part of me wanted only to be a woman on an open highway—with her feet on the dashboard and a man's hand on her thigh, a vast blue desert sky beyond the windshield, an endless road ahead.

As we hit the edges of the city, the tumbleweed turned to me and said, "I think I'll just keep loving you forever, if that's okay." Was it okay? It was. It was okay if the world wanted to give me all the love that any person ever had for another person. I wanted all of it. When I saw myself through C's eyes, I deserved none of it.

When I saw it through my own, I deserved a tiny little piece of it. Maybe.

Almost ten years of recovery and it was still hard to live anywhere but black-and-white extremes, still hard to inhabit the gray tones. The wild vacillations of melodrama offered refuge from muddier truths. It was easier to argue with C's accusations in my head than it was to sit with the pain that fueled them.

When I heard the tumbleweed talk about love, it wasn't just his voice I heard. I also heard C telling me quietly, before I moved out for good, "Some things are unforgivable."

Back in Los Angeles, I found myself bent over the crinkly paper of a doctor's table, getting a chlamydia shot in the ass. A miracle is just the world letting you know it can still surprise you.

The last time I'd been bent over a table like this, with a doctor beside me, it was at the hospital during the thick of my contractions; finding the only posture that made them bearable.

At our wedding ceremony, in that tree-dappled sunlight, I certainly hadn't imagined myself sitting down one day to google *Can chlamydia be transmitted through breastfeeding?*

The baby sucking her two fingers, the shot of antibiotics in my ass—I had to squint to hold both images in my sight at once. It was hard to be in the same room with my baby and the tumbleweed at the same time. One of them meant vigilance, the other surrender.

The tumbleweed was staying in LA. He was renting a converted garage near my mom's house. The first time he came over, he told us a story about staying up all night to get rid of mice in

an old apartment, drinking Carlo Rossi and doing endless lines of coke, emptying the reusable mousetrap over and over again.

Why was he telling us this story? I wondered too.

I think it had something to do with the fact that he'd been watching *Titanic* the whole time. It was the only movie he had on VHS, so he watched it on repeat, crying box-wine tears. This was the mythology he was writing for himself: the coke-addled mouse-killer with a sentimental heart. It was the version of being an artist I'd believed in when I was thirteen. And I guess, still.

My mom's house was a cozy stucco bungalow shadowed by shaggy palms and a sturdy bay tree whose leaves she used for lentil soups and cashew chili. Hummingbirds hovered at her feeder all day, their wings beating madly, thirsty for sugar and never satisfied. Tucked into her bathroom mirror was a postcard with a Buddhist mantra written in cursive script: *Gain and loss, praise and blame, all the same.*

I did not feel this way myself; I preferred gain and praise. I was thirsty for sugar, always. Maybe this was just another way I'd failed to receive all the gifts my mother had given me. She didn't care for dessert, and I couldn't get enough of it. She was more fully, constitutionally capable of committing herself to the well-being of others.

Sometimes it seemed like everything good in me had come from her, but that I would never be quite as good *as* her—always in debt, always an imperfect replica.

During that week in LA, it felt like I was working two jobs: the day shift with my mom and baby, the night shift with my

tumbleweed. These jobs demanded two different versions of myself. They could hardly be in the same room. Whenever they were in the same room, weird stories got told about dead mice and cocaine tears.

Trying to inhabit all these selves at once—the mother self, the daughter self, the teenage-love-affair self—felt like solving an LSAT word problem about a dinner party where X didn't want to sit next to Y who couldn't sit next to Z.

Whenever the tumbleweed spent time with my daughter, I wanted her to be good-natured and delightful, to show him how joyous and surprising it could be to have a kid. I imagined myself as a kind of salesperson, cold-calling to sell him on parenting. *It's not all sleep deprivation and resurrected childhood wounds! Look how curious she is about insects!*

And then I always felt sick with guilt, that I would want her to please him. I recognized this thing I'd always done, forcing myself into whatever shape I thought the man wanted me to have. Now I was doing it to her.

My mom liked the tumbleweed. Who didn't like the tumbleweed? She liked that he was Canadian. She was Canadian.

"He's very charming," she said. *But.* She didn't need to say that.

In my mother's backyard, my daughter loved finding tomatoes hidden like dusty red jewels. She pulled them off the vine and smashed them into her mouth until the juice left little trails of seeds across her cheeks. I had imagined many things about motherhood, but never this specific thing: how good it would feel to watch my daughter grin at the simple joy of a tomato breaking open in her mouth.

On a warm night, a friend and I walked to a strip mall for

milkshakes. We strolled beside the same streets I'd cruised back in high school, blasting PJ Harvey in my 1987 Toyota Camry at the cusp of a new millennium—seventeen and full of a thousand possible futures.

Behind us on the sidewalk, a mother and her tween daughter walked arm in arm, as I told my friend about the *chlamydia breast milk* Google search. Then I heard the mother tell her daughter, "We're going to let these women walk a little bit further ahead."

One night, the tumbleweed and I drove down to the beach. The sky was inky black behind the glowing Ferris wheel on the pier. The lighthouse towers loomed behind us like silent chaperones. I walked into the Pacific wearing a long dress that I pulled up around my knees. The waves got to it anyway. Back at the parking lot, my hem was heavy with salt water, dragging dirty sand along the bike path. Someone saw us standing under the pool of yellow light and said, "I wish I could be in love like that."

As we sat in his little silver car, the tumbleweed asked me what I wanted our relationship to become. I'd spent so much time trying to figure out what he wanted that I honestly didn't know what I wanted. Even though I hadn't had a drink in years—maybe *because* I hadn't had a drink in years—I knew I was not done with the part of myself that wanted everything.

We mapped three paths: we could end things; we could radically change both our lives; or we could keep on going in this middle space, full of intensity without assurances. Each path—ending, transforming, continuing—was hard to imagine.

But we liked going back and forth. I was hooked on hope and he was hooked on doom. Whenever he saw a puppy, he said, he just thought about how it would someday die.

What a ridiculous thing to say, I told him. Not because puppies don't die, but because he seemed so blatantly invested in a particular conception of himself. It was a comfortable discomfort for him, fast-forwarding to the part of the relationship where he would Inevitably Fuck Things Up. As if it were predestined. Even the anticipatory angst was part of his familiar routine, like pouring milk into his morning Cheerios.

To me, his cynicism was starting to feel more and more like an evasion. All his anecdotes about life on the road—sleeping with strangers, or getting into trouble with his tribe of lost-boy comedians—seemed like a failure of imagination, a way of keeping himself stuck inside a limited groove of living.

He believed self-transformation was impossible, while I found it addictive. Choose your heartbreak: stuck in prison, or always on the run.

In the tumbleweed's converted garage, one wall was just a massive mirror. When we fucked, his body moved above mine and his mirror body moved above my mirror body. Maybe I could just keep *one* of him, I thought, while his mirror-self kept fucking other women and living alone with his fridge full of grapefruit seltzer, his freezer full of mushrooms, his towers of amps.

Even when I played out the fantasy of "getting what I wanted" from the tumbleweed—monogamy, domesticity, chicken noodle soup, etc.—it only delivered me to the same set of questions about myself. Would I ever be able to survive getting what I wanted?

Would I ever inhabit that kind of partnership without getting restless inside of it? Sometimes I envied the integrity of his pessimism. It didn't damage anyone with its delusions.

The next day, when he came to my mother's house for lunch, my daughter skipped her nap and cried in her high chair at the table. He invented a game to entertain her: placing slivers of cracker on his palm and then closing his fist around it. She opened his massive fingers like flower petals and dug out every sliver. She couldn't get enough.

That night he said, "You loved watching me with your baby, didn't you?"

Of all the things he said to me, that was probably the cruelest. He didn't mean it to be cruel, or even see how much it hurt. But it did. Watching him with my baby woke up yearnings that were easier to bear when they were still asleep.

When the tumbleweed fucked me in ways I'd never been fucked, it was like meeting parts of myself I'd never met. It was still possible to do things I'd never done, to become a version of myself I'd never been. I thought of my mom yelling at my dad, before their divorce: "For all you know, I might want to become a priest." Some people get divorced and become deacons; others get divorced and get chlamydia.

On the phone, Harriet asked me, "What are the parts of yourself you don't yet know?"

In the moment I joked, "Whether I still have an STD or not?"

But her question was a great question. It was maybe the only

question worth asking. It could be a reason to get divorced. It could also be a reason to stay married.

The day I flew back to New York with my daughter, I left the tumbleweed's mirrored garage just before dawn so I could get back to my baby before she woke. I accidentally left my earrings on his nightstand, and he drove them back to me before my flight. He told me he just wanted to see my face again. Maybe I left them on his nightstand so I could see his face again.

Whatever our reasons, my flight still left at noon.

When he got back home to Phoenix, he texted me a photo of my Safeway roses tucked inside a pair of bleached deer antlers on his mantel. The brittle blooms were the brown of dried blood. It was a like a vanitas painting: a reminder that everything had an expiration date. But it was also a performance of that knowledge, that presentiment of doom. He was a man in love with the way he broke things.

In a long email, he wrote about my daughter crying during lunch: *In that moment, I just wished she wasn't there.* He wrote, *My whole childhood, my father wished I wasn't there.*

More than once, he told me, "You have a child; I *am* a child," but I couldn't hear it. I was suspicious of his wit. It was like he was retweeting himself.

But I was slowly learning that perhaps I should believe him. Not the content, necessarily, which was just cocktail-party shorthand; but the urge to say it, to keep saying it. He told me, "Believe me when I tell you who I am." The older I got, the more I

realized how little control I had over the stories other people were writing about their lives.

On the first day of classes that fall, I stopped on my way to campus to pick up another round of antibiotics. I'd expected pills, but instead it was powder to dissolve in water. I couldn't do this on the subway headed uptown. I'd have to duck into a bathroom at work and mix up the medicine before I led the new-student orientation at two o'clock.

Headed into the bathroom with an empty coffee cup in hand, I was intercepted by my dean, a charismatic, vivacious woman in her sixties. I loved my dean. I even loved our yearly ritual of my asking for a raise and getting turned down, because we still got to drink tea in her office and talk about teaching and romance and making art; about how our students sometimes expected us to be their mothers, how boundaries still felt like acts of violence but she'd gotten better at them a long time ago.

The first time I'd ever met her, during my job interview, she scanned my CV and said, "You've done a lot." I immediately started demurring, saying, "I've been lucky, I've had so many opportunities, I've had so much support." She looked me straight in the eye. "I know what you're doing, because I used to do it too," she said. "Don't deflect. Just own it."

Now it was ten minutes before I had to lead orientation, and I had the white foil packet of antibiotics in my hand, but I certainly wasn't about to tell my dean I couldn't talk to her because I needed to take my chlamydia medicine.

When she asked how I was doing, I said something vague but not entirely dishonest. "Oh, maybe a little overwhelmed."

Splinters

She looked me straight in the eye—I'll never forget the clarity of her gaze, its tender X-ray—and, without my mentioning anything about a man, told me that she used to be with men who brought chaos into her life.

She said, "I had to leave those men behind, in order to do my work."

Whenever I described our—what was it, exactly? our relationship? our reciprocal infatuation? our "thing"? our love affair?—I always led by saying I knew we didn't make sense: a single mom, and a perpetual bachelor. Of course we'd end. But every *of course* was just a hard shell protecting the softer flesh beneath, the embarrassment of my hope.

I wanted to be the exception to his pattern, the woman he ultimately decided to commit to. Some part of me still believed this was the ultimate measure of love—how much it turned you into someone you hadn't been before. The twenty-two-year-old in me believed in love as an unstoppable engine of transformation, capable of excavating new selves from the ashes of our old incinerated stories. The thirty-six-year-old me didn't want to pick up another round of antibiotics. The thirty-six-year-old me needed to buy more peanut butter and baby wipes.

I hadn't forgotten that lunch at my mom's house, and the tumbleweed's tight, restless smiles as my daughter cried. How I'd wanted my daughter to be quiet, and hated that I wanted her to be quiet, hated that I was asking of her what I'd always asked of myself: be what he wants you to be, so that he'll never leave.

Sometimes I lay awake at night, in the bed where he'd slept, remembering the endless highway, the desert breeze through our

open windows. Perhaps this was the fantasy, more than the man himself: speed and wind, a cinematic version of existence where I got to hover like a spirit just above the dull asphalt of daily life. Perhaps the fantasy was not domesticating the tumbleweed, but becoming him.

That fall I published a collection of essays. They were about families obsessed with their kids' past lives and people who disappeared into their online avatars. They were about my own pivot away from the volatile thresholds of infatuation and heartbreak to the daily rhythms of parenting and partnership. The book ended with a version of my life that was no longer my life.

When I did bookstore readings, the only thing I could hear was the sound of my own voice repeating the phrase *showing up,* over and over again. The narrator of those essays was trying desperately to convince herself to stay inside her marriage.

Once again, I went on book tour. For half of it, I took my daughter with me. She hid behind the hedges underneath my old college dorm and stole a saltshaker from the dining hall, clumsy with smugness. She slept with my mother in the hotel room while I hung out with the kids at my old college lit mag, drinking seltzer in the rickety wooden house where I'd spent four years drinking a lot of not-seltzer. The students asked me impossibly earnest questions. Did I think authenticity required breaking an existing form or structure? I said, "Yes!" in a too-loud voice. I was talking about hybrid essays, and thinking about my divorce.

In Pittsburgh, my daughter sat beside me at a bookstore signing table, sucking patiently from her blue sippy cup, gazing kindly

at the readers who told me their stories—about an estranged brother, a mother's addiction, a long surgical recovery. The photo I sent friends showed the two of us sitting side by side at the signing table with our matching cocked heads and focused gazes. *Little empath in training lol,* I said, but felt like a fraud for sending a photo that made it seem like everything was working great, vocation and motherhood entwined, when really I knew how many naps she'd skipped on the road, that she had started getting more upset about being left with sitters in hotel rooms.

That night in Pittsburgh, after our afternoon together in the bookstore, she'd thrown herself onto the hotel carpet and started screaming when she saw that I was leaving. There wasn't a picture of that moment, when she put her tiny arms around my legs. Or when she toddled after me as I went to the door, and I picked her up and whispered into her hot little ears, felt the tears on her flushed cheeks.

Whenever I traveled without my daughter, the absent equipment felt like a ghost limb: stroller, Pack 'n Play, car seat. I felt unnaturally light, accused by convenience—not jumping up to chase her tiny body through geometrically carpeted airport terminals. When I ate an entire breakfast burrito without interruption, it felt like I was getting away with a petty crime.

But the pile of crispy rust-brown leaves heaped outside a chrome diner in downtown St. Paul gave me a pang. *She would love jumping in these leaves.* Or every sloping parking lot—*she would love running up and down these lines of white paint.* Sometimes I tried to make eye contact with other mothers who were out with their children, catching their gaze to share a knowing

glance. *I'm a mom too.* Usually they just looked around, confused, trying to make sure their kid hadn't dropped a mitten.

But I needed them to know—even these strangers—that not all of me was there.

The tumbleweed was meeting me at a hotel in Houston. The Hotel Zaza. My plane landed in the middle of an oily sunset. The hotel swimming pool had underwater lights that flooded my skin with pink and purple. They made a creature of me. The humid night was a warm blanket thrown across the chlorinated water.

The tumbleweed was driving straight from a gig he was finishing that night in Austin. I tried to stay awake until he got there, but I couldn't—I'd woken up early that morning with my toddler in Boston, gotten her back to New York, gotten myself to Texas for another event. Walked to a drugstore for cigarettes and a disposable razor to shave my legs. I left a room card waiting at the front desk, and just after midnight, I woke to the sound of the door clicking open. He stood at the threshold with a guitar case in each hand. He crawled under the covers to hold me. It was the hallucination of a life that was nothing like the rest of my life.

By morning, the sheets were covered with lacy jags of period blood.

"Like a crime scene," the tumbleweed said, and what could I say? I agreed.

Two nights earlier, on a stage at Harvard, an esteemed literary critic almost my father's age had told me, "It's like your work is trying to break through shame into shamelessness."

The next morning, we ordered three breakfasts from room

service, and feasted on strips of charred bacon, waffle squares gleaming with their tiny wells of syrup, toast triangles dipped in egg yolk. He'd unlocked some hunger inside me. Now I couldn't stop eating. *Why don't you eat something, you anorexic bitch.* C's voice was there, too. I could remember our early road trip so clearly: bacon so salty it made my lips sting; that urgent desire to rush back from the bathroom to keep talking, the world like something we could plunder.

Lying beside the tumbleweed in bed, I noticed a tattoo of three letters on his chest that I hadn't seen before. For one wild moment I thought he'd actually gotten another woman's initials tattooed on him since the last time we'd seen each other. When he told me it was his nephew's initials, I felt a rush of relief. But I felt humiliated, knowing that he could have gotten another woman's initials tattooed on his chest without breaking any promises to me. He hadn't really promised anything.

He wasn't entirely gone, and he wasn't entirely there. Or rather, he was *fully there*—affectionate and infatuated—but only a little bit of the time. He offered fleeting glimpses of what his full presence might be like. Pavlov knew that intermittent reinforcement was more powerful than giving the dogs a treat every day.

When he'd said, "You loved seeing me with your baby," he might as well have said: *I know you don't want to raise your child alone, but you will.*

That fall, I grew obsessed with an exhibition of amateur home movies in the basement at MoMA. The subterranean rooms featured a hundred different screens filled with ordinary lives: kids pushing each other in sleds; a woman mock-proposing to another

woman at a lawn party; boys taking furtive sips of Manischewitz at someone's bar mitzvah, their glasses glinting in the ballroom light. Placards that usually announced the names of famous artists displayed suburban-sounding surnames instead: *Levitt family. Thompson family.*

Descending into this basement exhibit felt like letting a stranger, a hundred strangers, whisper secrets in my ear; like dropping into a collective subconscious—a place not of art, exactly, but the place art comes from. It was another cathedral of the ordinary, like Winogrand's photographs on the other side of the East River, except the artist wasn't famous. The artist was everyone. The artist was a little boy shooting footage of his plastic dinosaur in a carpeted basement in Newburgh, holding up a piece of lined notebook paper as a badly cropped title card: *Anything Stop Him??* The artist was a man taking a cross-country train trip, commenting on the scenery in a husky voice that sounded like Kermit the Frog after twenty years of pack-a-day smoking. Smoker Kermit was delighted by everything he saw. "So beautiful," he kept saying at the sight of the St. Louis arch, "so gorgeous."

My obsession with these home movies felt like another chapter in my stubborn love affair with the unremarkable. If this toddler playing in the snow was beautiful, and this awkward boy sipping his sweet wine, and this stay-at-home mom who looked bored—if it included everything, did it mean anything? There was no end to this version of profundity. It had no edges.

I never brought my daughter to watch the home movies, though they were full of her kin and kind: babies and toddlers

strutting around in their diapers, picking up empty milk cartons. While I watched each child, I was paying someone else to watch my own. Now that she was a toddler, she no longer slept in her stroller at museums, allowing me to ruminate peacefully on the relationship between domesticity and profundity. Now she wanted to climb things and break them, to injure herself in daring and inventive ways, to run madcap back and forth along the heating vents stretching the length of the lobby. Her joy was my teacher, too, of course—its suddenness, its clumsy grace.

When I left my own toddler at home in order to watch videos of other toddlers, it was like seeing my own life through the wrong end of a telescope: the banality of my days turned startling and poignant. It was daydream and homecoming at once. Beneath the citizen-self who woke up every day to make oatmeal for my child, who scrubbed the toilet bowl and excavated fossilized spaghetti from behind the radiator, there was another self—howling with reckless desire, thirsty for the sublime registers.

After Houston, the tumbleweed and I had different versions of the same conversation over and over again. Was he capable of monogamy. Was I capable of anything but monogamy. Could he imagine his life with a child. Gradually these questions revealed themselves as more rhetorical than actual. They lost their question marks.

Once, he said, "You're the best possible reason I could imagine to grow up."

But, but, but. Every word out of his mouth felt like a prelude to *but*. I wanted him to give up other women for me. I wanted the

alternate world in which my father had given up other women for my mother.

He said, "I think of a thousand reasons we can't be together, and when I hear your voice the whole thing burns to the ground."

One evening in the middle of a tantrum, my daughter started jamming her finger into the corner of her eye.

"Stop that!" I said sharply.

"But I want to!" she said. "I have to!"

I was the one who finally said, "Let's not do this anymore." But it felt like he was the one who made the choice. I felt embarrassed, almost erased, by the fact that what had happened between us was exactly what he'd thought would happen between us.

When we arrived at the end, as predictably as a car pulling up to the dot on a GPS map, it hurt like hell. That was the surprise of it—not the ending, but the fact that something so predictable could hurt so much. A miracle is the world letting you know it can still surprise you. Like a woman with her head on backwards, walking right over the edge of a cliff.

Only my Lyft app understood. Every time I was downtown, it automatically set my pickup location as Veselka, as if some part of me was still watching his cab drive away. As if the app itself were saying, *Get out of the bike lane.*

Once we were done, I was pincushioned with needles of memory: the wilting roses he tucked into the antlers on his mantel, his little-boy face in photographs, my earrings on his nightstand, the broken crackers in his palm.

I wasn't doing this nostalgic rummaging with memories from my marriage. Perhaps it was easier to hurt in this other way instead, to inhabit the old familiar rut of being a girl wanting more from a man than he wanted from her, a dynamic in which I felt powerless and harmed, which was—in many ways—easier than feeling culpable and harming.

Feeling hurt by the tumbleweed was a contained pain, like a trench dug into the open field of my divorce. There was no other shelter nearby, only the vast expanse of the irreversible.

My heart hurt like it had an infection. An earlier version of me might have smoked endlessly, cried for days in the bathroom, found someone else to fuck so I could go cry in *their* bathroom. This version of me got up every morning and nursed my daughter on the same gray velvet glider I'd nursed her on since she was born. This version of me went to faculty meetings, went to the pediatrician, called the insurance company, took my daughter on long walks and then returned us to our stoop, next to the hipsters reading Heidegger at the bistro tables who never offered to help lift my stroller up the steps.

This version of me didn't check his Instagram. This version of me spent whole days not checking his Instagram—not checking it, not checking it, not checking it—like starving myself in college, that self-denial as proof that there was some force inside me larger than my hunger. Perhaps I could call it dignity.

I didn't check his Instagram for long enough that I finally felt entitled to . . . do what? To check his Instagram. I saw his new kitten. I saw a blond woman leaning against his chest.

As I smoked on the stoop one Sunday afternoon, my loneliness

turned the corner and walked toward me in the form of a mother and father pushing a stroller together. I turned my face away because I didn't want to blow smoke toward their baby.

As we inched toward winter, our radiators started hissing and sputtering. They sounded angry. They spewed heat in flatulent gasps. Our apartment was a sauna. I wore underwear and nothing else. My daughter was waking up all through the night, crying out, whenever the pipes started clanging. At 3:30 one morning, I texted my super in desperation: *This is insane. Please help us.* I wanted him to see the time stamp. I knew I sounded unhinged; I wanted to.

In the gray mornings after those long nights, dead-tired and frizzy-haired, I pushed my baby's stroller to the park and heard the tumbleweed's voice in my head, saying he wanted to change his life for me but ultimately couldn't. I knew what *couldn't* meant. It meant he didn't want it enough. My problem sometimes felt like wanting everything too much.

Some part of me believed that art could come from this acute wanting, too. But more and more this belief was starting to feel like a song I'd heard a long time ago, in a bar somewhere. I couldn't quite remember the tune.

There were more work trips that fall, more mornings spent wrestling the filthy red carrier for my daughter's car seat. Nothing like pushing a travel stroller into the cold wind off Lake Michigan to give your self-pity a set of sharpened nails. *I am doing this on my own I am doing this on my own I am doing this on my own.* So I grinned into the ice breeze and took a selfie with my

daughter—the gray forever of the lake at our backs—and sent it to eleven different people. Everyone texts endless photos of their children, but for me it felt grasping and desperate. Because I wasn't raising her with anyone, I wanted to raise her with everyone.

In Iowa City, I pushed her stroller past streets full of memories from my twenties. The intersection where I got hit by a car while carrying a pink box of tiny key lime pies. The City Hall office where I went to pay my parking tickets once I'd gotten so many they towed away my little black Toyota. Everything I lost back then, I felt sure I would get back again.

When we finally found a playground, I realized it was across the street from the apartment where I'd lived for two years. At the time, I'd never even noticed the playground was there. More visible had been the white gazebo nearby, where I'd brought a big red Solo cup of whiskey one night and drunk-texted my mom, *can't go home from the party the party at my house.* That drunk girl had plans that involved being loved hard enough not to need whiskey any longer. Now my daughter had plans that involved the jungle-gym bridge jiggling under her blue Velcro sneakers.

While she bounced on it, I called my mom. "Ten years ago," I said, "this wasn't how I imagined things turning out."

She said, "And you have no idea where you'll be ten years from now, either."

Not for the first time, I listened to the voice of my mother and looked at the face of my daughter and thought: *There is no end to this love. It will tug at your sleeve until you die.*

With my daughter, the words that came out of my mouth—over and over again, like a mantra—were not *Do you*

love me?, but *Do you know how much I love you?* When I pressed my ear to her chest, against the cotton of her striped pajamas, I needed it like fuel—the other side of the question mark, the impossible flutter of her little heart.

That winter, I was Mama and I was also the Plaintiff. We went through four rounds of revising our settlement. The old drafts became scrap paper, with my to-do lists on the back.

In her massive corner office, wearing a bright silk scarf under her black motorcycle jacket, my lawyer raised her eyebrows when I told her I was sober. "You're alcoholic?" she said. "Are you afraid he'll use it against you?"

I hadn't even thought to be afraid. Sure, I was alcoholic. But I was sober. I mean, *very* sober. I was ready to list for my lawyer all the ways I was Functional Beyond Question, the same way I'd wanted to mail my perfect report cards to my dad after the conversation when he asked me why I was getting a B– in World Cultures.

Instead, I just said, "Should I be afraid?"

"Not unless you relapse," my lawyer said. "Just don't do that."

It had been years since I'd wanted to relapse. And this wasn't wanting. This was just noticing. Noticing the dive bars, and the brick-walled taverns with sconce candles. The sports bars with windows full of green clovers and Budweiser signs. The fancy liquor stores with their crates of chardonnay in the windows, their pristine gin bottles, their punning sidewalk chalkboards. DON'T WHINE! GOT WINE?

This wasn't wanting. This was just wondering, What would it be like, after all these years, to feel that flush of relief again?

One Saturday morning, I clipped off too much of my daughter's pinkie nail and it bled everywhere. While I held her in my lap, the blood streaked across my purple pajamas, the same ones I'd been wearing when my water broke. Big fat tears streamed down her round cheeks. She kept raising her hand and saying, "Ham," "ham," "ham."

Somehow I had no Band-Aids in my medicine cabinet. Perhaps because I hadn't bought them. This was why people raised children with partners, I thought—so that you could have two people keeping track of the Band-Aids, or else so that one person could run out to the bodega and buy some more, while the other one stayed home with the toddler.

But it was just me, so I got us both bundled up for the bright cold morning, to get the Band-Aid for her little ham. No one around to say, once it got quiet again, *Don't you love how she says "ham"? Isn't it just the sweetest thing you've ever heard?*

Now that I'd woken from the extended daydream of the tumbleweed, I was just a single mother again. I had no mental obsession to lift me, like a sudden gust of wind, from the day-to-day business of wet wipes, wet fruit, wet snot. Whenever I lost patience with my daughter, I wondered if I was forcing her to bear the brunt of my heartbreak; if single parenting meant she was getting an inferior version of the parent I could have been in a better partnership—if she was getting a more short-tempered,

impatient, stressed and harried mother. Our *if only* selves are infinitely virtuous, and impossible to confirm.

Winter was approaching, along with the first anniversary of my separation. The universe had never promised me anything in exchange for my divorce—certainly not a second chance at the marriage plot. The universe had smelled the sage smoke drifting over my palm-frond duvet, and now it was saying, *You made your bed, now lie in it! All the sage in the world won't save you from it!*

Maybe the voice of the universe wouldn't use exclamation points as gratuitously as I did. But I suspected otherwise.

When I'd visited the tumbleweed in Phoenix, he'd given me one of his merch shirts. It had a sketch of a hyena beneath the words *Trust Me*. Months later, I told him the back should say, *All he gave me was this stupid T-shirt, and chlamydia.*

But it wouldn't have been true. Because he gave me a lot. He gave me Safeway roses at Sky Harbor. He gave me an open sky without a place to dock. He gave me the bittersweet hope of knowing I could still hurt. I wasn't yet depleted.

C gave our daughter a stuffed Minnie Mouse half as big as her whole body and she loved it with fierce devotion. Minnie was both her precious child and her rascal alter ego. When I told her not to climb on the table, she said, "*Minnie* wants to climb on the table." It was Minnie who loved mixing the melted butter and white sugar and yolky eggs into a grainy sweet yellow mush for our cookies, who loved flinging this mush onto the ceiling. It was Minnie who got her teeth brushed first at the dentist, even

though she didn't want to; Minnie who wanted to bark at the barking sea lions on their sun-drenched rocks at the zoo.

Minnie's bliss was as real to my daughter as her own. It was as if she hadn't actually been somewhere until she'd brought Minnie, until she'd thrown Minnie up into the air, watched her spin and twirl and eventually land with her stuffed yellow legs splayed across the ground.

Four times a week—coming and going from drop-offs—Minnie was ferried in a brown paper bag between her two homes. The blade of that plural, still.

Sometimes I imagined Minnie's shenanigans in this other home I never saw: C hiding Minnie behind the couch, or laying her across a steam radiator to get dry after she'd been given an impromptu bath.

When our daughter said, "Minnie goes in the brown bag!" she was telling us what she needed—a bridge between her homes, these two shores of love.

Sometimes our version of parenting felt like those games where two people take turns drawing parts of a fantastical creature: someone draws the head, then folds the paper and hands it over; someone else draws the torso, then folds the paper and hands it back. Neither seeing what the other has drawn: a green donut head, covered with crayon spirals of blue hair; a huge purple belly that almost reaches the edges of the page; spindly orange stick-figure legs. Pink wheels for feet. Revealing only the edges of our lines. Sometimes not even that.

Drop-offs no longer involved yelling or profanities. They no

longer involved speaking. He didn't think it was productive for us to speak. Friends told me, *You can still speak to him. He doesn't get to decide.* But after a year, two years—I found I didn't know how. We hardly ever made eye contact. We were like two people who'd never met, except we had a child together.

I would kneel at the doorway to his apartment, sandwiched between a Bangladeshi medical clinic and a bagel shop, and brush green flecks off her shirt, flakes from the dried seaweed she'd been eating on the bus ride over. She peered eagerly through his mail slot to watch for his sneakers coming down the stairs.

One Sunday I ducked into the grocery store across the street, where mounds of fruit were piled in bins outside: six kinds of mangos, tiny crab apples, Hami melons hanging from the awning in little mesh hammocks. They sold produce that was hard to find anywhere else: custard apples, hairy rambutans, pomelos with rinds thick as thumbs, yellow dates still clustered on their branches, prickly pears with a French label, *figues de barbarie.* Figs of cruelty.

As a reward after drop-off, I started buying unfamiliar fruit and learning what to do with it. Boil the quince until it's pink and sweet. Eat the dragonfruit with a spoon, straight from the halved bulb of its pink reptilian skin. Let the passion fruit shrivel until it's wrinkled, then loosen the pulp until it slips free like an oyster, moving as a single creature. Sprinkle it with sugar. Drink it in a sour gulp.

Every time I dropped my daughter at C's apartment—whenever I saw her run to him, whenever I saw him sweep her into his arms—I felt pangs of sorrow and gratitude at once. I

knew that everything I'd loved in him—his loyalty, his goofiness, his imagination, his empathy, his capacity for delight—were gifts he gave to our daughter. It was easier to forget these parts of him than it was to mourn them. But there they were, for her.

In the settlement, we had agreed that our daughter would spend Thanksgivings with C. Just thinking about the holiday hurt, like a sharp inhale of air on a frigid day. Kyle, knowing how hard it would be, invited me to spend the holiday with her family down in Baltimore. We'd found our way back into closer friendship after that hard winter, and I was grateful for our return—for her invitation.

On my way to the train station, rolling my suitcase down the Brooklyn sidewalks, I passed a mother with her baby in a carrier, mouth partway open in sleep; and then a mother on the subway, her toddler throwing his water bottle onto the filthy floor; and then a mother at the Baltimore train station, changing her newborn's diaper, his cries as thin as unspooled thread.

At Kyle's house that night, I slept on a foldout couch under a plaid blanket with thick fringe. When I woke up in the early morning, in the dim light, the chubby wool tassels looked like my baby's fingers. My dream mind thought, *My baby's fingers have followed me to Baltimore.*

Thanksgiving morning, we ran the local Turkey Trot through suburban streets. "Good Morning, Baltimore" boomed from speakers in the trees. My hands were numb in the early-morning cold. As I weaved between parents pushing strollers, my lungs burned with icy air. My spectral teenage self—the one who'd

raced on the cross-country team, who'd pushed up impossible hills—was doing battle with the thirty-six-year-old body of a woman who stoop-smoked on the nights her daughter was away. Crossing the finish line felt good. It also conjured an old, stale logic: if it hurts, it must be good I did it.

At the big meal, I helped myself to heaping portions of everything: slabs of turkey breast wrapped in crisp skin, cranberry sauce with maraschino cherries, a goopy, delicious casserole made with cream of broccoli soup and crispy fried onions. The first time I mentioned my toddler, shame rose like acid in the back of my throat, as I wondered what everyone must make of me talking about my toddler on Thanksgiving rather than being with my toddler on Thanksgiving. An elderly aunt graciously asked what words she was saying these days. My voice started cracking as I launched into the little catalogue: *shobby* for stroller, and *fa fa* for flower, and *gob gob* for Grandma. Later, once the conversation had moved onto something else entirely, I said, "And *ham*! For hand!"

One of my porcelain crowns came loose in a mouthful of cranberry sauce, a cap from one of my countless root canals, and I crept away to the hallway bathroom to fish it out of the back of my mouth. *While I'm here, might as well,* I thought, and pulled up the cell phone video where my daughter tried to roll her tiny wooden car under the stove—so pleased with herself at first, and then confused about why it wouldn't go any farther, and then amused, her laughter erupting like confetti. In the bathroom, I watched that video over and over again.

Just once more, I told myself. Then once more after that.

Later that night, Kyle and I drove to a strip-mall drugstore

for dental putty so I could reattach my molar. The crown was wrapped in tissue paper in the pocket of my down jacket. It was oddly satisfying to deploy the dental putty—the tiny pea-sized dab of gray, the glue stink, the biting down, clenching my jaw for long enough and then, voilà. All done.

Driving home, we blasted a radio station playing pop songs from the decade we'd been teenagers. There was no pleasure in the world more precisely molded to the contours of my psyche than driving on moonlit roads with a friend, listening to '90s pop and fumbling for the shape of our feelings in the dark. Kyle had given me this holiday without my daughter as an experience of presence rather than just absence. All this time, our friendship had been teaching me about ongoingness—how intimacy holds friction alongside sustenance, how pain and proximity emerge from the same honesty.

That Christmas, my daughter and I flew to England to spend the holiday with my brother and his family. My parents came too—not just able to spend holidays together, but able to enjoy it. My daughter stayed up for the entire overnight flight, tracing her finger along the laminated airplane safety card to find the little baby. Which cartoon woman was his mama?

My brother's house had been a pub before it was a house, and a brothel before that, and before *that,* during a nineteenth-century cholera epidemic, it had served as a warehouse for bodies. My brother's house seemed to be telling us that everything we did was just a tiny moment inside a story much longer than any of us.

Our third night in England, we all went to dinner at a pub called Harry's. I sat between my father and my daughter, trying

to keep her from climbing out of her high chair by feeding her bits of pink peppercorn salami and buttery spears of asparagus. I'd told her the asparagus would make her pee smell funny, so now she was saying "Pee smell funny" on repeat. All the while, I was listening to my dad explain the connections between Russia's GDP and its mortality rates. But my daughter was fussy, and I knew we'd probably have to leave before getting any of the bread pudding I'd been eyeing ever since we sat down.

My dad was talking about declining alcoholism rates and how sometimes the same things that were improving health could actually take a toll on certain sectors of the economy (i.e., the vodka industry) and I was *sort of* getting all this, as I wiped gleaming trails of butter off my daughter's cheeks, and fished around in her lap for the wet floppy disk of salami that had gotten tucked somewhere in the folds of her dress, and she wanted me to find it, find it, *find it,* and also sniffing around her diaper, to see if I needed to change her, all the while catching parts of phrases, like "accounting for quality of life as well as life expectancy," trying so hard to track what my dad was saying, trying so hard to think of a follow-up question that would indicate I understood.

Sometimes taking care of my daughter made me feel like kneeling at the feet of the world, begging it—someone, anyone, my father—to understand, *You cannot expect me to do this on my own.*

Finally, I turned to my dad—my hands full of balled-up baby wipes—and said something I had literally never said before: "I don't understand what you're saying." I gestured at my daughter wriggling in her seat, wiping her buttery fingers along the tablecloth, amidst the mess of crumpled napkins and food scraps. "I just can't."

I'd never allowed myself to say this to my dad directly: *I am so lost.* Instead, I always tried to be the things I thought he wanted from me.

He looked at me tenderly, he could see that I was overwhelmed, and then he kept talking about the Russian GDP, as if it were the only thing he knew how to do.

Underneath the desire to impress him, there had always been another one lurking—the desire not to have to impress him at all. To fall apart in front of him. To ask him why he never wanted his two nights a week. To throw a tantrum and have it be okay.

Then my daughter started crying, and I began packing up our things. I took her home early, before the food arrived. When everyone else came home a few hours later, my dad handed me a take-out box of bread pudding.

We aren't loved in the ways we choose. We are loved in the ways we are loved.

That Christmas, my daughter's favorite picture book was *The Polar Express*, a story about a nighttime train snaking toward the top of the world. Inside the cozy compartments, children sat on plush red seats, drinking hot cocoa and eating nougat candies. When I was a kid, I loved this part of the story most—the journey toward the North Pole. Once they arrived, it got less magical.

The story began with anticipation: "I was listening for a sound, a sound a friend had told me I'd never hear—the ringing bells of Santa's sleigh. Late that night I did hear sounds, though not of ringing bells. From outside came the sounds of hissing steam and squeaking metal."

I needed to hear this. You hope for bells and get a train instead. The grace you imagine is rarely the grace that arrives.

As we read, my daughter sat in my lap and pointed at each page, one by one—*this page, this page, this page*—as if otherwise I'd have no idea what to do next.

On the page where the conductor says, "To the North Pole, of course!" I always raised my finger to point at the ceiling, and did my silliest voice for the conductor. My daughter always raised her arm at the same time, her tiny finger also pointed, giggling madly, looking up at me to see if I'd seen. I knew there would never be a word for how this felt.

For Christmas, my nephew got a baby lizard—a bearded dragon he named Taco. They brought him home from the pet store during my daughter's nap, when I was sitting on the couch with my laptop, reading the fifth draft of my divorce settlement.

"This is Taco," my nephew said, in a matter-of-fact but affectionate tone that reminded me of my divorce lawyer introducing me to her junior colleague. "He eats crickets for breakfast and crickets for dinner."

When I clicked the yellow circle in the corner of the settlement, clause 3B became very small but did not disappear entirely. I asked, "What about lunch?"

"Dragons don't eat *lunch*," my nephew said, in the patient voice he reserved for replying to obvious questions, like the time he'd told me his favorite flavor of ice cream was rainbow ice cream, and I asked him what it tasted like, and he said, "Um...*rainbows?*"

Taco was beige and nubbly as sand, barely larger than my middle finger. He had bright black swiveling eyes. They'd brought

him home in what looked like a deli take-out container, and we placed it beside the kitchen radiator to keep him warm. My nephew explained that Taco needed heat because he was from the desert. The two of us sat there on the kitchen tiles, bringing this animal back to some approximation of his homeland.

It felt consolidating—to know exactly what a creature needed.

But maybe Taco needed more. Every once in a while he scrabbled his little webbed feet against the plastic walls of his container, furiously pedaling. The jig was up: he was terrified.

On Christmas Day, we went to services at the cathedral, a massive stone structure with a soaring roof that had survived the bombing raids of World War II. Partway through the service, my daughter got fidgety and I went to sit with her at the back of the church. The stone was cold beneath me; her body was warm in my lap. My nephew whispered urgently in my ear, wanting me to see the Lego model of the cathedral in the back. I imagined a little Lego divorcée crouched in the back, with a tiny Lego pack of cigarettes tucked like contraband in her purse.

The God of my shampoo bottles, in all his inscrutable, elusive benevolence, was suddenly right here beside us, palpable in the heat of my daughter's body and the breathy, fluted whisper of my nephew—who had found, in a Lego cathedral, precisely the holy chamber he needed.

My daughter's favorite part of England was the suburban grocery store we visited. A creature of city bodegas, she'd never seen one so massive. She got to sit in a silver shopping cart, with her doughy legs dangling, as we rolled through aisles full

of sickly fruit—pale, dented oranges; brown-mottled bananas; rosacea-tinted apples covered with flat bruises—and eventually arrived at the nirvana of the yogurt aisle: hazelnut, rhubarb, salty caramel, and banana toffee. Nouns were attached to other nouns in inscrutable ways: rice apple, gooseberry fool. I didn't need to understand what they were to put them in the cart.

The grim bins of fruit juxtaposed against the ridiculous plenitude of the yogurt shelves felt like a scolding. Don't demand what the store doesn't have. Just fill your cart with yogurt you never imagined. Don't hate the tumbleweed because he doesn't want to father your baby. Just be grateful he reminded you it was possible to be consumed by desire.

Almost two decades earlier, near the end of my eating disorder, a psychiatrist told me I'd have to figure out what my anorexia did for me, before I'd be able to get rid of it. Whatever it did for me, I would need to figure out another way to do that for myself. These instructions were more useful than most of the wisdom people offered about self-destructive behavior. This shrink understood that my disease was also an attempt to make something happen.

Getting my heart broken by the tumbleweed was a useful pain. It told me I could still want something so much I was willing to be broken by it.

My aunt once told me she'd always believed that some love affairs were epic novels, while others were short stories. Some were just poems. One-night stands were haikus. You couldn't fault a poem for not being a novel. You might not want the poem to last for eight hundred pages, anyway. Just because a relationship

didn't last forever didn't mean it had failed. I wanted to feel this way about the tumbleweed. I wanted to feel this way about my marriage too.

Roland Barthes once asked, "Why is it better to last than to burn?"

A sober heroin addict once told me, "I like being hungry. It's my body telling me it wants to be alive."

FEVER

How long does the virus live on doorknobs? How long does the virus live in subway cars? Does a scarf around your mouth keep the virus from getting in? Does a scarf around your mouth keep the virus from getting out? Where did all the pasta go? Black market toilet paper. Vanilla extract hand sanitizer. Quarantine relapse rates. What if I'm muted even after I unmute myself? Was Donald Judd a single dad? Did Donald Judd have a nanny? Do hedge funds always make money when other people lose money? Old trash art. Does your shit smell different to you after COVID? Do kids ever die from COVID? What happens when you go too long without touching someone?

L ike every quarantine, ours began with a series of sudden
subtractions: classes, hugs, subways, childcare; the bodies
of friends in my living room; the bodies of strangers brushing
against mine on the sidewalk; and finally my own body, not so
much subtracted as distorted, the virus bringing shivers and night
sweats and muscle aches rippling from my neck to my heels.

For weeks, the only other person I touched was my daughter.
She was two. Outside our apartment, the streets were empty, the
sirens constant. The hospitals were running out of ventilators.

We stopped leaving the apartment after I became symptom-
atic. I went downstairs only once, to take down the trash when
it was overflowing. I couldn't smell it, because I couldn't smell
anything. But once the pile of banana peels and mashed zucchini
pieces became impossible to push deeper into the bin, it was
time. In the vestibule downstairs, a man in a blue mask uncov-
ered his mouth to speak, and I shrank away from him. He prob-
ably thought I was afraid of what I'd get from him. Really I was
afraid of what he'd get from me. Why couldn't I just tell him, *I
have the virus*? It got caught in my throat. I had a vector's shame.

The virus. Its sinewy, intimate name. What did it feel like?
Shivering under blankets. A hot itch behind the eyes. Three
sweatshirts in the middle of the day. My daughter trying to pull
another blanket over my body with her tiny arms. A throbbing

in my muscles that made it hard to lie still, and hard to imagine doing anything else.

When lockdown began, before I realized I was sick, I made a schedule to keep us from going insane during our long days. *Reading time, dance time, drawing time.* A cutout octopus next to "Cleaning/Chores," as if we'd deploy eight arms to wipe the door handles with bleach. A cutout tiger next to "Walk/Adventure!," as if we'd see exotic animals on the sidewalk.

The cherry blossoms beyond our windows seemed tone-deaf in their extravagance. The spring sunshine arrived like someone grinning on a hospital ward.

At first, I'd refused to believe my own fatigue, even though I kept falling asleep on the couch while trying to return emails during naptime. But eventually there was no denying the pangs running like electric currents through my legs, wearing me out like exercise. A few days after I lost my sense of taste and smell, I started seeing articles about this new symptom. That's how it was—bodies in the news, and the news in our bodies.

After I developed symptoms, C and I decided to keep our households separate because it seemed, to both of us, like the safest course. If I got too sick to take care of her, I'd tell him. What would that look like? I wondered. How would I know?

When I stood after picking up things my daughter had dropped or tossed, the corners of my vision fluttered with dark flecks. The virus claimed my bedroom as its own. It was my new partner, wetly draped across my body in the night, salting my sheets with sweat. When I woke in the darkness, I checked

the news on my phone before I could remember not to. When I walked to the sink for water, I had to sit down on the floor halfway, so I didn't faint.

Once I knew I was sick, I waited till late at night and then posted a sign for my neighbors downstairs warning them I had the plague. Every sick person could be someone else's patient zero. The virus briefly turned each of us into a lethal weapon. There was something beautifully grotesque about the phrase *shedding virus,* as if with a black light you would be able to see the sloughed-off sickness like molted snakeskins curled all over my apartment, crumbling to dust.

On Valentine's Day, a month before lockdown, C and I had finally signed our divorce papers. The junior lawyer on my case watched me print my initials forty-eight times, once at the corner of each page of the settlement, and I pictured C putting his initials next to mine, at his own lawyer's office, the next day. I imagined him seeing my initials again and again, each pair confirming this is what I wanted.

After the document was signed, my lawyer told me that in a few hours she was flying to Barcelona for a bachelorette party. Maybe this was her life: divorce settlements every week and bachelorette parties every weekend. A Zen lesson. Never forget this glass will someday break.

Once we'd finished, I hustled to the subway. I had only another half hour of childcare. The day was frigid but bright, the sun suspended above me like a glistening eye. In her drawings that winter, my daughter had started to make messy yellow scribbles in

the upper corner that she called "the cold sun." She was trying to understand, I think, how a day could be full of light without being full of warmth.

That day I was living inside one of her drawings, under one of her cold suns. The chill was stark, but the sky was blue and wide open like a doorway. Both things were true, the bitter wind and the brightness of the sky. Neither one dissolved the other.

In the beginning, we all talked about The Quarantine. As if it weren't plural. As if we weren't all living different ones. I was lucky. I had a job and a home and a healthy daughter. Although I was sick I wasn't in the hospital. People said quarantine was tough on parents, and tough on people who lived alone. Being a single parent killed both birds with one stone.

The inside of my mind was a corridor echoing with the sound of my own voice reading the same picture books over and over again. Mr. Rabbit, I want help. Hello, Stripes. Hello, Spots. Hello, WHOA. What's that? It's a RUNAWAY PEA. Puffins sit on muffins. Snakes sit on cakes. Lambs sit on jams. Little girl, you really do want help.

On our schedule, I'd listed games that seemed impossibly exhausting once I got sick: tea party, dance party, tearing-up-tissue-paper party. The live feed from the zoo was hit and miss. Sometimes it was joyful pandas rolling down a grassy hillside. Sometimes it was just a koala with closed eyes who looked ill, like the rest of us.

It hardly mattered what I put on the schedule anyway. My daughter knew what she liked. Her favorite game was leaping headfirst from the laundry basket onto the hardwood. Her

second-favorite game was stuffing my bras in the garbage. Her third-favorite game was squirting diaper cream onto the floor and then handing me one of her wipes and saying, "Mama wipe."

When I gave her A Look, she smiled slyly. "Wipe, *please*." She knew the drill.

In those early days of the pandemic, I often dreamed about dinner parties I hadn't been invited to. Romanticizing other people's quarantines was just the latest iteration of a long-term habit. Yes, I often wished my quarantine was another quarantine, as I'd often wished my marriage was another marriage. But when had I ever lived inside my own life without that restlessness? Quarantine taught me what I'd been taught so many times before but still had trouble remembering—that there were so many other ways to be lonely besides the particular way I was lonely.

In the meantime, my toddler was pouring shards of pita chips down the neck of her rainbow llama pajamas. She spent her days spearing Internet-delivered raspberries with the baby fork. At least one of us could still taste something. She didn't seem sick at all. It was as if her restless body were living for both of us. She conducted intense, inscrutable projects, using her toy wok to carry my lucky hawk's feather—found in a yard upstate, on a sunny day, in another universe entirely—to her little wooden kitchen, where she stirred it with a little wooden knife. What was she doing? Her eyes gleamed with focus. She wanted to take care of everything. She tried to put a diaper on her wooden zebra. She tried to put a diaper on our Dustbuster. She tried to put a diaper on our tube of Clorox wipes and then tucked it under my comforter, saying "Night, night."

Sometimes, she said, "Mama *help*." She needed something but she didn't know exactly what it was. I knew exactly what I needed: another human body. I breathed the scent of her scalp. I let her press her little toes against my thigh. "Mama *leg*," she said, delighted. Sometimes it was enough just to name the world, to call out its parts.

On Day 8 of our isolation, my daughter glanced toward our window and said plaintively, "Outside." On Day 9, we spotted a toddler in a puffy orange coat lurching toward her father on a driveway across the street, and my daughter called out: "Orange baby!" Seeing another person felt like spotting a celebrity. Once the toddler was gone, my daughter called out: "Orange baby come back!"

The last time I'd felt this far away from the world was also the last time I'd eaten without tasting—at seventeen, when I came home from a week in the hospital with my jaw wired shut and my face swollen past recognition. My mom draped sheets all over our mirrors because I couldn't stand the sight of myself, and squirted Ensure into the gap behind my back molars with a plastic syringe. For two months, I used a notepad to write because I couldn't speak. Years later, I looked back at those scribbled notes, hoping to find shards of profundity, but found only loops of need, *More Vicodin, please. More Vicodin, please. More Vicodin, please.*

No Vicodin in my pandemic apartment. Just baby Tylenol and bananas like mush against my tongue and another sober alcoholic on FaceTime telling me that a few of her sponsees had started drinking again because the Fucking World Was Ending. When rain started falling on the empty streets, I stuck my hand out the

window, just for a moment, just like I pressed my cheek against my daughter's belly, just to feel something that was still there.

During quarantine, I texted with the man I'd been dating that winter. Our first date happened at a dessert bar. What else do you suggest when you meet a sober woman on the apps? The thing I loved best on his profile was a photograph of him smearing black paint across a canvas. The caption said, *See, abstract expressionism is easy.* We met two days after I'd signed my divorce papers. He was divorced too, but he didn't have any kids. He was tall and sandy-haired. He was handsome but his face was hard to remember. He'd gotten a PhD in philosophy but now he worked at a hedge fund. His jeans looked expensive and made me wonder if he had twelve identical pairs stacked in his closet. He did.

He moved and spoke with a disarming mixture of confidence and vulnerability, a man who'd been desirable on the New York dating scene for years but still had the residue of a high school nerd inside. He was so smart it flooded me with adrenaline, as if I were about to do something brave and exhausting just by talking to him.

Not too far into our first date, he asked if my divorce was recent. It didn't seem like I'd been dating for a long time, he explained. I seemed genuinely unjaded. That was his way of telling me he was a little jaded. But his conversation was also animated by genuine curiosity that showed up at surprising moments. When I told him the only time I'd ever flown first class was to Des Moines, his eyes lit up. They actually bulged, almost like a cartoon. Eventually, I'd start calling this expression his slot-machine look, because it made me feel like I'd just hit some kind of jackpot. "First class to *Des Moines?*" he said, delighted. He wanted to know all about

flying first class to Des Moines. He wanted to know all about my midnight Vegas wedding. We talked until the place closed, until the waiters seemed annoyed, until the chairs around us started getting flipped onto tables.

When he kissed me on the sidewalk outside the dessert bar, our kiss had sex in it. I hadn't been sure it would, but it did.

He confessed that his favorite photo from my profile was the one where I was talking to a friend in a bookstore, grinning huge and gesticulating wildly. "That's what it feels like to be around you," he said. I wanted to believe in that version of myself, with a big smile and a lot to say, someone who could make another person, even a jaded person, feel like the world was infinite again.

On our second date, the ex-philosopher and I went to a Korean spa deep in Queens, a four-story red brick palace full of hot plunges and theme saunas arranged in a little village of huts—the ice room, the clay room, the salt room, the gold room. There was a noodle buffet and a rooftop Jacuzzi.

"It's too much for a second date," he told me before we went. He was a veteran dater. He knew the rules. But I wanted to make him do things that were *too much,* like make out with someone in a 180-degree hut with gleaming golden walls, or confess vulnerabilities he hadn't ever spoken out loud. I wanted to coax him into acting like someone he didn't recognize.

Leaning against the brick wall of that fortress spa, we made out like teenagers. I wanted to feel him losing track of time, losing the contours of his jadedness, reaching for me in the dark.

On our third date, we sat in front of an artificial fireplace in

the penthouse lounge of his glass high-rise. The Sky Lounge, it was called. Like the frequent-flier clubs my father frequented. As I leaned my head against his shoulder, he told me he often described himself as the villain in a rom-com. Like, he was the finance guy you *didn't* want the plucky heroine to end up with. I wanted so badly to impress him that I should have just called him Daddy. He peed infrequently, as if he were made of sterner stuff than the rest of us.

It was easy to daydream about building a life with him. Not a return to my youth, as I'd sometimes felt with the tumbleweed—that gushing endlessness, that superlative exuberance, that sense of falling-in-love-with-you-like-we-knew-each-other-in-a-past-life-so-I'm-at-the-front-desk-of-your-Houston-hotel recklessness. This was the opposite, a forward push into adulthood: imagining the brownstone mortgage, more kids, an ice-maker in the fridge, family dinners in a backyard strung with fairy lights. The bourgeois banality of my daydreams was its own humility. Maybe money was just the broken language I used to tell myself what I was really hungry for. The brownstone fantasy was how I told myself I wanted a life that might look—in a decade—as if it had no gash in it.

This was impossible, of course. My life, my daughter's life, C's life—our lives would always hold this rupture. But it soothed me to imagine a time in the future, when I might be remembering these days from the inside of a very different life—a life happening inside one of the townhouses I saw walking home from the subway, their bay windows oozing lamplight.

Even as I fantasized about our brownstone life, that Brooklyn version of a white picket fence, some part of the fantasy chafed, like a pair of expensive shoes that didn't quite fit.

I'd trusted this belief before—that the story of love could save me. That if I could just believe in the narrative, playing like a movie in my mind's eye, it would be enough. It hadn't been. It wouldn't be.

Trusting the stories I told myself about romance made me feel like a moth stubbornly ramming itself against a flickering bulb. The bulb would never be the moon. The marriage plot would never be the moon. Eventually, the moth would sizzle its wings against the bright glass, or else die of exhaustion.

Lurking underneath my brownstone daydreams was a more primal hunger—to be taken care of. This had something to do with money—I'd been paying the bulk of the bills for years—but it had more to do with the fantasy of someone kneading the hard concrete of my shoulders at the end of the day, and telling me to put down everything I was carrying.

In this version of my life, my husband would send me to bed when I got sick, press the cool back of his hand to my forehead, pull my cold-sweat-dampened T-shirts over my head, bring me a bowl of ice cream for breakfast. When there was a tiny finger slippery with ruby blood, he'd grab the princess Band-Aids, or else he'd say, *Damn, we ran out of Band-Aids,* and *we* would be a home his voice had made, rounded like the arch of a doorway.

It was hard to daydream about a faceless phantom, but if I gave this apparition from the future a face—say, the sharp-eyed face of the ex-philosopher—it was easier to believe in him. Easier to believe in the *we* of a doorway lit against the dark. In my life of endless to-do lists, lockstep schedules, white-knuckled refusal to let any of it drop, it was easier to admit how much I

longed for care if I gave this desire a body, and dark expensive jeans to wear; gave it hands stroking my hair, and a voice insisting that I rest.

No matter what clothes this fantasy wore, one thing was clear: it was no longer about building a life, but *re*building one. Any version of this life would be built over the bones of what came before.

I liked when the ex-philosopher called himself a rom-com villain because I'd started to doubt myself as a heroine. For years, whenever I'd imagined myself starring in the movie version of my own life, I thought of myself as a character you might root for.

Now I wasn't so sure. I'd left a man whose first wife had died, a man stricken and traumatized by grief. I wasn't sure anyone would root for me, if she wasn't my friend or my mom. I wasn't sure what narrative arc I was tracing, or what ending I deserved.

When I'd first gotten on the apps, a year after my separation, it felt like poking a vast spiderweb of fragility and need, facing all these blustering performances of masculinity: the Kilimanjaro selfies, the windblown yacht shots, the cultivated leisure poses over frothy lagers. Every profile was an intricate human machine I wanted to take apart and take care of. The Jersey musician/copywriter. The Rikers Island corrections officer. The coffee roaster. The SVP. What was an SVP? The first time, I had to google it. The seventh time, I didn't. Someone in Greenpoint wanted me to know he was passionate about pasta and climate change. Someone in Tribeca wanted me to ask him about the time he'd accidentally killed his sister's hamster. Someone in Chelsea wanted

Leslie Jamison

me to know that one thing he was never going to do again in this life was "eat beets." In one of his photos, he was striding shirtless through a blizzard. He was a possible life.

I tried to imagine how radical honesty would play on my profile.

One Thing I'll Never Do Again: *get married in a Vegas wedding chapel at midnight*

Let's Debate: *if splitting custody makes me less fully a mother!!!???* ☺

Toward the bravado of all these men, I felt an impossible swelling tenderness. Brimming like a too-full cup of coffee. As if I were a mother to them all.

I'd been dating the ex-philosopher for a month when the world came to a halt. My university closed. The grocery stores ran out of cleaning supplies and hand sanitizer. The ex-philosopher texted to say he had a fever. It didn't feel like anything major, he said. His doctor said it wasn't the virus, because he wasn't having trouble breathing.

His fever lasted two weeks. By the time it broke, I was sick too—and both of us knew to call the illness by its name.

During total isolation with my toddler, the days were endless and also irrelevant. Tuesdays were Wednesdays were Fridays, except sometimes it was raining outside and sometimes it was sunny and sometimes someone broke into the vestibule of our building to ransack the Amazon packages.

Our days were full of repetitions, clicking like a metronome: the teakettle shrieking, the clatter of oatmeal-crusted bowls in

226

the sink, the toddler scattering her tiny hats and gloves across the floor for the umpteenth time, then saying, "Mama FIX it."

As a way of marking time, I tried to feed her something new each day. Boiled zucchini, sliced rings of pineapple, raspberries before they fuzzed with white beards of mold. Pasta shaped like bow ties. Pasta shaped like wagon wheels. Peanut butter straight from the jar. Sometimes I caught myself gazing at her with jealousy. She could still taste. I missed the taste of chocolate, the taste of apples, the taste of cheddar cheese, even the taste of the instant coffee I drank when the good coffee ran out. I missed smells I'd never even loved: plain yogurt, Windex, the vegetable reek of a mold-spotted cucumber. The urine tang or compost stink of my daughter's drooping diapers.

Once rumors of lockdown began, the grocery stores had been full of empty shelves and overflowing carts: the woman hoarding cat food and instant coffee, the man whose arms were loaded with soap, as if he would do nothing but clean himself until the end of time.

Ten days into isolation, once my apartment was full of bulky recycling bags, I googled *toddler art project + old trash*. My daughter and I ended up drawing a road on the back of a flattened cardboard diaper box. We pasted illustrations from a picture book whose pages she'd torn out. In pink marker, I copied a quote from a poem Sylvia Plath had written for her newborn son: "Love, love, / I have hung our cave with roses..." Old trash was the new cross-stitch. My daughter scribbled over the Plath with marker, and the words felt truer obscured by her messy circles, spackled with her fish stickers.

After I'd gotten her to bed, the ex-philosopher and I sometimes

went on dates by watching the same movie at the same time, from our separate apartments. We live-texted furiously. We leaned toward camp. When we watched *Labyrinth,* we texted about the little puppet worm wearing a scarf, and the open-secret sex appeal of David Bowie as Jareth the Goblin King. When we watched *Indiana Jones and the Temple of Doom,* we tried to find the right emojis for the dinner party where the giant snake was full of little wriggling snakes. When the evil sorcerer held up the beating heart of his human sacrifice, wearing a skull helmet that curved down toward his mouth like a microphone, I said it looked like he was ready to give a TED Talk. This got the *haha* emoji response, and I felt the adrenaline rush of a small victory.

This still gave me pause about our dynamic—how much I wanted to impress him. I thought frequently about a conversation we'd had in that rooftop Jacuzzi, on our second date, when I'd told him about being morbidly shy in junior high school, lying in bed at night trying to figure out how to respond the next time one of the popular girls asked why I didn't shave my legs; or what to say to the popular brother and sister I drove to school with, all three of us ferried by a handsome stoner senior who played Phish live jam sessions in his VW van. I hated the music, but bought my own Phish CD anyway—desperate for blueprints of how to be. Arriving at college, after years of saying nothing, I'd groped for a way out of that spectral husk of a self: binge-drinking my way through late nights at the lit mag, collapsing into the ratty red velvet couches, finally finding a place where I belonged.

"Hmmm," he said after a moment, squinting at me. "That's such a...standard story."

I blinked at him.

"There's something so *familiar* about it," he said, then put up scare quotes. "'Shy girl finds herself in quirky creative community.' Like it's from a movie or something."

The child in me felt like I'd failed. Huddling in that chlorinated water, I rummaged around in the drawers of myself, looking for a less standard anecdote—one that might be good enough for him.

Later that night, I asked the ex-philosopher if he thought it was accurate to say some people were more interesting than others. "Or is the concept so subjective that for anyone—like, *anyone*—there is someone else who would find that person the most interesting person in the world?"

I was pleased by the generosity of this notion—that every single person was the most interesting person in the world, to *someone*. We were in a room with golden walls, hot as an oven, like an oracle's cave—a place where truths like this could be spoken.

"Oh," he said, "I think some people are just boring."

My mother is the only person I've never needed to impress. During our morning commutes to elementary school, stuck in gridlock on the 405, I sat silently in our silver Toyota, thinking nothing of the silence. I only thought of that silence years later, when I realized that I'd never been comfortable in silence with anyone else.

After jaw surgery, when my mouth was wired shut, my mother was the only person I wanted to see. I felt too depleted and boring for anyone else, my little notebooks peppered with scribbled anxieties too banal to share with anyone but her, begging her to put

a pair of scissors on my nightstand, so I could cut my wires open if I ever threw up in my mouth. I had no profundity to offer, only tedium and request. Her love was not a fish I did my seal tricks for. As long as she never died, I would be okay forever.

After my daughter was born, it felt easy to share the newborn days with my mom, their repetition and delirium, endless glasses of ice water, tiny diapers full of mustard poop—because she'd always been glad to dwell in the most humdrum parts of my existence.

Whenever I sat for long stretches with my daughter during quarantine, reading the same picture book for the fourteenth time; or hiding the squeaky giraffe behind the chair, then revealing it, doing it again, and again, and again—I tried to think of my own boredom as a gift I was offering her, the fact that she did not have to interest me, that this was not something I required of her.

All those hours, my boredom reached back to the younger version of myself, who felt she wasn't allowed to bore anyone. Anyone except her mother.

In recovery meetings on Zoom, the other sober folks sat in Brady Bunch boxes on my screen, their cats' tails swishing across their computer cameras. Our ragged voices recited the serenity prayer out of sync. One of the best things about speaker mode was that it let me scroll away from my own face. This was what recovery had been inviting me to do for years—get away from myself.

Remembering basement meetings, I yearned for their physicality: the creases of strangers' papery palms against my own; the stem of a plastic fork still warm from someone else's grip as

I pronged a vanilla-frosted slice of sober-anniversary cake; the raspy voices and minty gum breath of chain-smokers offering collective prayers.

In recovery, I'd spent a decade trying to move past the melodrama of self-hatred. But during my divorce, the siren call of extreme thinking got so powerful again—the urge to see myself as either innocent or diabolical, when of course I was neither, and C was neither.

I wanted to learn how to treat myself more like a stuffed animal—the way my daughter tucked her stuffed fox under a blanket tenderly each night not because it had been good enough, but because it needed to sleep.

One afternoon the ex-philosopher sent a more emotive text than usual.

"It's begun to set in with me how much you've been through over the last couple of weeks: 24/7 childcare without backup, the emotional toll of pandemic and self-quarantine, keeping up with work, all while being sick. It's really a lot."

I nearly cried when I read it. My throat clamped up; I tasted salt. I felt overwhelmed by the size of this longing—how much I did not want to be alone.

I felt like I was going feral, spending this long away from other adults, holding open my palm to receive the wooden lemon my daughter had cooked in her tiny frying pan, its two halves stuck together with Velcro; then watching her take care of our last remaining tube of Clorox wipes as if it were her child—fastening a bib around its neck, tucking it under my palm-frond duvet. "Can you make him some rainbow tea?" I'd ask her, when the Clorox

tube woke from its nap, giving her a project just to buy me five more minutes to return work emails. I was overwhelmed by work, and how none of it was getting done, but also grateful for the reminder that my life was more than these endless rhythms; that it was larger than a wooden lemon with a Velcro heart.

Without childcare, the only time I could teach was at night, after putting my daughter to sleep. So I leaned back against my headboard with my earbuds tucked in—lifting one out every twenty minutes or so, just to make sure she wasn't crying—and spoke to the rattled, earnest faces of my students in their Zoom boxes.

One student wrote about an old photo of Brigitte Bardot gnawing on a chicken thigh, which was a way to approach her anorexia; one wrote about cussing at her betta fish, which was a way to approach climate crisis. In our one-on-one conferences, when they told me they were having trouble writing, the mother in me thought, *Of course you're having trouble writing. The world is broken. You haven't seen another human being in two weeks.* The *other* mother in me—the tired mother, the impatient mother, the all-day-long mother—thought, *How are you having trouble writing? If you don't have a child, you've got nothing but time.*

Smell came back slowly. I couldn't tell if the faint, almost floral taste of cantaloupe was really there or not. It kept flickering in and out, like a stuttering light bulb. My first taste of peanut butter, its faint nutty sweetness, was like a stranger standing at the end of a long corridor, barely visible but *there*—more than six feet away, but better than no one at all.

It made me giddy, the return of these everyday smells. The waft of roasting coffee, the faint residue of sliced apples on my fingers, the scent of my daughter's curls when she first crawled out of bed, caught somewhere between soap and honeycomb— ordinary and holy.

When we finally left our apartment, it was like returning to a ghost town. Playgrounds were locked. Shops were closed. DUE TO THE SPREAD OF COVID-19, WE ARE CLOSED INDEFINITELY. Their handwritten signs summoned the apocalypse films I'd loved back when they'd seemed like fantasy rather than prophecy. People walked loops around the park in masks. Buses rolled down Seventh Avenue without passengers.

Near the Gowanus Canal, the South Brooklyn Casket Company was still running, its warehouse full of coffins glinting in the sun, workers in their blue masks loading them into trucks. The canal itself was an avenue of greenish water slicked with rainbows of oil.

Years earlier, I'd come to the Gowanus with a friend on Valentine's Day. We'd written wishes on tiny pieces of paper and shoved them into bread loaves, then thrown these loaves into the dirty water. It was a love spell. A few weeks later, I met C.

It's what the fairy tales have been trying to tell us for centuries. Don't be afraid of never getting what you want. Be afraid of what you'll do with it.

The city had been throwing waste into the Gowanus for years. At the bottom of the canal, there was a ten-foot layer of chemical sludge called black mayonnaise: half coal tar, half sewage. But

something about the landscape was oxygen to me. It all carried the filthy, stirring energy—almost sexual—of a place that wasn't supposed to be beautiful but *was*. Toxic and shat-upon and glimmering in the sun. The surface of the water was full of swirling oil slicks that looked like internal organs: spleen, stomach, small intestine. I could have spent hours watching them emerge and dissolve, if I wasn't watching my daughter's body instead, making sure she wasn't wriggling between the fence slats and hurling herself into their dirty rainbows.

Every time my daughter saw the little boat moored behind gleaming tangles of barbed wire, she cried out, "My airplane!" She loved to take tiny twigs and push them through the fence so they could swim in the dirty water. She loved running in the grassy enclosure bordered with signs saying, DOGS KEEP OUT. She loved scooting her little butt down the wide stone railing beside a set of steps. "This is my little slide," she said, very matter-of-fact. She made it what she wanted it to be, just by deciding to use it that way.

When I blew soap bubbles for the other toddlers at the canal park, you would have thought I was a fucking god. I felt grateful for the sunlight on dirty water, for the sulfur breeze, and for the guy running a metal detector along the muddy banks. He never gave up hope.

When the city started cleaning up the canal, dredging up the black mayonnaise, it was bittersweet—like a bartender kicking out a beloved old regular at closing time. He stank a little, but what would things be like without him? Where would he go?

Once I'd fully recovered, C and I returned to our regular custody schedule. We didn't want to ride buses, so we walked

between our apartments, six miles round-trip, pushing the stroller along quiet sidewalks, and then back again, empty.

The first night my daughter spent with C, I met the ex-philosopher. It felt vaguely reckless and indulgent, even though we'd both recovered. In those days of strict quarantine, it seemed like the only people you were allowed to see were family, and we were not family. But I was desperate to see him. It had been almost a month since I'd spent time with anyone besides my daughter.

When we hugged, he blurted out, "I got nervous on the way over." I felt nervous too. I'd been so long in the world of my daughter; I had to summon another version of myself for him.

Prospect Park was emptier than I'd ever seen it. We sat together on a craggy rock at the top of a grassy hill. The whole night had an epic, almost cinematic sheen—wisps of cloud against the moon, his hand in mine—but the rock itself wasn't comfortable. It dug into me like a tricky follow-up question, like the subtext of his company.

Back at my apartment, we made tacos—the kind with hard yellow shells, from a box—and filled them with glistening sautéed mushrooms, salty as seawater, and refried beans from a can. He clapped his hands at these creations, delighted like a child. He loved the cardboard road my daughter and I had made—wanted to know which parts of it she'd done. "She made that purple scribble over there," I said, "and that big slash of marker over there."

We talked about my daughter in this way, as a set of curated anecdotes—a few representative details. But it made me nervous to think about sharing the actuality of parenting with him: the constancy and repetition, the ways it was neither new nor revelatory in most moments, just more of itself.

He confessed that when he'd said he was nervous to see me, he meant that he'd wondered if I would be oddly calibrated after spending all my time with a toddler. I imagined a version of myself regressed to my daughter's toddlerdom: smearing avocado across my face, drawing on the walls with marker, no longer telling him standard stories about college, just thrusting a tiny wok full of wooden fruit into his face, saying, *Eat.*

But also, it was good to see him. To feel his arms around me. We opened a tube of raw dough and baked cookies at midnight, ate them with glasses of cold milk—standing by the stove in nothing but our socks. I was glad to taste them, their butter and salt, and the chocolate on his tongue when we kissed. The midnight milk was pure and rich and ours.

Sometimes I imagined introducing the ex-philosopher to my daughter, but couldn't quite imagine who I would be around them both at once. The first time he entered my apartment, he'd remarked on her tiny shoes. How sweet. And yes, they were. He wondered what she was interested in. It took me a few seconds to reply. She was two. She was interested in climbing on stuff and jumping off stuff. She was interested in putting diapers on cleaning supplies.

Sometimes I looked at his life and saw emptiness. Sometimes I saw freedom. His childless divorce seemed like a more manageable history than my own. When he eventually got married and had a child—as I was sure he would someday, even if it wasn't with me—he'd be starting with a clean slate. His story could be whole and right.

When he'd first told me the story of his marriage and divorce,

now seven years behind him, I could hear genuine pain in his voice, but also the well-worn grooves of an oft-told tale. I asked if he felt like he was still learning things about his divorce; if he was still discovering what the experience had meant to him. He said no, not really. Every time he told the story, it came out roughly the same.

On Sundays and Wednesdays, the ex-philosopher and I took long masked walks through the empty streets of Brooklyn. He liked my apartment because it was low enough to hear the birds sing. For weeks, he was the only other adult I saw. Our dates were the only time I wasn't with my daughter. Most of these nights, we ended up back at his apartment on the seventeenth floor. His glass walls overlooked the neon signs of an over-crowded hospital. He kept a flock of plants that were his fragile, silent children. He had a banana tree so tall it strained against the ceiling, and a rubber plant that oozed white sap from its trunk. He cooked us stir-fries full of tofu skins and Chinese broccoli. He would often preface things he told me about his job, his home, his exes, by saying, "The thing I always say about this is..." Letting me know I was getting a secondhand sentiment. A polished stone of selfhood.

His shower was a graveyard of expensive conditioners left by other women he'd dated. When I asked if it stirred up old feelings to see things that belonged to his exes, he said no. I nodded, receiving the news about this different way of being alive.

Ever since his divorce, he'd dated many beautiful, interesting, intelligent women—and had fallen in love with none of them. Listening to him say this was like receiving an assignment. Break

his pattern. My own pattern involved turning men into assign-
ments. Make him faithful. Make him fall in love with you.

Intellectually, I knew that love wasn't an assignment—
something you could excel at, or make yourself good enough
for—that it existed outside these logics of achievement and was
more about failure, and wanting, and trying. That it involved
being an imperfect version of yourself—grouchy and defensive,
telling the same story over and over again—and feeling *this* self
loved, too. Viscerally, I wanted to experience the sort of love that
could liberate everyone involved from their hamster wheels of
self-performance.

Often, my conversations with the ex-philosopher felt like jam-
ming together two jigsaw pieces that almost fit, but didn't. He
told me once that it seemed boring to drink alone at home. He
couldn't imagine what you would *do*.

"Oh, there's plenty of stuff you can do!" I said, too loudly. "You
can drink straight from the bottle and read old emails from exes."

He squinted at me, not cracking a smile.

"That's just one example," I said.

Could I say another thing about getting drunk alone that he'd
find funnier? Did he realize I'd been kidding? And *had* I been
kidding? I mean, it wasn't a joke insofar as it was something I'd
done many times.

Every day he sat in his living room for back-to-back Zoom
meetings. All his colleagues had escaped to their country homes.
Once I overheard one complaining about the fox who kept get-
ting into his swimming pool. Over the phone, I told my therapist
I loved how he got so immersed in his work that I'd be standing

in his kitchen, doing the dishes right in front of him, and he wouldn't even realize I was there. Saying this aloud, I could hear the way it reeked of childhood: the absent father at his desk, or on some faraway airplane in a darkening sky. The only attention worth getting was the kind that wouldn't offer itself to you. Or else it came when you'd done something that required correction.

One time, as I was making us sandwiches, he was watching me spread the hummus so intently that I finally asked, "Is there another way you want me to spread the hummus?" A thirty-six-year-old mother, asking this man if there was another way he wanted her to spread the hummus. A quiet voice inside me said, *You're doing it fine,* but another voice was louder. It said, *If you get this right, maybe it will be enough.*

On the mornings I spent at his apartment, he always brought me the same breakfast: plain yogurt mixed with frozen blueberries, partially thawed into a smear of purple slush. I didn't like it that much, but I ate it anyway, because he'd made it for me, and it felt so good—even in this small way—to be taken care of.

My daughter's favorite new hobby was tapping her little fingers against the kitchen table and saying, "Mama write eeeh-mail!" Mama had a lot of emails.

During our first faculty meeting on Zoom, I kept myself muted while she sang "Let It Go" and brought her face as close as possible to my screen, confused about why these faces weren't responding more enthusiastically to her performance. She eventually retreated to the couch to flip through picture books.

After a few moments of quiet, my chat jumped with a private

message: *Leslie look behind you!* When I turned back, she was jumping off the bookshelf.

This was the other side of working from home without childcare, not just the futility but the exposure—your inattentive parenting broadcast to your colleagues. *Please watch me Not Be Enough in two ways at once.*

She was fine! She was easily bribed with a granola bar. Before I knew it, she was trying to serve everyone rainbow tea, thrusting a little wooden cup toward the face in every square.

During a Zoom reading a few weeks later, she discovered my secret stash of cigarettes and tore one open like a tiny burrito, spreading loose tendrils of tobacco all across the floor. I was reading an essay about quarantine parenting, and now—suddenly in frame—she was demanding that the audience hold not only her curated presence, but her actual presence, her wry grin and plundered treasure. She'd taken the version of myself I performed for the world—poised as a tight-rolled cigarette—and scattered my self-possession like a pile of tobacco tendrils. I was a tangle of tea leaves spread across the floor. A prophecy too messy to decipher.

That spring I was writing an essay about the artist Donald Judd. Writing it on Thursday mornings, at least, when I woke up in the ex-philosopher's glass high-rise. I'd always found Judd's work austere and unyielding: Concrete boxes lurking in the middle of galleries. Metal slabs that other people found profound.

A few weeks before lockdown, I'd taken my daughter to see a retrospective of his work at MoMA. Never before had it been so

clear to me how much his objects looked like playground equipment. His ladder of burnt-orange rungs looked to her, *clearly*, like a jungle gym. The red circular tube on the floor might be an empty kiddie pool? She wanted to climb on all the objects—or through them, or over them.

The objects. I'd trained myself not to call them sculptures, because Judd hadn't thought of them that way. And neither did my toddler! She wanted to crawl through the blue steel boxes, to bang her tiny fists against an iron slab. The one thing she didn't want to do was stay in her stroller. Her eagerness to touch Judd's work—to bang on it, climb on it, crawl beneath it—was undistracted by any search for latent meaning. She was an unwitting, squirming disciple of his famous pronouncement that "a work needs only to be interesting." The phrase had always made me hear my mother describing her twenty-two years of marriage to my father: "Well, at least I was never *bored*…"

Judd's boxes and ladders were impeccably crafted, stark in their silhouettes, and utterly sure of themselves, but they made me feel nothing except inadequate, for failing to understand them. His sleek boxes responded to my hunger for comprehension with a reticence close to silence. His art felt like yet another impassive male face in which I was hunting for an aperture. Now I was trying to write the essay about Judd's opacity while taking care of my toddler during quarantine, which felt a little bit like trying to talk to my dad about the Russian GDP while keeping her from climbing out of her high chair.

When we'd visited the Judd exhibition together, I'd told myself I would return alone to have a "real" experience of the art. With a few quiet sessions in the galleries, I might become the

kind of astute critic who could decode Judd's concrete boxes. But of course this didn't happen. The world shut down instead. When the exhibition catalogue arrived in the mail, my daughter pulled it off the coffee table and climbed on top of it, saying, "Baby climb mountain!" She cracked it open and hastily turned its glossy pages, muttering, "Pictures, pictures, pictures."

To me, Judd was the ultimate Distant Daddy artist. But part of what began to compel me about him was the fact that—as it turned out—he'd made much of his artwork while taking care of his children. He'd been a single dad.

Years earlier, when I'd visited his home in Marfa, it hadn't looked like a home that had ever been inhabited by children. It was a boxy, symmetrical space, with a kitchen full of furniture that looked a lot like Judd's art: simple silhouettes, perfectly crafted. The space was uncluttered and intentional—as if daily life could become an art object, as if living were something that could happen without making a mess.

But it turned out Judd had raised his children there. When he and his wife separated, Judd brought his son and daughter (then nine and six) to live with him in Texas. He fought for primary custody at the Presidio County Courthouse. There was an unexpected pleasure in reading these words, *courthouse* and *custody fight,* knowing that even this maker of clean, elegant objects had led a messy life.

Later, I would read that Judd had removed the bathroom of his home to make the interior more symmetrical. He built a freestanding adobe bathhouse nearby. A particular way of living—perfectly symmetrical, but you have to shit outside.

On one side of the house, beside his daughter's room, Judd had planted an alley of grass and seven plum trees. By way of explanation, he'd said only, "She wanted a yard."

For my magazine article, I was going to interview Judd's son, Flavin, about what it had been like to grow up with Judd as a father. I scheduled our interview for the time of my daughter's afternoon nap—or rather, the window of time in which I thought her nap was most likely to happen.

When we got on the call, I thanked Flavin for taking the time. He said, "Isn't that the one thing we all have too much of right now? Time?"

"I know you've got kids," I offered.

"They're somewhere else," he said, but not in a way that invited follow-up questions.

During his early childhood, Flavin told me, his father's art had filled their SoHo loft. As soon as Flavin learned to walk, he learned, "Don't walk through the art." When he was six, he started to draw plans for objects of his own. Not boxes, like his father made, but triangles. These triangles moved me. They seemed like an attempt to engage with the parts of his father he wasn't supposed to touch—and also a way of making the art his own, by changing the shape.

Flavin told me that his dad was the only single father making lunches for his kids in Marfa, though he also said his dad would ask him and his sister to keep their milk cartons under the table, because he didn't like how they looked.

When I asked Flavin how his father's life as a parent had shaped his life as an artist, I was desperate for him—really, for

anyone—to tell me that being a parent meant you could make art that wouldn't have been possible otherwise. If my days were spent peeling stickers off hardwood, setting up tea parties for stuffed flamingos, and wiping diaper cream off the crib bars, then I needed someone to say that art can happen inside these days, too. Not only that, actually—but also that they enable art that wouldn't have existed otherwise.

I'd written a book about sobriety and creativity, and maybe parenting was the new sobriety—a condition of regularity, rather than recklessness, that I needed to prove generative; a way of living built from daily accumulations more than epiphanic watersheds. You didn't write in the glow of your own self-immolation, but in the puddled light of a cell phone screen, or by the metronome of a breast pump.

Flavin wouldn't give me what I was looking for. Or at least he wouldn't give it to me in the shape I'd been expecting. He insisted that parenting hadn't influenced his father's art-making; they were simply two practices inspired by "the same philosophical system." And what was that system? Stripping away the gauze of tradition and replacing it with careful attention to the proximate world—its shapes, its materials, its horizons.

Had there been times "the philosophical system" hadn't fit together so cohesively? I suspected it had sometimes been exhausting for these kids to be raised by a father with such a demanding, rarefied concept of attention. I found it oddly reassuring to discover a photograph of young Flavin watching television with his mother.

Some part of me railed against this easy refutation of influence—felt that it was somehow a luxury, or an act of denial,

to think of a father's art as *un*informed by his children. Having a consistent philosophical system seemed more possible to imagine with a nanny.

But just as I began to press this question with Flavin—of *course* being a parent influenced one's art, didn't it?—my daughter started crying in the next room. Maybe she'd had a bad dream. Maybe her diaper needed to be changed. In any case, she was awake. She needed me. The conversation was done.

It was hardly surprising that I'd recognized Judd as a Distant Daddy rather than a single father. I was primed to notice one archetype more than the other.

But of course there was another single father right in front of me, right on the other side of the East River: my daughter's father. He was raising her on his own just like I was, just as he'd never wanted to; struggling to devote himself to his art too.

The mornings I perched on the ex-philosopher's stark white bed, facing his tall windows, it wasn't lost on me that there were certain similarities between him and Judd—or at least, in how they both made me feel: messy and needy, not sure how to read their elegant, self-assured surfaces. In his living room hung the three canvases he'd been painting in his profile photo. *Abstract expressionism is easy!*

Sometimes when I worked in his bedroom, listening to his Zoom calls beyond the wall, I imagined reading him the paragraph I'd just written, wondering if he'd find it smart—just as I sometimes imagined dead Judd rising from the grave to read my words and judge them.

One Sunday night at my kitchen table, the ex-philosopher told me that there was something about our conversations that felt unsatisfying to him. His comment was like a heat-seeking missile the universe had sent to destroy me.

He actually said it this way: "It feels like our conversations are about 85 percent as good as they could be." When we talked, he said, it felt like we were always driving on the back roads, never on the freeways. I wanted to ask, *Why would you rather drive on a freeway?*

He tried another analogy. It was like we were going to a museum, and the first case was full of Byzantine coins. "And I *like* the Byzantine coins, I'm *interested* in the Byzantine coins," he explained, "but I don't want to spend *the whole time* at the Byzantine coins."

These metaphors were like little sculptures he'd been carefully whittling for the entire duration of our relationship. A different person might have cut him off. But I was a person who wanted to hear every single one. It felt like I was studying for a test, and this was the only way I could correct my own mistakes. It was like a drug I couldn't give up, or a false prophet I'd followed—the fantasy of being interesting enough to deserve love.

After our conversation that night, I filled the last page of one of my writing notebooks with things I wanted to say to him, divided by subheadings, *a, b, c,* about our different styles of talking, our different ways of being, how interesting it was that we were different in these ways and how we might speak better across them. Part of me felt sad each time I spotted those notes at the back of my notebook, which was otherwise full of outlines and brainstorms for my Judd piece, lesson plans, and notes on student

essays; the handwriting was looping and messy and it filled all the margins. Now at the end, in tight print and neat bullet points, I'd written myself a set of instructions for how I might better compel him. A revised blueprint for myself.

The frantic drawer rummager inside me was still hunting for a better anecdote to explain my own vulnerability—and now also trying to figure out if I could just spend less *time* on everything I talked about, so I could be exactly the person he wanted.

Could it be true that my mother had never been bored by my father? Didn't everyone sometimes bore the people who loved them most? Wasn't that ultimately a more sustainable notion of love, anyway—a love that wanted to involve all your tedious moments, rather than turn away from them?

When the ex-philosopher eventually broke up with me, it happened on the steps of a church. I made him take off his blue disposable mask because it felt too sinister to be romantically rejected by a man wearing a surgical mask, like he was maybe going to operate on me after he was finished breaking up with me.

When I finally stood up to leave, he asked if he could give me a hug.

I said no. Without any explanation, or apology. What little person lived inside me, saying no like that? She was someone I wanted to get to know better.

At first I wanted to believe the injury was only to my pride, not my heart. Like when a car ran over my foot, years earlier, and I knew I'd be fine—even lying flat on the asphalt, surrounded by tiny key lime pies, already saying, *I'm okay I'm okay I'm okay.*

Sitting on the church steps—with a mask balled up in my pocket and a rom-com villain holding my hand—I knew I wasn't broken. The things that might have broken me had already happened. I just wanted my hand back.

The day after the ex-philosopher became the *ex*-ex-philosopher, I saw a guinea pig running free in the park. More like *scuttling* free, on his tiny legs. His tufted fur was toffee and white, like one of those chewy caramels wrapped in wax paper. He kept returning to the same picnic blanket to nibble carrots from the fingers of his owners, who said his name was Peanut. Some part of me knew that the fact of Peanut in the world, the way he made me feel that day, mattered more than the ex-philosopher ever would.

Or at least, that's what I wanted to believe—that my capacity for wonder was stronger than my resentment, that I cared more about the teeming girth of the world than the rejection of a rom-com villain who wasn't right for me anyway. Sure, yes. But also, I was angry.

Have you ever woken up next to someone in an eye mask? I have. In his glass high-rise. It was like getting fucked in the middle of the Javits Center. All those windows overlooking the plague city. He was a moral vegetarian already making money off the pandemic recession.

Something about my anger felt energizing—the pure song of it, the river, the fire. Maybe it was something about its baffled, misdirected honesty, the way it said, *This hurts!*

My anger was completely out of proportion. He hadn't done anything wrong, only decided he didn't want to date me anymore.

My therapist asked the natural question: "Is it really him you're angry at?"

The only thing the ex-philosopher and my ex-husband had in common was that both of them invited me to live in the story of our relationship rather than its daily texture. Saving the widower from his grief. Saving the ex-philosopher from the vacuum of his finance life.

This was one of the lessons I kept learning: the difference between the story of love and the texture of living it; between the story of motherhood and the texture of living it, the story of addiction and the texture of living it, the story of empathy and the texture of living it.

What I wanted to say to the ex-philosopher on the church steps, with our masks dangling around our chins: *Tell me I'm good enough for you!* And also, *Free me from the endless work of being good enough!* Some part of me had certainly sought refuge in this work. Worrying about being good enough distracted me from thinking about my role in the end of my marriage.

Maybe that's why I kept showing up for him anyway, the old groove of *Am I Am I Am I enough.* Don't tell me I'm spreading the hummus wrong. You never made a daughter. You never kept another human alive from your own meat.

After my foot was run over, my broken bones became visible only as they healed. Thick white calluses emerged on my X-rays as the fractures repaired themselves. It was like that with the ex-philosopher too. Only with time did I start to see the ache of losing him more clearly—not *him,* exactly, but those daydreams

of another life. My future had no face, so I'd given it his face, for a while.

Looking back on our months together, I saw a woman sitting in a big T-shirt hugging her knees close to her chest, talking to a perpetually calm man about his divorce; a woman who cried at the text saying, *It's really a lot,* who needed to hear it.

The shame I felt at being broken up with made me wonder—not for the first time, but with a new acuity—why I always wanted to be the one who ended things, why I still wanted to be the one who was desired more, as if this was the most meaningful form of power I could imagine. If I was always the one who left, I might end up alone, but at least it would be an aloneness I'd chosen.

In the aftermath of my marriage, this power had come to feel claustrophobic and corrosive—and then I got dumped, and I didn't even have it anymore. Maybe the fear of being left was just a way I protected myself against the deeper fear that I'd always, eventually, want to leave.

But the fact that you didn't have to do everything you wanted to do? That you weren't beholden to every feeling you had? That was hope.

The ex-philosopher wasn't my happy ending, and he wasn't an epic punishment, either. He was just an opportunity to stand in the muck of hope and uncertainty, swiping and tapping. As it turned out, I was neither a villain nor a goddess, but just—as they say in recovery—a woman among women, a person among people. No better or worse than the rest.

Crazy to say so, but being rejected felt like free fall—as if one

person not loving me meant that I wasn't good enough for any-one to love. I clutched at certain fantasies of purity that I was too ashamed to name: intimacy without boredom, love without contingency, beauty unhaunted by guilt; an experience of moth-erhood that wasn't shadowed by divorce.

But I was learning that intimacy was always riddled with the things I feared would destroy it: tedium, resentment, festering hurt. My love for our daughter would always hold the vows I'd broken, alongside the versions of our life I'd dreamed, and then buried, and then grieved. There was no living apart from this grief, and no end to it—the mistake had been believing that a good life had to remain unsullied by it.

My daughter had a set of puffy stickers she loved to use as tiny dolls: a man farmer and a woman farmer, a papa chipmunk and a mama chipmunk. Each one was about an inch tall, with a sticky back that got covered with grit and dust because she refused to put them on their laminated backdrops: the hayloft, the pasture, the chipmunk cottage. Instead, she gave them baths and dried them with a washcloth, then tucked them under a blanket to listen to stories, then placed them face down on the couch to sleep.

One day she told me she wanted to take her sticker family to her dad's, so we put them in a little Ziploc sandwich bag and car-ried them with us. They were little diplomats traveling between two hostile nations.

When they returned, the tall farmer had a short dark hair stuck to his back. It was the closest I'd gotten to C's hair in a year and a half, the hair that used to be all over our pillows, mixed

with mine, and caught in the shower drain we shared. Now it was like a relic, something exotic and precious—the only part of him I could still touch.

One day my daughter came back from C's apartment and told me about a plastic cupcake she'd accidentally flushed down the toilet. She'd been very sad, she explained, but then Daddy had gotten a letter from the cupcake. It was having an adventure at the bottom of the ocean! It was happy down there. Turns out the cupcake was making friends with a seahorse, a starfish, and a shark. It was probably going to send another letter soon.

I recognized the voice of that letter. I'd known that voice once.

Over and over in my mind, I replayed one moment from the beginning of the pandemic, the last drop-off before I got sick, when I looked at C and said, "Take care," and he looked and me and said, "Take care."

In those quarantine days, I circulated gratitude lists over email with the other folks in my recovery meetings. Usually my lists started and ended with my daughter: how she gave both of her stuffed foxes hugs so neither one would feel neglected; how she hunched over her little wooden kitchen, frosting her wooden cookies with diaper cream, shooting me a look when I said her name, like she was *just too fucking busy*. I loved how she put the blanket over me on the couch, saying, "Mama cozy also"; how she begged for FaceTime with Taco the lizard; how she said "rains," plural, as in "all the little rains." How she loved the manatee sticker she called Big Boy. How she pointed at the photo of me

pregnant in the hospital waiting room and said, "Baby still in the mama house."

She liked to sort the world into mama things and baby things: mama fox and baby fox; mama pear and baby pear; mama stick and baby stick. In this way, she was making sure that everything in the world was getting taken care of.

Loving her wasn't a pure feeling. It was an everything feeling. It shuttled back and forth between wanting to merge with her completely and wanting to flee. Was my love for her contaminated by checking email every two minutes on my phone? Did this polluted attention count? And who was doing the counting, anyway?

My notion of divinity was gradually turning its gaze away from the appraising, tally-keeping, pseudo-father in the sky who would give me enough gold stars if I did enough good things, and toward the mother who'd been here all along—with less patience for my performances and more patience for everything else. I was living toward joy that was less about earning, and more about ambush. A joy you might call grace.

When summer arrived, the world started opening. One Sunday after drop-off, I drove out to the Rockaways with a friend. We parked behind an overgrown bodega called Pickles & Pies, then laid our towels on the hot sand as a huge rainbow jellyfish kite rippled above us in the sky.

Nearby, a man sat alone on a blanket grounded with little plastic anchors. There was something poignant about all his neat edges: his crisp cubes of watermelon, his blanket keeping its steady square against the wind. In this pandemic world, he

was determined to have an experience play out exactly as he'd imagined it.

Meanwhile, families all around us surrendered to the chaos of spilled orange soda and sand-crusted sandwiches, licking neon-bright Dorito powder off their fingers and passing out plastic shovels to their children.

Whenever I wasn't with her, children were always exactly my daughter's size. Or else they were the size she had just been, or the size she would be.

At twilight, my friend and I smoked cigarettes beside sand dunes full of seagrass rippling in the wind. Behind our sunburned bodies, the shadow of a nursing home stretched longer and longer across the sand. A woman in a bikini danced to the salsa music from a boombox perched on someone else's towel. It was a form of communion, a way of touching without touching—one stranger dancing to another stranger's music.

Those families on the beach were a reminder of what I'd chosen to break. But I knew this would happen no matter how I lived: I'd spot the impossible ideal somewhere else.

This was the summons—with motherhood, with romance, with everything: To stop fetishizing the delusion of a pure feeling, or a love unpolluted by damage. To commit to the compromised version instead.

In my firehouse days, a friend told me that surviving divorce isn't about getting what you want, because you won't. It's about making the best life you can, with what you get.

In July, I drove with my daughter to visit Casey and Kathryn

on the Eastern Shore of Maryland. These were the friends who'd gotten married just six months before my separation, and then come up to Brooklyn with their power tools, a year later, to help build my furniture.

One of my least favorite things about being a single mother was getting the car packed for road trips, which felt—without the presence of a second adult—like a punishing logic puzzle. How do you get the sheep across the river without leaving them alone with the fox? How do I get the bags downstairs while the toddler is upstairs, and everyone is honking at my rental car in the middle of the street, and now the toddler is throwing a tantrum in the back seat because the fruit snacks aren't the *right* fruit snacks, just as I'm realizing that we left the necessary moose in her crib? The frustration always returned me to the same deluded mantra: *If only I had a partner.*

We drove south through Jersey, past factories like cities made of smoke towers; marshlands full of wind-rippled cattails, and row houses with yards full of soggy patio furniture and the occasional black eye of a trampoline. It was like a heavenly vision—not because it was idyllic, but because it was somewhere different from where we'd been. A highway sign just north of Philly reminded us, TRENTON MAKES, THE WORLD TAKES.

Strapped into her car seat in the back, my daughter begged for more granola bars and scrunched her face into funny expressions in the rearview mirror. *I am a silly pancake. I am a little piece of cheese.* She still didn't know very many words, but she was better company than anyone else I knew. With some childcare restored, I got to feel this way again.

Down on the Eastern Shore, Casey and Kathryn had a wooden

farmhouse, fields of green soybean plants, hot-pink wildflowers, a vegetable garden, and a back porch stocked with six flavors of seltzer. They joked that they were the lesbian farmers Rush Limbaugh had been scared of. They were living what their wedding vows had promised: a deep unity strengthened by habit. Their care was like static electricity in the air. They rubbed each other's backs without even thinking. They noticed small chores the other had done.

I wasn't naïve; I knew they had their frictions too, but their presence in my life felt witchy and spiritual—more like magical realism than documentary. Their marriage was a sign from the universe begging me not to retreat behind the hardened calluses of compromise. True love wasn't a delusion I needed to give away like an impractical, too-tight cocktail dress. I didn't have to convince myself to go on a mediocre third date with every finance guy and his fentanyl history. Dramatic disillusionment was just another sheltering alibi.

Which is all to say: my pessimism was just as melodramatic as my optimism, and my friends were there to interrupt it with a plate of pancakes. Their love was daily and curious. It said, *Just because one love didn't work doesn't mean another can't.* Just because showing up hadn't saved my marriage didn't mean showing up was the wrong thing to believe in.

We set up a kiddie pool in the grass beside their split-rail fence and my daughter jumped into the cold hose water in nothing but a diaper. She gave her purple plastic dinosaur a bath because this was how she maximized her pleasure—by sharing it. She helped her plastic turtle ride on the sturdy boat of a green sponge.

Would every moment of our happiness carry grief in its veins? I had not solved this problem, only learned to live inside it. Perhaps being haunted was its own uncanny abundance.

At the docks, we ate cherry ice cream in the sunshine and watched tiny white jellyfish pulsing between the crab boats. My daughter called out, "My airplane! My airplane!" just like she did when we spotted boats on the Gowanus. Casey pulled a long green catalpa pod off a low-hanging tree branch so my daughter could play it like a guitar.

After months alone, all this goodness was so sudden and sweet that I barely knew what to do with it. Sometimes I punished myself with the idea that every beauty I gave my daughter was compromised because we were getting it like this—from a life I'd asked her to live in pieces, in two homes, in a family that wasn't whole. But these sponge boats and catalpa guitars suggested something else: this beauty wasn't tarnished. Or rather, every beauty was.

On that trip, my daughter was still sorting everything into mama things and baby things. Mama carrot and baby carrot, mama pasta and baby pasta, mama grass and baby grass. The cul-de-sac at the end of their country road was mama circle; the little patch of tar in the middle was baby circle. If you existed in this world, you were either a mama or a baby. You were taking care of someone, or being taken care of.

My daughter was both. She was practicing loving things. She loved her little plastic dinosaur by putting him in the kiddie pool. She loved her baby pancakes by putting them in her mouth. She knew the baby circle had once lived inside the mama circle—in

a hospital waiting room, in a blue maternity shirt, on a freezing day. But she knew the mama circle was bigger than the baby, and the baby circle was bigger than the mama, too.

Part of me felt flooded with sufficiency. Sunlight could fall on a patch of tar, on a country road, and we could stand there and have everything we needed. It was enough.

Another part of me knew it was okay to want more than just our clasped hands—to want twisted sheets in a Houston hotel room, and quiet mornings at my laptop, tap-tap-tapping at my keyboard while grad students read Marxist theory at sidewalk tables below. It was okay to want cigarettes at the beach, and bone broth underground. My daughter broke me open for the whole world. She broke me open for everything that wasn't her.

On that sunlit asphalt, her tiny hand was in my hand, until it wasn't. Until it was pointing at something else instead: tar ribbons in the road beneath our feet, radiating from the dark heart of the baby circle, gleaming like veins of oily black blood. Mama lines and baby lines. When I bent down to look closer, the waist of my shorts rubbed against my scar—that doorway between the world before her and the world she made.

She wasn't going back inside me. My scar wasn't going anywhere. The sunlight wasn't going anywhere. Until it did. And even then, we'd have the night.

Acknowledgments

Thank you to my editor, Ben George, who brought his whole heart and soul to the work of this manuscript, and to Jin Auh, who offers every kind of support I could imagine from an agent—and also something else, deeper and beyond. Thank you to my wonderful teams at Little, Brown and the Wylie Agency; to my foreign teams at Granta and beyond, especially Karsten Kredel and Robbert Ammerlaan; and to those editors who worked on the original essays whose traces ended up in these pages: Emily Greenhouse, Ann Hulbert, and Charlie Homans.

Thank you to my early readers (and dear friends): Colleen Kinder, Harriet Clark, Heather Radke, Lynn Steger Strong, Robin Wasserman, Nam Le, Kyle McCarthy, Michael Taeckens, Melissa Febos, and Mary Karr. Thank you to *all* the friends who helped me through these years and the process of writing about them. What endless grace. Thank you, Staci Perelman. Thank you, Sawyer, for our Saturday sleepovers, our honest conversations, our shared years, and all the years to come. I love you very much.

Thank you to all the women who have helped take care of my

daughter, especially Madelaine Lucas, Grace Ann Leadbeater, Hannah Gold, Hannah Kaplan, and the incredible Sandra Rodney. I'm grateful for your company and friendship, and for making possible the time in which writing happened at all.

Thank you to my family, in all its messy branches. Most of all my mother, whose mothering anchors my mothering. Whose love textures everything I've ever done.

To Eli, my love. Home is wherever I'm with you. To Vera and Roy, it is a joy to be in your lives and to have you in mine.

To Ione Bird: my heart, my joy, my days. This book is most of all for you.

About the Author

Leslie Jamison is the author of the *New York Times* best-sellers *The Recovering* and *The Empathy Exams;* the collection of essays *Make It Scream, Make It Burn,* a finalist for the PEN/Diamonstein-Spielvogel Award; and the novel *The Gin Closet,* a finalist for the *Los Angeles Times* Book Prize. She writes for numerous publications, including *The New Yorker, The Atlantic,* the *New York Times, Harper's,* and the *New York Review of Books.* She teaches at Columbia University and lives in Brooklyn.